D0897578

Culture Strike

Culture Strike

Art and Museums in an Age of Protest

Laura Raicovich

VERSO

London • New York

First published by Verso 2021
© Laura Raicovich 2021

3 5 7 9 10 8 6 4 2

Verso
UK: 6 Meard Street, London W1F 0EG
US: 20 Jay Street, Suite 1010, Brooklyn, NY 11201
versobooks.com

Verso is the imprint of New Left Books

ISBN-13: 978-1-83976-050-1
ISBN-13: 978-1-83976-051-8 (UK EBK)
ISBN-13: 978-1-83976-052-5 (US EBK)

British Library Cataloguing in Publication Data
A catalogue record for this book is available from the British Library

Library of Congress Cataloging-in-Publication Data
Library of Congress Control Number: 2021930005

Typeset in Sabon by Biblichor Ltd, Edinburgh
Printed and bound by CPI Group (UK) Ltd, Croydon CR0 4YY

for Giacomo Cender

Contents

Introduction 1

1. Revelations 15
Artist Nan Goldin and the Sackler Family * The
Historical Roots of Museums * The Untenability
of the Universal * Progressive Era Reform

2. Art and Context 43
Colonialism and Repatriation * Dana Schutz at the
Whitney * The Philip Guston Retrospective *
Sam Durant at the Walker

3. Show Me the Money 75
Questions for Philanthropy * Warren Kanders,
Tear Gas, and the Whitney * Reimagining Public
Funding * Questioning Governance

4. Unlearning, Undoing, Remaking 110
Alternate Storytellings * Approaches to
Decolonization and Indigenization * Survivance

5. The Neutrality Problem 132
Spilled Ink * Materializing the Neutral *
Working toward the "Not-Yet"

6. Going Forward 141
Who Is "We"? * Collective Work *
Invitations to Participate * Public Culture

7. Liberation Serif 154
 COVID-19 * Breath * Reckonings and Demands

Acknowledgements 169

Selected Bibliography 174

Notes 189

Index 203

Introduction

We are living in an age of protest. Around the globe, radical movements, from prison and debt abolition to Extinction Rebellion's climate activism, have penetrated mainstream discourse. Culture and art have, necessarily, also come under fire. While art has enormous potential to shift society, the institutions upon which it relies help hold systems of power in place. As much as I love museums and have dedicated my career to them, they are repositories of cultural hegemony, mirrors of society's ills, from enormous wealth gaps and other legacies of colonialism to the exclusion of historically marginalized groups. Museums and cultural spaces are part of the systems that protests hope to undo. I believe this undoing and redoing can not only make museums better for more people, but also map ways to make change in society at large.

My most recent experiences as the director of the Queens Museum, by turns exhilarating, challenging to my core, and heartbreaking, are central to this thinking. I led the museum for three extraordinary years through moments that proved to be highpoints of my professional life, and others that threatened to thwart my deeply held convictions of art and culture's vital engagement in societal change. A public museum, it is situated within a public park, in one of the most ethnically and culturally diverse geographies on the planet. In a city of immigrants, Queens, host to New York City's two airports, is the place most newcomers arrive. Many stay in the string of neighborhoods along the 7 train, the borough's spine, which transports a population that speaks over 138 different languages and dialects.

Each subway stop opens doors into different cultures. And yet, we are all New Yorkers.

In awe of these realities, I took up my post at the Queens Museum in January 2015. Just eighteen months later, the election of Donald Trump would dramatically shift the landscape in which I worked. While the museum remained on an upward trajectory of increased attention, support, and visibility, the results of the election deeply impacted the staff and our publics and collaborators surrounding the Museum. Over a decade before I arrived at the Queens Museum, community organizers had been hired in a brilliant move to connect with nearby immigrant communities. Led initially by Jaishri Abichandani, and then by Prerana Reddy, this organizing effort created a new model for how museums could engage with their publics. The goal was not just to bring people to the museum, but rather to leverage its resources to surface and enact desires of these communities via cultural organizing.[1]

In the aftermath of the election on November 8, 2016, the Trump administration's policies and rhetoric unleashed a Pandora's box of hate, and one of its primary targets was immigrants. At this museum these new conditions were no mere abstraction, but an all-too-harsh reality. Five percent of the Queens Museum's staff received Deferred Action for Childhood Arrivals (DACA) protections, President Obama's executive order that provided legal status to many people brought to the United States without documents as children. This group heard Donald Trump's promises to repeal DACA, without which they would risk losing temporary relief from legal uncertainty, or even face deportation to countries they had never visited.

Further, in the weeks following the election, many of the people with whom the museum's staff had collaborated for more than a decade and a half—through its free family programs; the New New Yorkers art classes taught in over a dozen languages; gatherings and classes at Immigrant Movement

International in Corona, Queens; and other long term partner-ships—[2] now feared leaving their homes and even sending their children to school.[3] Whether or not the participants in these programs possessed documentation, there was worry of being caught up in a raid or being in the "wrong place at the wrong time." I started getting Facebook alerts from various local groups spreading news of Immigration and Customs Enforce-ment (ICE) being at one or another subway stop, or heading to a particular neighborhood. Some even claimed that the alerts themselves were fake, sent out on social media to stir further anxiety and fear. City council members planned special sessions to reassure their constituents, and New York City Mayor Bill de Blasio convened a town hall in Corona with then–council member Julissa Ferreras-Copeland, along with a cadre of city agency heads and local uniformed police, to reassure immi-grants that we were "all New Yorkers" no matter immigration status, and that local police forces and the educational system should be seen as allies.

In this climate, at the museum, we started holding weekly all-staff meetings. We contacted immigrant rights groups to be sure to stay updated on any changes in policy (whether local or federal) and shared this information with our networks; we coordinated with city agencies to be sure our staff and publics could access important information about their rights; we assembled a list of the museum's resources that could be lent to local groups; and we decided to join the art strike called for Inauguration Day.

On January 20, 2017, while the Queens Museum was closed to regular operations, the staff created a program that invited the public to work with a printmaking collective on creating posters, buttons, and other ephemera for the coming protests. Over 300 people gathered in the atrium that day. I was deeply moved by this gathering of retired school teachers, artists, students, and local moms and grandmas. Throughout the day several in attendance thanked us for creating a space to gather

on a day they felt so vulnerable. On that rainy day, it never would have crossed my mind that just over a year later I would resign my post.

What happened over the following twelve months would prove immensely complex. Several trustees did not like the fact that we were joining the Inauguration Day strike. Their position was that we should continue to do the work we had always done, but to do it quietly. At least one trustee expressed a fear of retribution from Trump via punitive tax audits of board members. From my perspective, not only had the political environment created a predicament in managing a staff with a significant number of increasingly precarious immigrants; I also felt strongly that we needed to be forthright and direct in our support for the communities with whom we had built a great deal over the years. Trust was at issue.

The staff and I drafted a restatement of values, which we felt would be an important buttress of our work. This took the form of a letter "from the director" that we posted to the museum's website. I presented the values statement at the next board meeting, where it was unanimously approved. The statement, since removed, included the following:

> The Queens Museum asserts a deep commitment to freedom of expression, and intentionally supports and celebrates difference and multiplicity as fundamental to our collective liberation. We believe that art can shift the ways in which we experience our world, and therefore art, artists, and cultural institutions have a powerful role to play in society.
>
> Therefore, the Queens Museum:
> - advocates for art as a tool for positive social change, critical thinking, discussion and debate, discovery and imagination, and to make visible multiple histories and realities;
> - supports and initiates projects and programs that are inspired by actively listening to the needs and aspirations

of the communities we serve and consider to be our valued partners;

- works to engender respect for a diversity of cultures, broaden access to ideas and art, and connect the public to opportunities for civic agency;
- uses our resources—human, financial, environmental, and beyond—to create greater equity, inclusiveness, and sustainability, both within our institution and in the broader society.

Outside of the Queens Museum, artists, art workers, curators, professors, and others started organizing with, as one Google group's name made clear, a Sense of Emergency. Around this time, New York's Museum of Modern Art installed an exhibition of art from their collection by artists who would no longer be welcomed into the United States due to the Trump administration's so-called Muslim ban. The Solomon R. Guggenheim Museum submitted amicus briefs to the Supreme Court to overturn the ban, which were co-signed by the Association of Art Museum Directors, the American Association of Museums, and more than one hundred museums all over the United States.[4] Smaller organizations were doing whatever they could.

From the Sense of Emergency cohort, a new working group formed, calling ourselves Art Space Sanctuary. The group was headed by Abou Farman, an artist and professor of anthropology at the New School, as well as a dedicated immigration rights activist. We looked to the sanctuary movement of the 1980s in Latin America, largely carried out by clergy members committed to liberation theology and using churches to shelter people fleeing violence, and the New Sanctuary movement of the 2000s, spearheaded by an interfaith group of leaders in the United States seeking justice for migrants and immigrants.

We thought that Art Space Sanctuary could communicate that cultural spaces were, in fact, for everyone, and that within these spaces there could be ways of conveying care and support.

The Queens Museum had a long history of collaboration with frontline organizations, including the immigrant advocacy group Make the Road, and addiction support group Drogadictos Anónimos, and among others. The idea was to create a series of protocols that would allow museums and cultural spaces to make connections between audiences and these organizations so that we could support vulnerable populations. I strongly believed that the Queens Museum would be an ideal organiz-ation to embrace this concept given our long-term relationships and the extant programming of the museum. We hoped to gather a critical mass of cultural organizations that would become Art Space Sanctuaries by agreeing to the guidelines Farman had developed and made public on a website.[5] This, we hoped, would signal the cultural sector's support for the vulner-able people who worked in the museum as well as visited. The guidelines were flexible, and given that the Queens Museum already had relationships with many frontline groups, it made sense for us to sign on. Buoyed by the enthusiastic support of a few trustees, I presented it at our next board meeting.

The response was profoundly disappointing. A handful of board members thought the idea completely untenable, express-ing fears that the notion of cultural sanctuary would turn the museum into a place for people "to hide out or sleep," a funda-mental misunderstanding of the concept. With outspoken opposition to the initiative, it was impossible to move it forward. Moreover, the rhetoric of the rejection was grounded in the notion that as a public institution we should not, and indeed could not, "take sides" in the political debates around immigra-tion: we had to repudiate a pro-immigrant initiative like Art Space Sanctuary in order to maintain a supposedly "neutral" position. It was demoralizing.

The situation was further complicated in June 2017 when the Mission of Israel to the United Nations contacted the museum about renting the galleries to hold an anniversary event for the historic vote that paved the way for the creation of the

State of Israel in 1948. The Queens Museum's physical building was an appealing location for the event because it was where the UN General Assembly met from 1946 to 1950, prior to the museum's existence. Their proposal was to reenact the vote that took place on November 27, 1947; then–vice president Mike Pence was to be their keynote speaker, addressing hundreds of invited guests.

I felt deeply uncomfortable with this space rental proposal. Typically, rentals of the museum were for weddings, bar mitzvahs, and other types of celebrations; this was a very different kind of event. Not only was I gravely concerned about the operational impacts of an event of this scale, as well as its security implications; the mission's confirmation of the vice president of the United States attendance more than four months strongly suggested the political nature of the proposed event. With its government sponsorship and roster of politicians speaking and attending, I believed this was an event engineered to support the views of particular government aims, and that this violated what had been a long-standing practice—and at the time, I believed, a policy—of not renting space for such political events. Recognizing the unique character of this proposed rental, the matter was escalated to the board for consideration. I recommended against hosting the event, but the decision was ultimately up to the trustees.

After much debate, the board decided to decline the Mission of Israel's proposed event. Two days later an article appeared in the *Jerusalem Post* stating that I was "anti-Israel" because I had edited a book about cultural resistance that contained a section about BDS, the movement inspired by Palestinian civil society's call to boycott, divest from, and sanction Israel. The article was highly critical of me for my supposed canceling of the event. A New York City Council member called for my dismissal and started seeking support for a petition, and the *New York Post* piled on with additional criticism. The board then reacted with great speed, reinstating the event it had days earlier rejected. No

public statement corrected the misperception that the initial decision was mine.

I found myself under an avalanche of hate for alleged anti-Semitism. In the aftermath of these articles, I felt I had to prove to board members, never mind the online universe that was now propelling vitriol at me at staggering speed, that I was indeed not an anti-Semite. My Jewish husband counseled me to talk publicly about his family's history, to relay that his grandparents were Auschwitz survivors, that our son had a bris, and that my grandmother had helped Jewish men escape across the border of fascist Italy during World War II. It felt horrible to trot out these facts about my existence in the effort to convince people who had known me for years that I did not hate people for their cultural or religious backgrounds.

Meanwhile, the work of the Queens Museum was garnering broader acknowledgment by the public. It was particularly encouraging when the *New York Times* profiled my work at the museum.[6] We had just opened a series of successful exhibitions, among them *Never Built New York*, which featured an array of architectural projects planned but never realized that made unique use of the Panorama—a 10,000-square-foot model of every building in New York City's five boroughs that is a center-piece of the museum's collection. I was also deep into planning a major exhibition of artist Mel Chin's work (which I would cocurate with Manon Slome and the nonprofit arts organization No Longer Empty) that would fill the entire museum, with major projects that would spill into various public sites throughout New York City. Additionally, we had recently received significant grants from prestigious foundations. With these promising fundraising results, we had achieved a financial milestone toward which I had been working since my first days at the museum. There was a lot to be proud of for everyone associated with the museum.

Nonetheless, as fall unfurled and the Mission of Israel's event took place at the museum, the politics of the event became

clearer. At the November 28 event, Pence delivered his speech as planned, which went far beyond a celebration of Israel's anniversary: it turned out to be a forty-five-minute policy speech previewing the Trump administration's intent to move the US embassy from Tel Aviv to Jerusalem. Trump made his public announcement of the move from the White House just a week later,[7] and in the days that followed, protest led to violence in Jerusalem and criticism from many US allies and the United Nations. Against precedent, the Queens Museum's building had been used as the backdrop for an announcement of a major shift in US foreign policy.

As fall stretched into winter, I could tell that a small group of board members were unhappy with my leadership, particularly around my recommendations that we participate in the Art Space Sanctuary initiative and decline the Mission of Israel's event. The job of the director is difficult enough without this kind of doubt from a board, and after a grueling year-end, I decided in late January 2018 to resign. It broke my heart to come to this conclusion because I knew I had so much more to contribute to the museum and its publics.

There were a few board members who did not like that I was determined the museum should take a position on events that deeply impacted our staff and surrounding communities via our operations. I believed that as a cultural space reflecting our collective values that we could not remain "neutral," especially as the very foundations of democracy seemed to be crumbling around us. Neutrality, in fact, is not at all neutral; rather, to paraphrase the South African anti-apartheid leader Desmond Tutu, it is a position in and of itself that supports the status quo. And given how the museum had always operated, as well as its commitments to its own staff and collaborators, we knew the realities that confronted us could not be met with indifference.

Since my departure from the Queens Museum, I have been contemplating the history of how museums came to be in the

United States, and how they operate today, particularly in the ways their modes of storytelling embody specific politics and how we might understand their connection to a whole matrix of power relations and ideologies. Amid calls for diversity, equity, and inclusion in our spaces of culture, there is no way around a confrontation with neutrality as a persistent ideology within the museum. In a sense, it is the expertise of the museum that makes it trustworthy; that it selects art and makes exhibitions that are educational, that instruct its publics. However, there are many structures, from operations and governance, to curatorial choices, and the treatment of staff, that undergird these selections, and the ways in which they are presented and interpreted by the museum, that are directly oppositional to any desire for diversity and inclusion. The problem lies in the fact that these structures are unseen and unregistered, and that they undeniably privilege those of specific class, race, educational, and social backgrounds. If we truly want to undo barriers to inclusion, we must face this false neutrality and dismantle it.

Further, the problem with neutrality as a claim for a museum is that it fundamentally neutralizes any criticism, dissent, or alternate history that it might present, which contradicts its very claims to education and free and open exchanges of ideas, as we will see enacted in forthcoming chapters. Neutrality, in effect, results in the disenfranchisement of artists or publics that may engage in debate within its walls because the institutions' very power structures, historically and operationally, nullify concepts of civics to maintain a neutral position. This manifestation of "neutrality" requires that both sides of any debate are equally strong, or must be equally represented. This simply doesn't measure up in reality.

According to the American Alliance of Museums, "museums are considered the most trustworthy source of information in America, rated higher than local papers, nonprofits researchers,

the US government, or academic researchers."[8] But they are also places of profound alienation. Their typically grand architectures have served many purposes beyond the "simple" task of containing and ensuring the safety of artworks. These include signaling the importance of art and culture in a society; the colonial might of a nation; the generosity and largesse of major arts patrons; and, perhaps most tellingly, the tastes of the patrons who founded the institution or provided its foundational collections and objects. And even still, there is a common misperception of what non-profit, tax-exempt status means, particularly as it pertains to remaining "neutral"; it is consistently held, by trustees and staff alike, that there are limits on what kinds of opinions institutions might express in order to protect their tax-exempt status. In fact, there are only two things that by statute non-profits may not do without jeopardizing their status: 1) they may not campaign or lobby for or against an individual candidate for office, and 2) they may not campaign for or against a particular piece of legislation.[9]

Over the past several years, protests have erupted regularly around how museums are funded, how they are organized, what they show and how, who holds power within their structures, and how they reflect, or fail to reflect, a whole diversity of identities. In this book I examine examples of these protests or calls for accountability in order to delve into both the histories of museums and cultural institutions in the United States, and the useful lessons that might emerge; these constitute fascinating and revealing entry points to the manifestation of coloniality, white supremacy, class bias, and innumerable other social dimensions that persist and are contested today.

As publics increase their demands for greater agency, inclusion, and diversity, cultural spaces must examine their own ways of being in order to remain relevant. I believe that to address the inequities that continue to haunt our institutions, and indeed society, we could not find a better place to begin than by dismantling the myth of neutrality in our cultural spaces.

You might be thinking that everyone knows there is no such thing as a neutral space. However, the idea of neutrality manifests within cultural organizations in surprising ways. Consider this: with a membership of over 40,000 people and organizations, the International Council of Museums (ICOM) bears considerable weight in its areas of expertise. Founded in 1946, for nearly fifty years the organization has defined the museum as "a nonprofit institution" that "acquires, conserves, researches, communicates, and exhibits the tangible and intangible heritage of humanity and its environment for the purposes of education, study, and enjoyment."[10] Recently, however, a group of ICOM members decided to revisit this definition, as some felt it was out of date. They proposed new language that describes museums as "democratizing, inclusive and polyphonic spaces for critical dialogue about the pasts and the futures" that "safeguard memories for future generations and guarantee equal rights and equal access to heritage for all people." The proposed language goes on to say that museums aim to "contribute to human dignity and social justice, global equality and planetary well-being."[11]

In mid August 2019, backlash against the new proposal culminated with its dismissal as "ideological" by more than twenty-four of ICOM's country branches, including France, Italy, Spain, and Russia. While such disputes over the definitions of long-standing institutions are not rare, in this case it is noteworthy that the branches framed their objections in terms of the "ideology" the new language signaled; the implication is that the previous definition was *not* ideological, and by extension that the activities of museums proceed from a "neutral" space.

This question of whether museums are neutral, then, is the crux of a contemporary conundrum about how stories have been told, who has told them, why and how they have been framed and historicized, and what it means that foundational stories are being challenged today by a whole diversity of perspectives. The people who hold these diverse perspectives, it must be noted, have been marginalized from society for their race,

gender identity, class, educational levels, ability, etc., throughout many decades. Since museums are the West's mode of preserving history, we then must ask, has the museum ever really been a neutral space? Has it not always had an agenda in its formulation? Is this necessarily always a bad thing? Especially if those agendas include things like "human dignity" and "planetary well-being," which are clearly positive aims? There seems to be widespread discomfort around these ideas, as well as fear that cultural institutions and museums will somehow be reduced if their founding biases are made visible. It is my contention that these biases exist throughout human culture, and that we must, at minimum, see them and confront the intended and unintended consequences of this very human condition.

At a moment in human history when we must contemplate our own potential extinction due to extreme climate conditions we have brought about, and when nationalism has risen and xenophobia internationally has reared its head yet again in increasingly virulent and violent ways, how does culture respond? And how do museums remain relevant in such times, especially when various publics and foundations are calling on museums to be publicly accountable for the ways in which they make decisions and for the ways they work? It is in this context, and at this urgent moment, that I believe we must be able to identify the biases of our museums, to understand the worldviews they both promote and marginalize, and to interrogate these ways of being, working, organizing, and making culture.

I approach this project with a great deal of love for museums, especially the ones that I address specifically. They are struggling to change and reflect our highest social ideals, just as they confront their own blind spots and failures. We must identify why and how we are failing, and fully embrace these failures as the starting point for reimagining the museum—but that is just the beginning. Art workers of all stripes are dedicated to shifting the practices of our institutions, and I hope to give their hard work the credit it deserves. They, more than anyone, know how

much has been accomplished, yet how much further our museums and cultural institutions must go to create a truly accessible, participatory cultural commons.

Through a close look at recent controversies around culture, from the swirl of revelations about where the Sackler family's fortune was made, to the latest COVID-19-era demands for unionization and equity, I look at how neutrality, in all of its institutional guises, manifests itself in the presentation of art, its selection and collecting, the public relations undertaken to shape messaging, where the funds come from to pay for culture, how these systems are governed, and who and how the operations of museums support systems of power.

This book not only offers analyses of the sometimes-obscured problematics of museums, but also points toward some ways they can be better for more people—questions I approach through speculative thought, including on how we might act collectively to achieve these important transformations in the cultural field. Via these two sides of the same coin, I hope that with some care and patience, as well as some fortitude, we might look deeply at what can and should shift, and then imagine how.

1

Revelations

Sitting in the Bartos Theatre at New York's Museum of Modern Art in November of 2018, I was waiting for curator Paola Antonelli to kick off one of her "R&D Salons," which bring together artists, scientists, activists, experts, and various other creative minds to think through thorny questions of our times. Salon twenty-nine was titled "Dependency" and featured a fascinating lineup from artist and disability activist Park McArthur to counter-anthropologist Gina Athena Ulysse, who made her presentation, in part, through song. It was to be capped off by artist Nan Goldin, known for her intimate photographic work, particularly a tender and brutally straightforward series of portraits from the early 1980s titled *The Ballad of Sexual Dependency*.

Goldin took the stage and her voice began to quiver. She was quickly overcome by emotion—she was making a presentation not about her artwork, but about the activist group PAIN (Prescription Addiction Intervention Now), which she had founded following her recovery from addiction to the powerful opiate painkiller OxyContin.

PAIN's stated mission is quite specific: to publicize the troubling links between the pharmaceutical's production and the philanthropic Sackler family, whose name is deeply imbricated with art museums the world over. As Goldin explained at a later protest in front of the Metropolitan Museum of Art, in March 2019, "We're here to call out the Sackler family, who has become synonymous with the opioid crisis," gesturing to fellow activists who held aloft signs and banner that read "We're here to call

15

out the museums who allow the Sackler name to line their halls, tarnish their wings, to honor the family who made billions off the bodies of hundreds of thousands."[1]

The Sackler name has been inextricably tied to art and philanthropy for decades; indeed, their largesse has been likened to that of the Medicis for their provision of major funding to museums, from the Met and the Guggenheim in New York to the UK's Tate Modern and National Portrait Gallery, and the Louvre's Sackler Wing in Paris. And yet the money that enables this generosity, or at least a big chunk of it, comes from what we now know is a very dark place.

One arm of the family, until early 2019, was intrinsically involved with the running of Purdue Pharma, the maker and mass marketer of OxyContin. Though originally presented as nonaddictive and safe, this extended-release version of oxycodone, a drug 50 percent stronger than morphine, has proven to be incredibly addictive and highly potent.[2] After years of misinformation and marketing to doctors as an addiction-resistant panacea for all manner of persistent pain, the drug, according to the Centers for Disease Control and Prevention, Oxycontin contributed to over 200,000 deaths caused by opioid overdose in the United States since 1999.[3]

The namesake of the Washington, DC, gallery to which he donated $4 million in construction funds and over 1,000 precious objects of Asian Art, Arthur M. Sackler, along with his brothers, Mortimer and Raymond, was trained as a doctor. Arthur was also an entrepreneur and successful advertising executive who saw the potential for direct marketing to doctors as a way to exponentially increase sales. In 1952, the three brothers purchased a small company called Purdue Frederick, which over time evolved into Purdue Pharma. By the 1960s, the firm had grown into one of the leading purveyors of tranquilizers, and Arthur Sackler made a fortune marketing them. He simultaneously ran an advertising company and a journal for doctors, which proved to be an effective way to boost sales. Sackler was

also known to have bribed a Food and Drug Administration chief to promote certain drugs.[4] When he died in 1987, Raymond and Mortimer bought out Arthur's descendants' stakes in Purdue. While all of the Sacklers certainly became wealthy before 1987, Purdue Pharma would soon be yielding profits that made their prior fortune pale in comparison.

Purdue's most successful drug during the 1980s was MS Contin, a time-release morphine pill that allowed patients to experience relief from pain over many hours. However, by the time of Arthur's death, the patent was running out and generics would soon take its place. As often happens in the pharmaceutical industry, Purdue sought to improve the formula so as to continue to reap high margins on sales under a new patent. The result was OxyContin, which Mortimer and Raymond Sackler rolled out in 1996 "with one of the biggest pharmaceutical marketing campaigns in history, deploying persuasive techniques pioneered by Arthur."[5] Their formulations provided small dosages as well as mega-pills that vastly exceeded the potency of other opiate pills on the market. As Barry Meier, *New York Times* reporter and author of the 2003 *Pain Killer*, put it, "In terms of narcotic fire-power, OxyContin was a nuclear weapon."[6]

Between 1996 and 2017, the use of OxyContin (and its generic, instant-release version, oxycodone) skyrocketed, making billions in revenue for the Sacklers still affiliated with Purdue Pharma and cultivating a generation of addicts and their untimely overdose deaths. How did this medication get so popular so fast? The fact of the matter is that the Sacklers were following a model they had been for more than a half century: aggressive marketing, directly and relentlessly targeting doctors to prescribe OxyContin not only for acute pain that might follow surgery but also for long-term chronic pain. Further, Purdue not only worked doggedly to destigmatize significant medical hesitancy to prescribe opiates, but it also capitalized on a misconception among doctors that "oxycodone was less potent than morphine."[7]

By 2005 several states had brought suits against the makers and marketers of oxycodone over their roles in myriad overdose deaths, including Purdue Pharma and members of the Sackler family. While the legal battles had only just begun, the fact remained that the billions in revenue from these drug sales has made this family one of the wealthiest on the planet. Of course, the Sacklers are also a major donor to the arts. At the time, the Sackler name remained on the walls of some of the world's most august cultural institutions, and these institutions were caught in a double bind: Should they continue to be grateful for financial largesse that fundamentally supports their work while acknowledging the deep ethical problems in using such funds to support cultural endeavors?

Given Goldin's status as a highly collectible artist whose work is desired by and represented in nearly all major museum photography collections, she saw an opportunity to use her leverage to make change. In 2018, she and a group of supporters kicked off the PAIN protests by dumping hundreds of "prescription bottles" of OxyContin into the reflecting pool at the Met's Temple of Dendur, an iconic ancient Egyptian structure located in the wing that bears the Sackler name. Then at the Guggenheim in 2019, on whose board Mortimer D.A. Sackler sat until 2018, and whose education center was named for the family in 2001, Goldin staged a theatrical and impactful "die-in." Hundreds of "prescription slips" for OxyContin were dropped from the upper ramparts of the museum's famous spiral, which floated down on a crowd lying on the floor of the rotunda chanting "Shame on Sackler." Meanwhile, large banners unfurled over the railings of the ramp declared "Take Down Their Name" and "200 Dead Each Day."[8]

While these were surely powerful symbolic gestures, it wasn't clear if anything would, in fact, shift. Even if public pressure were exerted on these eminent institutions, their relationships with donors often went back decades, and museums rely heavily on private philanthropy to make possible not only maintenance

of current collections and facilities, but also day-to-day operations and temporary exhibitions, not to mention future growth.

Then came March 2019. The National Portrait Gallery in London declared that it would not accept a gift of $1.3 million from the Sackler Trust. Why did they make this decision? Because Nan Goldin had told the *Observer* she was in discussions with the gallery about a retrospective, which she would refuse if they continued to accept Sackler funds.[9] In short succession, Tate, the Met, and the Guggenheim followed suit, each stating in their own way that they would not take future gifts from the family. Each noted that while the Sackler's past generosity was laudable, current lawsuits and revelations about the family's involvement in this health crisis made it problematic to accept new gifts. Many of the Sackler foundations simultaneously announced they would suspend any future gifts.

Then in July 2019, the Louvre announced it would remove the Sackler name from the galleries named in the family's honor.[10] The announcement stated that there was a twenty-year concession on the naming and, since that initial period had lapsed two years prior, that the Sackler name was due for retirement. While the Louvre did not identify ongoing international protests by Goldin and PAIN as the reason for its decision, it is worth noting that the Louvre announcement followed another round of PAIN protests on July 1 in Paris. Following these events, under ongoing pressure from PAIN, schools like Tufts University took the Sackler name from their walls, and NYU's Langone Medical Center decided to take no further funding from the family.[11]

In the midst of this distancing, however, fears within museums were rising that similar scrutiny might be applied to other donors, prompting Daniel Weiss, president of the Met, to state, "We are not a partisan organization, we are not a political organization, so we don't have a litmus test for whom we take gifts from based on policies or politics. If there are people who want to support us, for the most part we are delighted."[12] The concern was that if wealthy people felt they might have to

undergo some kind of vetting, it would debilitate cultural organizations from raising funds. The museum felt it had to continue to declare its neutrality, even as it was being forced to radically shift its relationship with a major, longtime donor.

This wasn't the first time the Met had rejected taking funds from a now-unsavory source. In the early fall of 2018, I received an email from the Met's Department of Islamic Art inviting me to a small discussion at the museum in late October, which was supported at least in part by funds from the Saudi government. About two weeks later, on October 2, Jamal Khashoggi, the Saudi dissenter and columnist for the *Washington Post*, was brutally murdered and dismembered in Istanbul. Over the ensuing weeks, it became increasingly clear that the Saudi royal family was likely to be involved in the crime.

On the morning of October 18, I received the following deceptively anodyne email:

Dear Colleague:

We want to thank you for your upcoming participation in "Collecting and Exhibiting the Middle East." It is our pleasure to host this small invitation-only scholarly seminar on how encyclopedic museums collect and exhibit modern art from the Middle East. This is an important conversation and core to our work as a global institution at The Met, as it is for each of the participants. While this conversation and a subsequent public colloquium were to be supported by external funds, in light of recent developments we have decided that the Museum will itself fund this event.

Again, we look forward to seeing you next week,
Dan Weiss

That same morning, it was announced in the *New York Times* that both the Brooklyn Museum and the Met would be

returning funds from the Saudi regime for upcoming programs.[13] Divestment from these funds made an important statement about the non-neutrality of the sources of these funds. Indeed, the museums could not possibly claim Saudi support could be neutral following Kashoggi's murder.

When two major New York City museums divest of funds from a particular donor, it is an acknowledgement that money is not neutral, and that there are limits to the kinds of support a cultural space will accept if they contradict the stated values of the museum. And while there are certainly very real, material differences between the Saudi Royal Family and Sackler situations, in a cultural moment that has brought scrutiny on many aspects of society, the museum and cultural world seems more connected than ever to international, national, and local events. But how exactly did we get here? Why has this moment of seeming accountability arrived? And what does it mean for the ways in which museums currently operate? How does the myth of neutrality manifest within our cultural spaces, and why is it so problematic? To get deeper, we need to understand the nuances of neutrality more expansively, as well as how cultural spaces have evolved over time.

~

Vasif Kortun, a Turkish writer, curator, and educator now at the helm of the Istanbul Museum of Painting and Sculpture and formerly director of research and programs at SALT Istanbul, speaks of the time registers in which cultural space must operate. He writes:

> It is essential to recognize that institutions exist in three different times concurrently. Exhibitions perform in the "present time." Meanwhile the institution is a heritage machine bearing and asking questions around unresolved, ignored, absented and obscured stories from the past, and also negotiating, fermenting, testing out, in the best case, possible futures.

> Museums' mandates used to be clear: to do everything in their
> capacity to advocate a better world than the one received . . . The
> "better" is unambiguous . . . To support, cherish and voice
> these rights is not becoming political in a narrow sense of the
> word. It is simple decency.[14]

These different time frames that Kortun references require an
understanding of the ways in which cultural institutions in the
United States came to be, and how their evolution from Euro-
pean models embody ideologies from both continents.

Having emerged during Europe's eighteenth-century colonial
expansion into North America, cultural institutions in the
United States reflect some of the values, forms, and power struc-
tures of their forebears. The European museum, from its roots
in Hellenic Alexandria, through to Renaissance Europe and the
Enlightenment, was driven by a desire to bring objects and learn-
ing together in space. Whether initiated by wealthy patrons,
royalty, or the church, European collections and their display
invariably signaled particular interests, ideals, ideology, and
tastes, as well as wealth and power. The presentation of these
objects and their messages ranged widely, from the cabinets of
curiosities assembled by prolific collectors of "strange" objects,
to the church's drive to convey the stories and lessons of its
doctrines via stained glass, paintings, frescoes, and cathedral
architecture, to monarchs commissioning and displaying art in
grand style to reinforce their authority, wealth, and influence,
to the newly minted European bourgeoisie's use of portraiture
as a way to signal their social and economic status. The Western
meaning of art and its display has long been equally as violent
and layered as the subject and form of the artwork itself.

While Enlightenment ideologies brought notions of society's
improvement through science and art, it was not until the French
Revolution that the Louvre Museum became public in the way
we imagine museums today. In 1793, it was declared that the
collections that had heretofore belonged to the king of France

were now the property of the French people. In keeping with the revolution's ideals of liberty, equality, and brotherhood, the Louvre was not only opened to the people of the republic, but it also served as a symbol of the new democratic order. As two prominent museum historians noted, "In the ten-day period that had replaced the week, the museum reserved five days for artists and copyists, two for cleaning, and three for the general public. So popular were the public days that the crowds of visitors attracted swarms of enterprising prostitutes."[15] Not only were the collections owned by the people, but they also existed for their entertainment and enjoyment.

The European museum also served as a symbol of national power, as the Louvre did ostentatiously during Napoleon's rule. Until his defeat at Waterloo in 1815, it was the repository for the spoils of his colonial conquests and aggressions in the form of art looted from Italy to Egypt. While some number of these objects were returned upon his defeat, a significant portion remain in France, providing physical evidence, and continuation of, historical conquest. For example, the Quai Branly–Jacques Chirac Museum in Paris "holds nearly 80 percent of the works of African art in French public collections, around 70,000 pieces in total."[16] Beyond France, European nations' colonial projects brought looted objects and artworks into European museums in vast numbers. Amsterdam's Rijksmuseum, for instance, holds about 4,000 objects whose provenance is traced to the Netherlands' colonial period in South and Southeast Asia.[17]

In the mid eighteenth century, the European museum was still evolving into the form we see articulated today. This time period saw a major shift in the classification and organization of European collections, which in turn signaled a new pedagogy of museums: "The previous arrangement had been based on a comparison of the aesthetic qualities of paintings, but the new system aimed to teach visitors about the history of art based on a series of great masters and regional traditions rather than based on the artistic quality of the works."[18] This revised emphasis on

the educational aspect of the artworks on display, rather than the pleasure delivered by their aesthetics, has not only played an essential role in the evolution of museums intercontinentally over subsequent centuries; it has also served to cement ideas about the public's relationship to these institutions, as seen today in widespread notions that art is a public or common good, regardless of the funding structure that underlies its presentation.

The Enlightenment period, with its commitments to individualism, reason, and the separation of church and state, is perhaps equal only to modernism in its impact on museums and cultural institutions. In fact, the Enlightenment idea of universal man, and subsequent reification via modernism, lies at the core of the emergence of the myth of neutrality in museums. I've been in an ongoing conversation with Charles Esche, director of the Van Abbe museum in the Netherlands, about the ways that ideas of "universal" knowledge relate to art. During one of our discussions in 2018 Esche said, "in this model of an international and universal museum that we are talking about . . . you can walk into a museum and inhabit a universal identity. The universal identity can work up until a point, until some aspect of your own identity, and its relationship to the objects on view, suddenly leaps up and slaps you in the face."[19] The idea behind this kind of museum is, at least in part, that we all come from the family of humanity, and that there are commonalities and resonances that run through culture, throughout history—that link us, one to the other, in spite of our differences. That we can all "simply" be human in this space is a profoundly appealing idea that makes museums attractive places to visit, particularly as sites that carry our common culture, writ large. It signals that we are all part of one society. Right?

While this sense of belonging to the universe of humanity is certainly lofty and appealing, it signals precisely the problem with thinking a museum can be a neutral space. As Esche told me, "At a certain moment, you're likely to come across this jarring conflict between that claim of universality and the reality of this display of white supremacist, European power, Euro-American power,

that's being enacted there in the name of the universal. The universal falls apart."

Both the modes of display and the fact that objects are physically located in a geography different to where they were produced highlight the difference in the ways that Western and non-Western art and artifacts are treated. This can be identified in many institutions via the physical installation of the works, the histories of their acquisition, and why and how they came to be sited within a particular museum. This is where histories of colonization and exploitation become part of the present lived experience of a visitor in the gallery. Realizations about which side of the exploitation equation your personal history lands on will often surface big realities; suddenly the museum doesn't seem quite so universal anymore. Or, perhaps more poignantly: *this definition of the universal does not include you.* When this moment occurs, that universality reveals itself as a mirage. Esche observes: "The museum is built on a lie. It's built on a universality that comes from a highly specific identity that is white, male, heterosexual, ableist, highly educated, wealthy, and so on."

There is a fundamental claim of the universal museum as a neutral space, made for all, but it is not at all a neutral space despite such claims. This neutrality and universality is claimed on behalf of a white, Euro-American perspective. Under the banner of universality, neutrality hides that there has always been a perspective, a set of biases, an exclusivity, that is at its core political, and has always been. Further, claims to neutrality can ultimately serve to disenfranchise audiences from their civic rights and responsibilities. The claim of neutrality, effectively insists that nothing critical or politically challenging can be expressed without the onus of "both-sideism." Neutrality, then, not only creates an artificial antagonism between the institution and its critics, but it also neuters political action, or at minimum does its best to defang its impact.

Further, an extension of this idea of universality is embedded in the ways museums imagine their audiences as a generic body.

And yet this version of "generic" is in fact raced and classed and gendered, excluding many facets of identity that might influence how or what work is presented and received. And herein lies the kernel of alienation for anyone who identifies outside the imagined "generic human." Chapter 2 closely examines how this has played out really via Black-led protests of the display of Dana Schutz's painting of Emmitt Till, *Open Casket*, at the 2017 Whitney Biennial, and the controversy over Indigenous-led protests of Sam Durant's sculpture *Scaffold*, at the Walker Art Center.

So, if museums are spaces for holding culture, their logics are nearly exclusively dependent on a white, Western view of the world—not only in their physical forms, but also in their modes of presentation, pedagogical tropes, and operational and funding structures. Exposing these realities reveals the ruse of neutrality for what it is—a reinforcement of the inequitable status quo. Keeping this state of affairs in mind, let's return to the early days of institutional development in the United States. As this history unfolds, it will become clear how the discussions about the inheritances of colonial conditions and universalism play a role in how US museums are perceived and function today.

In 1773, the Charleston Library Society in Charleston, South Carolina, provided natural history artifacts that led to the foundation of the first museum in the Americas. The society, created in 1748, consisted of a group of "gentlemen" who agreed to purchase books, pamphlets, and other materials to share among themselves, and what would soon grow to be a sizable membership. Indeed, the drive was so strong to introduce these learning materials to a larger public that a 1762 advertisement for the society stated, in the overtly racist language of the times, "The gross ignorance of the naked Indian must raise our pity (so) it is our duty as men, our interest as members of a community, to take every step, pursue every method in our power, to prevent our descendants from sinking into a similar situation."[20]

Having survived war, fire, and multiple natural disasters over the span of its existence, the society's holdings were stored in various members' homes, in a local free school, and even in the upper floors of a member's liquor warehouse. As with other early museums in North America, this institution was modeled on European conceptions of the museum and focused on objects of natural history; its mission was "to collect materials for a full and accurate natural history of South Carolina."[21]

It was at this moment in the late eighteenth century that the museum emerged in North America, an early institution reflecting both burgeoning colonial power and collective desires of the colonizers to make meaning in the "New World." Most early museums in this geography, like the Charleston Library Society, were devoted to understanding and classifying the natural environs studied by the Europeans who migrated across the Atlantic during this period—the same Europeans who were actively attempting to disappear the cultures indigenous to these territories, and had killed millions of Native people through early colonial settlement.

By the mid nineteenth century, major collections of Indigenous American objects were established at the Smithsonian (1846), the Peabody Museum of Archaeology and Ethnology at Harvard University (1866), and the American Museum of Natural History (1869), followed by the Field Museum of Natural History (1893). And they collected not only art and everyday objects, but also human remains.[22] As historian Amy Lonetree notes, since Indigenous populations were "vanishing ... anthropologists at the turn of the twentieth century imagined themselves in a race against time. They saw themselves as engaged in 'salvage anthropology' to collect the so-called last vestiges of a dying race."[23] Of course, that "dying race" was precarious only because of the brutal genocidal and assimilationist policies and practices of the colonial government and people.

While natural history and anthropological museums are not the focus of these chapters (except in relation to recent protests

concerning the American Museum of Natural History in New York City discussed further on), they had an important influence on the formation of US art museums. As with the Charleston Library Society, most early North American museums were initiated by "members" and over time were gradually opened, for short periods, to the public. Interestingly, the founders, members, and collectors involved in these early natural sciences museums often were not experts, but rather enthusiasts. For instance, Charles Willson Peale is credited with being the "first great American Museum director."[24] His Peale's American Museum in Philadelphia (founded in 1786), with branches in Baltimore and New York, not only held natural wonders and dioramas, but also included "portraits of nearly three hundred Founding Fathers, painted chiefly by himself or members of his family."[25] Peale was a painter and a naturalist—notably naming his sons Titian, Rafaelle, Rembrandt, and Reubens—and is considered an accomplished painter of the revolutionary period. His decision to open the museum was as much an indication of his politics as it was of the capitalist colonialism from which it was born. As John Simmons points out in his extensive history of museums, Peale, "wholeheartedly embraced the Enlighten-ment ideals of intellectual freedom and tolerance . . . with the democratic [and I would add capitalist] notion of providing instruction and entertainment to all visitors who paid the entrance fee."[26] From these very early days, the franchise of the museum, as well as its reliance on entrance fees and the need to attract a broad swath of the (largely white, educated) popu-lace, marked its relationship to capitalism.

As the political structures of the United States evolved, the definition of culture, along with its display, was important to its status as an emerging nation and quest to be a world power. Pivotal in this process were the men who gained major financial success in the United States: men who desired affiliation with the perceived cultural refinement of Europe, and therefore insisted the nation assert its ability to acquire works from "less

advanced" cultures. Indeed, between 1800 and 1900 in the United States, a pattern emerged that followed a formulation fairly common in England: "The wealthy private individual who left a personal collection to become a public museum."[27] This would become an enduring model in the United States, continuing to the present day, as evidenced both by the existence of the J. Paul Getty Museum and the Morgan Library, for example, as well as the beneficence of the Sackler family toward cultural institutions.

Another essential element of the museum's reimagination as a public venue was its relationship to education and literacy. Libraries, famously made publicly accessible by the largesse of Andrew Carnegie, are a prime example of this ideology in action. As a boy, Carnegie worked in a Pennsylvania textile mill threading bobbins for the machines. Wanting to improve his lot in life, he hoped to educate himself at the local library, which had a $2 subscription he couldn't afford. By the time he became a steel magnate and among the wealthiest people in the world, he used a portion of his fortune to build a network of local libraries across the US, with the stipulation that they be public and free.[28]

Further, museums, like libraries, were central to the democratic agenda of the development of the United States as a nation-state. George Brown Goode, American zoologist and assistant secretary of the Smithsonian in charge of the National Museum, said in 1889, "The museum of the future of this democratic land should be adapted to the needs of the mechanic, the factory operator, the day-laborer, and the clerk, as much as to those of the professional man and the man of leisure."[29] Thus, not only did the museum occupy the space of collections and study, but these ideals also had to be reconciled with a desire for public education.

While public education as a foundational idea and rhetorical position for museums in the United States evolved over the course of the last century, many of the same hurdles encountered

a hundred years ago have yet to be cleared. In 1917, the Progressive thinker and librarian John Cotton Dana wrote an essay titled "The Gloom of the Museum," in which he describes the reality that is the early twentieth-century museum, and, in his view, its failures with respect to its educational aims. Among his contentions is that many of the private collections that entered into museums were assembled by a very narrow demographic: men of wealth and education who made idiosyncratic and personal collections that ended up in the public sphere, whether via donation or purchase. These objects, desired and acquired by specific individuals, were not only raced and classed, but also came to represent what was "important" or even "excellent" in art and culture. Dana puts it bluntly: "These collectors were usually entirely selfish in their acquisition, rarely looking beyond their own personal pleasure or the aggrandizement of their immediate families."[30] Further, as collections of personal taste, they naturally excluded bodies of work, aesthetics, ideas, and makers with which or with whom the collector was not familiar, did not like, or simply never encountered. His analysis from over one hundred years ago remains strikingly relevant to museums today; indeed, his critique still stands. These collections, and the spaces that contain them were never neutral. They have always been about personal tastes and agendas, both private and public.

Taking into account the sources of many collections depicts only part of the picture. By the twentieth century, these donated materials had been part of the museum apparatus for more than a century, and during this time they had been studied by more than one generation of scholars, whose commitment to the importance of these items was only intensified by their study and by subsequent—credentialed—expertise. Thus a body of experts became the museum's devoted curators, from the Latin *curare*, meaning "to care for." So today, like in 1917, as Dana wrote, "as the collections were of very great value . . . the first thought in regard to them was their preservation; their

utilization [or even usefulness] being a secondary and rather remote affair."[31] While the rhetoric around the primary function of museums in the United States may sound a bit more nuanced today, and extends to the wonderful work done by educators and public programming staffs, invariably their work is less highly esteemed than that of the curatorial team. This disparity reflects an ongoing tension between these two necessary and important museum functions, which have yet to be meaningfully de-siloed and integrated with one another.

Even beyond these conceptual obstacles, as Dana points out, are the types of buildings erected to display invaluable collections. The architecture of the museum often hearkens back to its Alexandrian roots, as a temple devoted to knowledge. Once again, US museums followed the lead of their European forebears, leading to the establishment of monumental spaces that paid architectural homage to the Greek temple or the Renaissance palazzo (think of the Philadelphia Museum of Art, or the Met in New York City with their grand stairs, fluted columns, and imposing stone construction). These design decisions would entail another form of obstruction for the twentieth- and twenty-first-century museum to overcome: "Art museums [became] remote palaces and temples—filled with objects not closely associated with the life of the people who are asked to get pleasure and profit from them, and so arranged and administered as to make them seem still more remote."[32]

So how did this square with the impetus for democratic public education via the museum? The answer is, not very well (never mind questions of whether the public even *wanted* the kind of education on offer, and who this public might comprise, both of which I will address further on). John Cotton Dana's scathing critique of the early twentieth-century museum includes a sarcastic and yet strangely apt question: "Is the department store a museum?"

A great city department store of the first class is perhaps more like a good museum of art than are any of the museums we

have yet established. It is centrally located; it is easily reached; it is open to all at all the hours when patrons wish to visit it; it receives all courteously and gives information freely; it displays its most attractive and interesting objects and shows countless others on request; its collections are classified according to the knowledge and needs of its patrons; it is well lighted; it has convenient and inexpensive rest rooms; it supplies guides free of charge; it advertises itself widely and continuously; and it changes its exhibits to meet daily changes in subjects of interest, changes of taste in art, and the progress of invention and discovery.[33]

While some of these observations are out of date, there are more than a few strategies herein that might be unpacked for their relevance today. In fact, when I was director of the Queens Museum, I used to say, only half-jokingly, that many people came to the museum for the public bathrooms, and then stayed for the art. After all, Flushing Meadows Corona Park, in which the museum is located, is the fourth-largest public park in New York City (bigger than both Central Park and Prospect Park) but has few public toilets. The museum's bathrooms are clean and free to enter, and the building also happens to contain locally relevant, world-class art exhibitions and free kids' programming on weekends. What could be better?

Dana goes on to acknowledge the obvious, that "[a] department store is not a good museum," but he proposes this rhetorical flourish: "so far are museums from being the active and influential agencies they might be that they may be compared with department stores and not altogether to their advantage."[34]

It makes sense that Dana would create this particular type of "wish list" for the museum, given his history as a library director; he is celebrated for having radically shifted the ways in which libraries were used at the turn of the twentieth century. The City of Newark, New Jersey, where he oversaw the library and museum, was a city of immigrants, and he incorporated

foreign-language materials in the collection of the former, writing regularly in local papers to be sure immigrant populations knew about the resources available. He was also one of the first to create a separate children's room or section within the library, welcoming the youngest patrons, and further, he created "a 10,000-object loan collection primarily for use by the schools, but available to anyone with a Newark library card. The museum delivered loans to classrooms three times per week by truck."[35]

His commitment to the premise that regular daily life should enter the library paralleled his desires for museums. He insisted that the broadest public should be provided with access to the full range of reading material, from anarchist tracts to romance novels. He believed that the average person would find what they were looking for, and should be encouraged to encounter any variety of ideas on their path. In other words, libraries should not be "dumbed down," and library patrons should not be "protected" from ideas that some administrator considered difficult or dangerous. While his influence was far greater on libraries than museums, it is instructive to see how alike the two once were, and how differently they are perceived in the United States today. Indeed, the evolution of libraries in this country offers useful points for reflection on how museums might adapt in the twenty-first century.

While the parallels between libraries and museums are obvious, it is equally obvious that libraries feel different from museums. Why do they have a public spirit that most museums lack? Why are there lines around the block at some New York City library branches at 9 a.m.? Both institutions in the United States evolved in similar ways; so how have they diverged? And is this divergence relevant to the ways in which a stunningly broad swath of society feels welcome in a public library, but not in a museum?

One answer to these questions concerns access. Access to public libraries in the United States is remarkable, in part thanks to Carnegie's early interventions. According to one statistician

with the Institute of Museum and Library Services in Washington, DC, "There's always that joke that there's a Starbucks on every corner, but when you really think about it, there's a public library wherever you go, whether it's in New York City or some place in rural Montana. Very few communities are not touched by a public library." In fact, in 2013 there were more public libraries in the United States (17,000) than McDonalds outposts (14,000).[36] And of course, they are also free to enter, which removes a significant barrier for the public.

Let's return to Dana's essay, which clarifies another divergence between museums and libraries; the question of how expertise is embodied quite differently within the two institutions. Museum experts, Dana says:

> become enamored of rarity, of history ... They become lost in their specialties and forget their museum. They become lost in their idea of a museum and forget its purpose. They become lost in working out their idea of a museum and forget their public. And soon, not being brought constantly in touch with the life of their community ... they become entirely separated from it and go on making beautifully complete and very expensive collections but never construct a living, active, and effective institution.[37]

Museums and libraries in the United States originated in similar places and via similar patronage models, with their foundational collections coming largely from wealthy collectors of books and art objects, sometimes in conjunction with institutions of higher learning. However, the word "public" remains embedded in what we call the library. And while some branches are named for generous funders, their interests are secondary to the overall system. In fact, the Queens Public Library system, among the largest in the nation, boasts of having a branch within a mile and a half of every Queens resident, achieving a level of accessibility unheard of for a museum.

It is with these thoughts in mind that I spoke with Cora Fisher, curator of visual art programming, and Jakab Orsós, vice president of arts and culture, at the Brooklyn Public Library (BPL).[38] Orsós and Fisher center accessibility within their intellectual framework and, relatedly, see the library as a repository of ideas and public information, rather than of expertise. In this way, their hope is that when BPL explicitly presents issue-driven programs, audiences might encounter these as participants rather than as recipients of knowledge. In Fisher's words, when she and Orsós imagine programs for the library, they are "visioning an active civic body" that not only desires engagement with the subjects explored, but also expects the library to engage in issues important to their lives. This does not sound like neutrality because, strategically and purposefully, it isn't.

One example of how this works was an initiative that took place throughout 2020. Envisioned as a civic exercise in advance of the US presidential election in November, the 28th Amendment Project invited the people of Brooklyn to imagine what should be added to or omitted from the US Constitution. Comprising negotiations and workshops that took advantage of the dispersed conditions of the library branches, participants thought together about the role of the US Constitution historically and in the present day. They collectively critiqued and augmented existing documents, while forging possible alternatives, which were compiled and also ratified by the participants. This new Twenty-Eighth Amendment was then released to the public a few weeks before the 2020 Presidential election on behalf of the people of Brooklyn. Hundreds of people across the borough participated in crafting this new Amendment. With the help of moderators, it resulted in a document that addresses issues ranging from election reform and political participation to the right to bodily safety, greater economic equity, education, and healthcare, alongside criminal justice reforms and environmental justice.[39]

Programming conceived with these priorities and levels of engagement in mind draws a person into the library as a space of collective public knowledge—not only as a reader, but as an author as well. In this sense, the library is a space that honors not only the knowledge of "experts," but also the knowledge that each of us carries as individuals. These 28th Amendment workshops were one example of how to create spaces of mutual learning and engagement, connecting the civic, the personal, and the poetic. Cultural spaces can, should, and *must* host these kinds of gatherings, acknowledging not only how institutions choose to relate to the issues at hand, but also intentionally engaging with the public's lived experiences so that they can be hashed out in public. Rather than a space of abstracted expertise, the cultural sphere should be understood by the public as a zone in which to negotiate issues we may not necessarily agree on. Fisher aptly summed up this perspective when she said the BPL's "goal and the ethos [in art and public programming] is about being subversive, cultivating curiosity, engaging in democracy."[40]

Returning to the arc of cultural history, the Cold War held decisive influence on the role of culture in the United States. Emerging from World War II, the country was poised for economic prosperity in ways unimaginable amid the destroyed infrastructure of Europe. It was a moment when US art and culture grew with the expanding economy, while simultaneously aligning with the enduring trope that freedom and democracy had defeated fascism.

For some, the splatters and sprays in Jackson Pollock's drip paintings represented the strength and freedom of American life. The mainstreaming of his abstract expressionist style—in the pages of *Life* magazine, through its endorsement by prominent and wealthy patrons such as Peggy Guggenheim, and even via the promotional efforts of the CIA—echoed the dramatic freedom and individualism of American mythologies. In this

imaginary, the lone cowboy, the pioneer, the inventor, were all heroes, each pursuing bold, singular dreams. This art was as American as hot dogs and blue jeans (neither of which are actually uniquely American, but rather hail from immigrant traditions). And its characteristics fit into larger narratives that fought the figurative socialist realist propaganda of the Soviet Union, which by the late 1940s had replaced Nazism as the ideological enemy of the United States.

The unprecedented economic growth of the postwar years coincided with the distillation of modernism into its most concentrated form—conditions that were manifest in the United States in both museums and the culture at large. Within the museum, the white cube, the blank slate that transferred power and importance to artworks displayed within its walls, and itself a sign of aesthetic neutrality, became central to the museum's display tactics, convincing new generations of experts and publics of the onward progress of art through to the avant-garde of abstract expressionism. Meanwhile, the commercial art gallery also gained in prominence and power. Parallel forces, now inextricably intertwined, brought the symbolism of modern art together with ideology, and with the art market. Indeed, now it was not only the freethinking West versus the repressed East that was reflected in art, museums, and commercial art galleries, but also capitalism versus communism; the two economic systems went head to head.

As far as neutrality is concerned, it also played a particular role during this period that persists today. Claims to this "neutral" space of the gallery also serve to absent and disenfranchise publics from their civic rights and responsibilities. The neutral space, after all, demands a certain reverence, neutering or attempting to neuter criticality, and even political action, as it declares its dominance.

At mid century, the form taken by US hegemony inside the museum was a firm commitment to abstraction and universalism that rejected the socialist realism of Soviet art. Moving far

beyond the figurative propaganda of the prewar moment, the 1950s brought forth a deceptive skein of neutrality in a commitment to this type of art and modes of display, belying the profoundly political messages it was used to promote. This art became symbolic ammunition to discredit Soviet communism aesthetically, economically, and ideologically.

Then, in the 1960s, rebellions against the status quo emerged in every facet of American life, including protests aimed at cultural spaces and expressing specific frustrations around racial segregation, urban dispossession, working-class immiseration, and the jingoism of the Vietnam War. The long-standing wound of the enslavement of African Americans in the United States had already unleashed a powerful civil rights movement that crossed racial, ethnic, and class lines. Organizations like the Student Nonviolent Coordinating Committee (SNCC), founded in 1960 with the help of veteran activist Ella Baker, were gathering steam among students protesting a range of urgent conditions. The American Indian Movement (AIM) was founded in Minneapolis in 1968 to gain economic and civil rights for Indigenous people. Second-wave feminist activism put a spotlight on reproductive rights, sexuality, family, and employment, among other spaces of inequity for women. Specific to the art world, the Black Arts movement emerged in 1965, followed by the founding of the Art Workers' Coalition in 1969. The undifferentiated hegemony of the United States of the postwar years was shedding its veneer to reveal a populace that was as diverse as it was culturally vibrant. And those in power—the white patriarchy—were put on notice.

In her book *Whitewalling: Art, Race, & Protest in 3 Acts*, feminist cultural critic and art historian Aruna D'Souza dedicates a chapter to protests around the 1969 exhibition *Harlem on My Mind: Cultural Capital of Black America, 1900–1968*, held at New York's Metropolitan Museum of Art. As D'Souza thoughtfully lays out, the protestors' demands that Black communities be centered in art institutions remain both urgent

and highly relevant to today's cultural circumstances. These demands and the responses of the Met are poignant today because they are weirdly proximate to both protestors' demands and institutional responses 50 years later. D'Souza insightfully describes the steps taken by the Met to strategically expand audiences and avoid controversy:

> [The] Metropolitan Museum of Art did everything right when it came to what we might now call "diversity and inclusion," [and] it was imagined as an almost utopian effort to heal a festering racial divide in New York City. It was conceived explicitly as a way to invite heretofore ignored black audiences into the museum. It was put together with a staff that included black collaborators. Three separate advisory committees of black cultural leaders, "influencers," and experts were organized . . . But despite all of this—or rather because of it—the exhibition failed in spectacular ways.[41]

The most egregious error, within a web of missteps, was that while the exhibition brought images of Black people and Harlem inside the Met in unprecedented ways, *none* of these images were *produced* by Black people. At a historic juncture, "no black art was . . . included."[42] In spite of the advisory efforts of Black members of committees and consultants, this was an exhibition that largely came from the imagination of a single white man: its curator, Allon Schoener. John Henrik Clarke, a Black activist and historian whose work focused specifically on Harlem, wrote to artist Romare Bearden at the time, "The basis of the trouble with this project is that it never belonged to us and while a lot of people listened to our suggestions about the project very few of these suggestions were ever put in place."[43] The frustration and outrage among the advisors to the project, including Clarke, spread far beyond this group of relative insiders. The Harlem Cultural Council withdrew its support for the exhibition in November of 1968, after its

recommendations were ignored, and Harlem-based artist Benny Andrews started the Black Emergency Cultural Coalition (BECC) specifically to protest the exhibition. On January 12, 1969, BECC arrived at the police-barricaded Met with placards reading "That's White of Hoving!" "Harlem on whose mind?" "Whose image of whom?" "On the Out by Massa Hoving,"; they presented a list of demands including the "appointment of Black people on a curatorial level and in all other policy-making areas of the museum" along with a flyers that pinpointed their fury:

> One would certainly imagine that an art museum would be interested in the world of Harlem's painters and sculptors. Instead, we are offered an audio-visual display comparable to those installed in hotel lobbies during conventions. If art represents the very soul of a people, then this rejection of the Black painter and sculptor is the most insidious segregation of all.[44]

More than a few critics saw Met director Thomas Hoving's support for *Harlem on My Mind* as a cynical ploy to tap into the rising activism of the late 1960s in a way that would also advance his own desires for the museum, by drawing a direct line to its relevance to the communities in Harlem. In fact, simultaneous to the planning of the exhibition, Hoving was attempting to expand the museum into the public domain of Central Park to accommodate the Temple of Dendur. On the one hand, D'Souza explains,

> [Hoving] saw the Met as a site of "creative confrontation" . . . as a benevolent, neutral platform where not just opposing ideas but communities in conflict could come and work out their differences. But thanks to the emergence of the Black Arts Movement, itself fueled by the language of Black Nationalism, the Harlem cultural community had a much different, and

indeed progressive idea of what museums were and what they could be. Black organizers, recognizing them not simply as neutral platforms for display and debate but as mechanisms of power, sought to intervene in existing institutions—as well as create new ones—in ways that foregrounded museums' role in their communities, including acting as an active force in the struggle for racial justice. They were after transformation, not inclusion.[45]

Interestingly, in the wake of the effort to site the Temple of Dendur at the Met, D'Souza notes that "there were also calls by black community groups, politicians, and activist organizations to consider putting the Temple of Dendur in Harlem." Others demanded that the museum relocate parts of its collection to satellites throughout New York City in order to subvert the fact that many historically marginalized communities felt unwelcome at the Met's flagship on the Upper East Side of Manhattan.[46] To this day, these same swirling controversies and demands around museum spaces and their public function continue to resurface.

These concurrent struggles, concerning both Black leadership in art institutions and the relationship of the museum to urban space, index the power and wealth differential between those affiliated with the Met (at all levels) vis-à-vis the BECC and other Black community groups. Indeed, these deep-seated tensions make it clear why this venerable institution could never be considered to be a "neutral" space for debate about *Harlem on My Mind*. Hoving's ability to instrumentalize race-conscious advocacy and protest for realpolitik acquisition of public land cannot be separated from the exhibition's institutional failure and what transpired afterward.

The wing that Hoving proposed, the permanent home of the Temple of Dendur, eventually opened in 1978. It is named for the Sackler family, whose major gift made its construction possible, and was subsequently home to Nan Goldin's 2018 PAIN

protests. The accumulations, even in just this one example, of inequity are staggering. No museum is neutral, nor has it ever been. Indeed, from their very outset, museum structures have reflected a vast inequity of both power and wealth.

2

Art and Context

There is a paradox embedded in cultural spaces that bears addressing in greater depth. While museums replicate the very power structures around race, class, and identity that the wider society contains, their programmatic impulses and rhetoric claim a very specific type of progressivism: one that is "open to all" and aims for that elusive universalism, yet is so often perceived as elitist.

Developing "world class" public museums is central to these ideals, bringing us right back to a discussion of European colonialism. Consider, for instance, the power and authority gained by Lord Elgin when, at the turn of the nineteenth century, he took the exquisite marble statuary from the Acropolis in Athens to London.[1] Subsequently, the British Museum has enjoyed not only the prestige of those holdings in one of its premiere museums and access to these works for its citizens and visitors, but also the tourism dollars they attract to the institution and the city.

The debate over where the Acropolis marbles should be physically displayed rages on today. Even after a state-of-the-art Acropolis Museum was completed in Athens in 2009, at the foot of the citadel itself, the British Museum has denied its responsibility to return the marbles. In fact, the director of the British Museum, German historian Hartwig Fischer, stated in 2019:

> The artifacts of the collection of the British Museum belong to the British Museum and there is no chance of a long-term loan to Greece. In order for us to loan an artifact the lender must

recognize we are the rightful and legal owner ... When you move an artifact in a museum, you move it out of its context. However, this move is a creative act. This is true not only for the British Museum, but the Acropolis Museum as well.[2]

This is an outrageous statement, particularly given the fact that the Acropolis is visible from the galleries within which the marbles would be displayed if they were returned to Athens. It is also emblematic of how resistant cultural structures are to confrontation with reality. How could the British Museum possibly provide a more appropriate or necessary context for the Acropolis marbles than if they were sited adjacent to its ruins?

In 2018, a report on the subject of the repatriation of art was released, specifically with respect to African art, that sent shock waves through the museum world in the West. Commissioned by French president Emmanuel Macron, it calls unequivocally for the restitution of artworks taken during periods of colonialism and under a variety of coercive and objectionable circumstances.[3] The report's authors, Felwine Sarr and Bénédicte Savoy, make it clear that works taken under the dubious and highly inequitable conditions of colonialism should be returned at the request of the country of origin, following a period of collaborative research and information sharing. While calls for the return of such looted art have been underway for years, the report's conclusion has alarmed museum staff throughout the West with the specter of hundreds, if not thousands, of objects potentially in legal limbo, and visions of galleries emptied of both art and audiences. In a March 2019 editorial for *Frieze* magazine, however, Greek curator and writer iLiana Fokianaki deftly summarizes the situation as such:

White, Western museums still hold the power to adjudicate between the temporary and the definitive. They justify this power, claiming to hold the expertise and knowledge of "what is best" for these artefacts. A colonial logic persists in this

relationship between the thief and the owner: the purloiner holds the power. The use of the word restitution, cleverly decided by the powers at play, is rarely replaced with the more appropriate terms of repatriation or return – return to the rightful owner.[4]

While arguing that Western museums must comply with requests for return from an ethical perspective, Fokianaki questions whether the European holders of the works will in fact repatriate the objects in question, given the cultural and economic capital enjoyed by these Western, white institutions through their holdings of loot:

> The economic power of institutions of this caliber is sustained not only by them operating as vehicles of soft – or not so soft – diplomacy. It is also perpetuated through their position as beacons of the Western canon that dictates the rightful ownership of these artefacts, as well as determining what is culture or not. And it adds insult to injury: the countries afflicted by theft and their ambassadors (in the forms of corporations or wealthy jetsetters and patrons) often cannot support financially the life of these artefacts in the museums of their home countries, so they support them in these museums, since it is after all the only way for them to exit the vault and see the light of day, ever so briefly, in the form usually of temporary exhibitions. Or they simply approve of the looting.

And so questions of where these objects are today are not only in need of a historical reckoning but also must be understood within a framework of the ongoing impacts and contemporary realities of colonialism. While the explicit governance inflicted by colonial regimes may have ended decades ago, there remains outsized power, both symbolic and material, in today's continuation of the possession, display, and monetization of another nation's cultural patrimony.

Consider the Benin Bronzes. These exquisite artworks were looted in 1897 by British soldiers during the infamous pillaging of Benin City, in what is today southern Nigeria. Bronze, brass, ivory and other artworks and artifacts were chiseled off of buildings, taken from homes, removed from the King's palace, and subsequently sold to European museums at auction, or were just taken by individual soldiers.[5] Given this history, I wonder what it might mean for a Nigerian immigrant to France to encounter a Benin Bronze in a French museum, particularly as so few such treasures remain in Nigeria. Indeed this scenario doesn't seem unlikely, given that around 46,000 objects at the Quai Branly–Jacques Chirac Museum alone would qualify for repatriation, and both this museum and the Louvre have significant holdings from the country's colonial relationship to Nigeria.[6] In this French context, is the object displayed in the same way European artworks of the same time period are shown? Is it contextualized ethnographically or formally or art historically? Is it made clear how this object came to be in its current location? Is its author named? On this last question, artist Simone Leigh recently said,

> [Objects like the Benin bronzes] get detached from their authors, and so the authors become the connoisseurs, the collectors, of the artwork. Then their market value is created by those collectors. Their connoisseurship determines what becomes and doesn't become an important work. So that disconnection from the actual authors of the work is one of the peak reasons people don't think [art by Black people is already part of the canon].[7]

In this vein, does the apparatus of colonization become yet more blatant, not only in the continued display of the object in the colonizing nation's cultural institution, but also in the undeniable economic and political conditions that have made France a desirable destination for those seeking relative economic and

social security? How can these problematic and highly unequal relationships be redressed without the return of such works, or even the possibility of their return, not to mention the other reparative actions to undo the profound impacts of what Leigh describes above. It is nothing less than erasure embedded in the undeniable contemporary conditions of inequity created by the legacies of colonialism. How do museums approach these problematics of owning stolen objects? How do they encounter the dispossessed? Those whose material culture was taken? How do museums and cultural institutions replicate these oppressive conditions in their programming and operations by resisting entry into this discussion? And how can any of this be broached or resolved when unduly bound up in the pretense of neutrality?

Beyond the question of looted artifacts, parallel questions are embedded in contemporary art, as evidenced by two recent controversies that exposed how the supposed universality of museum audiences remains a fiction that often obviates rigorous contemplation of the institution.

The first is the public response to a painting by artist Dana Schutz that appeared in the 2017 edition of the Whitney Biennial. The biennial was organized in the wake of the killings of Trayvon Martin, Eric Garner, Tamir Rice, and Michael Brown; the 2014 protests in Ferguson, Missouri; and the emergence of the Movement for Black Lives and #BlackLives-Matter; as well as the campaign to mark the deaths of Black women, trans, and gender nonconforming people following encounters with US police forces, including Sandra Bland, Tanisha Anderson, Yvette Smith, Rekia Boyd, and, deplorably, many more since, including Breonna Taylor and Tony McDade. The resurgent strands of racism and white supremacy fanned by Donald Trump's 2016 presidential campaign and his administration's four years of racist rhetoric, along with the post-9/11 militarization of local police forces, mark a toxic convergence

that makes clear, once again, that Black people in the United States exist in a state of mortal danger—even conducting such mundane activities as making a call on a mobile phone in a relative's backyard, going for an evening jog, or walking home wearing a hoodie.

When the biennial opened in March 2017, artist Dana Schutz's painting *Open Casket* (2016) became the subject of intense scrutiny and controversy. The painting in question is a representation of Emmett Till's dead body lying in a casket; it is based on the devastating photograph of his tortured and beaten face. In 1955, after being falsely accused of harassing a white woman, Till, a Black child of fourteen years, was lynched by vigilantes. His mother, Mamie Till-Mobley, made the photo public in *Jet* magazine.

Formally, Schutz's painting roughly follows the cropping of the black-and-white photo, showing Till from mid chest up, in a coffin, wearing a formal black suit and white shirt. Schutz adds a bright-red carnation to his lapel, creates a lush interior for the coffin's cushioning, and then handles the boy's brutalized face with expressionistic brushwork suggestive of, if not specifically rendering, the fatal beating the boy sustained. Till's head is surrounded by a yellowish halo that melds with the pillow supporting his head. It is an affecting image, albeit in different ways than the graphic documentation of the photo released by Till's mother after his funeral.

On the day of the biennial's public opening, protesters Parker Bright and Pastiche Lumumba, both New York–based artists, stood in front of the painting to block its view as a way to reclaim this image from public consumption, at least partially. Lumumba said at the time:

It's insensitive and gratuitous for the artist, primarily—then the curators and the museum—to willingly participate in the long tradition of white people sharing and circulating images of anti-Black violence. There's a history of white people taking

pictures of lynchings. In 2017, for us to have a white woman painting that image with no context . . . that's a grossly deficient way of using one's privilege.[8]

Soon after, artist Hannah Black wrote an open letter demanding not only the removal of the painting from the exhibition, but also its destruction to prevent its further circulation in the marketplace. Black, in her letter to the Biennial curators, states:

> Through his mother's courage, Till was made available to Black people as an inspiration and warning. Non-Black people must accept that they will never embody and cannot understand this gesture: the evidence of their collective lack of understanding is that Black people go on dying at the hands of white supremacists, that Black communities go on living in desperate poverty not far from the museum where this valuable painting hangs, that Black children are still denied childhood. Even if Schutz has not been gifted with any real sensitivity to history, if Black people are telling her that the painting has caused unnecessary hurt, she and you must accept the truth of this. The painting must go.[9]

Her letter and the ensuing debates centered on whether calls for destruction of the painting were necessary, or should be considered censorship, and whether the subject of Black pain should be off limits to white artists. Many compelling arguments were made that stressed the power imbalance between Hannah Black, as a single artist calling for the painting's destruction, and the Whitney Museum and all it represents in its preservation and display of American art. Others found the call for the painting's destruction extreme; some recognized this call as a way to leverage power that one does not possess. Artist and writer Coco Fusco wrote an op-ed that directly challenged central elements of Black's critique, including Black's claim about the intentions of Till-Mobley in making the photograph of her son's body public:

I find it alarming and entirely wrongheaded to call for the censorship and destruction of an artwork, no matter what its content is or who made it . . . Black makes claims that are not based in fact; she relies on problematic notions of cultural property and imputes malicious intent in a totalizing manner to cultural producers and consumers on the basis of race. She presumes an ability to speak for all black people that smacks of a cultural nationalism that has rarely served black women, and that once upon a time was levied to keep black British artists out of conversations about black culture in America . . . Furthermore, in her letter, Black does not consider the history of anti-racist art by white artists . . . She does not account for the fact that black artists have also accrued social capital and commercial gain from their treatment of black suffering.[10]

Most commentators, no matter the specifics of their take on the matter, did not endorse the destruction of an artwork, except by the artist herself as a gesture of solidarity, or of editing.

The question of the propriety of the subject of the painting drew a great deal of analysis, particularly from people insisting that a white artist should be able to depict Emmett Till, or any other Black person or situation; they argued empathy should be fostered, particularly in politically divisive times. Others pointed out that such work by white artists must be accompanied by informed study of the subject matter and conviction, which many felt Schutz had not embodied in painting *Open Casket*. At the time, Schutz said, "I don't know what it is like to be black in America but I do know what it is like to be a mother. Emmett was Mamie Till's only son. The thought of anything happening to your child is beyond comprehension. Their pain is your pain. My engagement with this image was through empathy with his mother."[11]

The objections to this sentiment are clear; as a white woman she has no idea what it means to be a mother of a Black child. Further debates emerged about the intention of the curators, and

whether this painting was specifically chosen for its controversial character, or whether it was a blind spot in their own judgment that prevented them from foreseeing the furor that would follow. Many words were spilled over every aspect of the situation on Facebook and Twitter feeds, in art publications of all stripes, and a *CNN* op-ed penned by art historian and cultural critic Aruna D'Souza.

While there were many more nuances and details to the debates swirling around this painting, many were ultimately rooted in the positioning of this particular painting: that it was seen within this *particular* exhibition, at this *particular* museum. The history of the Whitney Biennial includes a number of controversies, protests, and debates, many of them surrounding the relative inclusiveness of the exhibition and the museum more generally. Whether in the withdrawal from the 2014 biennial of HowDoYouSayYaminAfrican? (aka Yams collective, a multidisciplinary group of artists of the African diaspora), or the Guerrilla Girls 1987 callout of sexism at the museum via their *Guerrilla Girls Review the Whitney* project, the exhibition itself has repeatedly been a flash point for protest on issues of race, gender, class, and the art world's inherent biases. Zooming out further to the Whitney Museum as an institution, I have heard many people, fairly or not, refer to the Whitney as the "Whitey" over the years, and the fact that Rujeko Hockley was appointed assistant curator in 2017, the first time a Black curator joined the full-time staff of the museum since Thelma Golden left in 1999, is a difficult reality to parse without recognizing the institution's predominant whiteness as an issue. At the core of the Schutz controversy, then, as it relates to the Whitney Biennial and the museum itself, is the following central question: How is the ideology embedded in the Whitney and the structures that enable the biennial revealed via the display of Schutz's work, and amid the subsequent uproar?

~

Only a few months before the 2017 Whitney Biennial opened to the public, the poet and essayist Claudia Rankine formed the Racial Imaginary Institute; its mission is to contend with the ways in which "perceptions, resources, rights, and lives themselves flow along racial lines that confront some of us with restrictions and give others uninterrogated power"[12] as well as with the many invisible ways whiteness, in Rankine's words, "is not inevitable."[13] In the midst of these debates swirling around the Dana Schutz painting, the Whitney invited Rankine and the institute to convene a free public event. Following the event, I was left with deep respect and gratitude for the presenters, who so generously tapped into the moment to confront its complexities. Nevertheless, rewatching video of those presentations and exchanges today, I feel deep frustration at the fact that if the same circumstances were to emerge again, the same debates and conversations would likely be repeated.[14]

From these presentations, I want to cull a few threads. Christina Sharpe, a scholar of English literature and Black studies, made a contribution focused on how the conditions of white supremacy are embedded in *all* conflict. It operates, she says, to "always answer white supremacy" by pulling the conversation away from the discussions of representation and "the intellectual work done by Black people around questions of art and representation and looking." She describes white supremacy's perception of the Black gaze as censorial rather than as a perspective that must be taken into account. She says,

> Polemic is not censorship. And representation in art is an arena of confrontation and conflict for Black people . . . Visuality is not neutral, it is founded on the logics of the plantation. Visuality is not simply looking, it is a regime of how we see and where one is located on the scale of seeing and being. A particular gaze, let me call it a Black gaze is cast as irrelevant, or it is cast as a censoring gaze or it is rooted in something called identity, which it appears only some of us have. But any

so called neutral position is a position of power that refuses to recognize itself as such . . . It is a useful fiction but it is only a fiction to insist that art lies beyond critique . . . intention aside, among the things that art may do is produce and reproduce pain . . . Art can be cruel interpretation or malevolent intervention . . . What if we proceed as if all the knowledge that Black people and others have produced about the representations of Black bodies and Black people in EuroAmerica's imagination actually mattered. What if this work actually shifted how we one talks about that work?[15]

Sharpe suggests the abstracted surface of Schutz's painting nullifies, contains, or indeed abandons the unobscured violence relayed by the photograph Mamie Till-Mobley gave permission to reproduce—permission given precisely to *convey* the horror of what had been done to her son. Till wanted her son not simply to be made visible; she wanted him to be *seen*. Artist Lyle Ashton Harris conveys this point clearly and succinctly during his comments at the Racial Imaginary Institute event when he says, "Any redemptive horror that is in the original photograph has been silenced or muted by what is, in effect, an abstract painterly rendering of an otherwise disturbingly uncompromising image." The painting fails because it abstracts the material brutality, cruelty, and violence of the white-supremacist abduction and murder that took place in 1955, abstracting an image whose power and meaning rely on its documentary undeniability. Further, Sharpe says, "images of Black people suffering don't actually do the work that we think they actually can or should do. All too often they hit in the register of abandonment. The work does this even or even especially when it purports to humanize Black people. That is when it purports to make manifest humanity that we already know to be present."[16]

Schutz's choice of this particular image needs to be considered in the context of the Western assumption that artists

have the right to choose their subject. There is not necessarily an identity-based limit on who can address a particular issue image or issue. *However*, as many Black feminist scholars including Christina Sharpe, Hortense Spillers, and Saidiya Harman contend, there is no such thing as a neutral gaze, particularly when it comes to Black subjectivity. The renowned scholar of African, women's, gender and sexuality studies, Tina Campt has written, "the choice to 'listen to' rather than simply 'look at' images is a conscious decision to challenge the equation of vision with knowledge . . ."[17] And "listening to" an image, requires a whole realm of historical, personal, and temporal care, a necessary attending-to. Therefore when an artist's work enters spaces of pain and suffering it comes with responsibility; it must be done with such intention and knowledge, as well as a sensitivity to how audiences may read the work. In some senses, this aspect lies at the core of this controversy. As multimedia artist Ajay Kurian points out in his statement at the Black Imaginary Institute event, given the histories of white ownership of Black bodies and the histories of white society's regulation of what can be owned by Black people—for example, redlining real estate to prevent Black homeownership in specific districts—ownership is a contentious condition in Black life.[18] Shouldn't these threads have been central considerations to any depiction, then, that seeks to confront the histories of white violence visited upon a Black person, particularly one made by a white person?

Toward the end of the Whitney event, this confrontation with the question of cultural appropriation and responsibility to one's audiences is taken further by an unidentified young Black woman. Here I want to interrupt the flow of this narrative. I have failed to identify this woman, via contacts at the Museum, via social media, and otherwise. This is important. She is the "Brilliant Black Woman at the Back of the Room," a person who is not connected to any of the insider networks that would allow me to identify her, and yet, her comments are the ones that resonate

most intensely for me years later. The very fact that I have been unable to figure out who she is signals the racialized structures within cultural space that, even as many exceptional Black thinkers and artists were in that room, it remained a space in which this young person was compelled to speak the thing that no one else said, the thing that had to be said, the thing that had the potential to crack open an "ability to identify with the experiences of others."[19]

So when, this woman wonders, will the perpetrators of extreme violence, rather than their victims, be the ones depicted in renderings such as Schutz's? "Focus should be shifted away from the boy who needs to rest in peace and his family who needs to finish grieving, and from the color of our skin, and start asking why did you and why is your image protected?"[20] Not only is this assertion powerful in and of itself, but it also offers an alternative path to the one Schutz took in depicting Till. As writer Sarah Schulman said at the Whitney event, white women must confront the image of Till because "we were the excuse for his destruction;" can we "reverse our historic role as perpetrators and fulfill the implications for action that come from that recognition." And to do this work as an artist, a curator, and an institutions requires far more robust structures of care and engagement than what unfolded around the Biennial.

A more recent story, which emerged three years after the Schutz controversy, might shed some light here. Philip Guston (1913–1980), a Canadian American painter, was slated to have a major retrospective, the first in fifteen years, organized by a coalition of museums: the National Gallery of Art in Washington, DC; the Tate Modern, London; the Museum of Fine Arts, Boston; and the Museum of Fine Arts, Houston. On September 21, 2020, the directors of these institutions released a joint statement delaying the presentation of Guston's work from 2021 to 2024 (the show had already been delayed by a year due to the COVID-19 pandemic):

> We are postponing the exhibition until a time at which we
> think that the powerful message of social and racial justice that
> is at the center of Philip Guston's work can be more clearly
> interpreted . . . The racial justice movement that started in the
> U.S. and radiated to countries around the world, in addition to
> challenges of a global health crisis, have led us to pause . . . We
> feel it is necessary to reframe our programming and, in this
> case, step back, and bring in additional perspectives and voices
> to shape how we present Guston's work to our public.[21]

The exhibition was postponed due to the inclusion of a body of
Guston's work that depicts figures wearing Ku Klux Klan hoods
and robes. They are often clownish, smoking cigars or packed into
small cars, and the artist even depicted himself, a Jewish white man,
in such robes in a self-portrait. The museums argue that this image-
ry is too provocative for an American audience in the current
moment. Darren Walker, a trustee of the National Gallery of Art
and Ford Foundation president, said, "What those who criticize this
decision do not understand, is that in the past few months the
context in the U.S. has fundamentally, profoundly changed on
issues of incendiary and toxic racist imagery in art, regardless of
the virtue or intention of the artist who created it." An open letter
signed by nearly one hundred artists, curators, and critics disagrees.
The *New York Times*, quoting from the letter, points out that:

> the postponement is an admission of the museums' "long
> standing failure to have educated, integrated, and prepared
> themselves to meet the challenge of the renewed pressure for
> racial justice that has developed over the past five years." They
> demand that the Guston exhibition take place as scheduled,
> and that the museums "do the necessary work to present this
> art in all its depth and complexity."[22]

While I join this latter group in these demands to contend
directly with the content of the work, I unequivocally applaud

the museum's insistence on slowing down. If they failed to do what the critics above propose, it is their responsibility to rectify the situation before displaying the work; to do otherwise is a profound disservice to the public and the artists' legacy. It is imperative that institutions create situations that engender thoughtful consideration, care, and interaction with a great variety of publics and stakeholders. In fact, Kaywin Feldman, director of the National Gallery in DC recently said, in reference to the Guston show, that "an exhibition with such strong commentary on race, cannot be done by all white curators. Everybody involved in this project is white."[23] In this statement, she is enacting this type of care, acknowledging that in spite of the inclusion of Black artists Glenn Ligon and Trenton Doyle Hancock's essays in the catalogue, that the whiteness of the curatorial effort, as well as the institutions, behind the exhibition must be taken into account.

What is further interesting, and relates to the Schutz case, is that Guston's Klan works present representations of perpetrators, rather than victims, by a white artist. Musa Mayer, Guston's daughter and head of the Guston Foundation, also responded with dismay at the news of the delay, saying,

> Half a century ago, my father made a body of work that shocked the art world. Not only had he violated the canon of what a noted abstract artist should be painting at a time of particularly doctrinaire art criticism, but he dared to hold up a mirror to white America, exposing the banality of evil and the systemic racism we are still struggling to confront today.

Of Guston's Klan figures, Mayer said,

> They plan, they plot, they ride around in cars smoking cigars. We never see their acts of hatred. We never know what is in their minds. But it is clear that they are us. Our denial, our concealment . . . My father dared to unveil white culpability,

our shared role in allowing the racist terror that he had witnessed since boyhood, when the Klan marched openly by the thousands in the streets of Los Angeles.[24]

Indeed, Guston's paintings of the Klan are depictions of perpetrators that clearly address the question asked by the unidentified woman and Schulman at the Whitney's Racial Imaginary event. And here, the question becomes: Is a two- or four-year delay what is needed in order to consider these works in today's context? The very long planning schedules of large museums make such extensions commonplace—but could this not be treated as a special case? Given the reality that these are predominantly white-dominated museums, it is wise to take a step back, think critically about the ways in which the planned exhibition presents these works, and, perhaps, make space for a fresh set of analyses of the work and its presentation within the exhibition. Whether this should take as long as the museums propose is another question.

Returning to the Schutz discussions, artist and writer Malik Gaines spoke potently to the subject of the suggested destruction of artwork. Following the demands that Schutz's painting be destroyed, many commentators relayed fears of a descent into fascist art- and book-burning, to which Gaines responded, "Can't we tell the difference between a gesture by an artist that's rooted in a Black critical negativity, and the violent instruments of racist state regimes?"[25] He further maps the histories of destruction in and of art, offering examples where it might produce generosity or space for reflection, from Tibetan sand mandalas that are swept away upon completion and Indigenous potlatch ceremonies in the Pacific Northwest, wherein objects of value are given away or destroyed, to the work of Japanese Gutai artist Saburo Murakami, who in 1956 stretched frames with paper broken through by the artist, or of American artist John Baldessari, who baked cookies with the ashes of his burned paintings to announce his commitment to conceptual art. In describing these circumstances and artworks, he notes, "Who

is authorized to destroy is the greater question than the destruction itself."[26] In fact, potlatch ceremonies were outlawed in the United States and Canada because it was considered "uncivilized" to destroy private property. Gaines further evidences this idea when he describes reactions to the destruction of the Los Angeles uprising of 1992, which was sparked by the acquittal of four white police officers in the brutal beating of Black motorist Rodney King; he speaks of the expressions of anger in news and public discourse that revealed the "destruction of property was far more outrageous than the destruction of life that had become normal among the police force in that city."[27] These very same claims were echoed in response to BLM protests in 2020. Destruction of property in capitalism is a very sore point, as will be discussed further on.

Connecting this conversation to that surrounding the Dana Schutz painting is the question of the Whitney as an institution and its responses, which included making a space for the necessary convening by the Racial Imaginary Institute. Artist Lyle Ashton Harris's final comments at the end of the Racial Imaginary Institute program are significant here. He responds to Claudia Rankine's attempt to bring the event to a close by refusing to allow the evening to end, reminding all in attendance that the controversy spurred by Schutz's painting is infuriating precisely because it has happened before, around many other artworks and exhibitions. His criticism is grounded in the cultural amnesia visible through the events surrounding the Schutz artwork not only at the Whitney, but at all cultural institutions. Harris says:

> It's not that Black artists or artists of color have not imagined whiteness . . . I like Dana [Schutz's work but] it's not complicated enough . . . It's not just a hypothetical relationship to the mother but to actually look at the mirror reflection of the whiteness that created that horror in the first place . . . Let's deal with both the cultural specificity and the cultural amnesia that is taking place.[28]

He demands recognition of the past—not only the work he and his peers have done in archives and through research, but also the knowledges created by projects like curator Thelma Golden's groundbreaking *Black Male* exhibition at the Whitney in 1994, or interdisciplinary artist Coco Fusco's writings from the late 1980s. He demands that we in the museum begin each conversation about race and institutions without pretending as though this is the first time such debates have emerged. It demands that the museum drop its ruse of neutrality.

This brings to mind phrases that artist Simone Leigh and writer and historian Sharifa Rhodes-Pitts have used for this particular condition, so often encountered in conversations about race. These terms came up during a conversation between the three of us, about how audiences are imagined by institutions for particular exhibitions or art projects, and specifically how Leigh is explicit about her work being made for Black women. Leigh said that this move avoids having to conduct "racial kindergarten" in relation to her work, meaning she can begin her discourse with Black women on her own terms, demanding that the institution reorganize itself around this assumption. Rhodes-Pitts's phrase "racial 101," referring to entry-level college courses, bears similar meaning and relays the problematics and extra work that they both feel is necessary to undertake within institutions before a more complex critical engagement can take place—something that can be taken to heart with respect to both the Schutz and Guston debates.[29] This is particularly relevant to the presumption, on the part of museums, of *who* their audiences comprise. The "general audience" is a fiction, as it is as raced and classed as "neutrality," which begs for a further reassessment of what and how institutions exchange knowledge with their publics.

Further, with respect to the Whitney's institutional frame for the discussion, it was uncomfortable that the representatives of the museum at the Racial Imaginary Institute event, beyond director Adam Weinberg's introduction, were largely limited to the two

curators of the biennial, Mia Locks and Christopher Lew (only the latter of whom is on staff). I wondered what the internal discussions were during this period. There are many brilliant people who work at the museum, and while this suggestion violates the "cone of silence" that descends upon any institution when controversy strikes, perhaps if it had made the issue public, or even created a space to unpack some of the internal discussions, the debate could have had a further curative or intellectual impact.

While the Racial Imaginary Institute event was important as a public program, it was only a single two-hour moment. The circumstances that led to its necessity occur too frequently, in a variety of circumstances and at different levels of publicness, within the Whitney and at many other institutions, to end the discourse and self-examination here. (Perhaps this is what the institutions that postponed the Guston show were attempting to avoid?) I am certain that thoughtful, deep discussions took place amongst the Whitney staff, and perhaps more could have been cultivated. What if, for example, front-of-house or janitorial staff had been included in the conversations? What light might they have shed on the range of ideas presented in the biennial, and the Schutz work in particular? And what if this had been shared publicly in some way? Might it be helpful to the audiences trying to work through their own personal feelings about the work on view and the many responses to it. The key here is that institutions like the Whitney often present themselves as monolithic, speaking in one institutional voice, but they are in fact comprised of many dozens (or hundreds) of people, with their own ideas and opinions about many aspects of the work they do collectively. To think more about this multiplicity rather than the fiction of the monolith, I believe, is an essential aspect of reimagining museums because it makes space for the recontextualization of work like Schutz's based on a whole variety of lived experiences, rather than its anointment simply as "great art." As I know from personal experience, fear often pervades the staff at the museum during controversy,

at all levels. This fear is partially tied to the possibility of internal retribution but also connected to a larger and more insidious dread; a fear of public failure. Revealing any vulnerability or uncertainty, in the face of critique, can be overwhelming given the perceived precarity within an institution. If only this fear of public failure, which would presumably result in the threat of exclusion from museum work, could be mitigated by the realization that courage and vulnerability are one and the same, we might be able to imagine better museums. Failures, particularly public ones, can be spaces of growth and learning for cultural institutions (indeed for all of us) as long as they are accompanied by an accountability which their publicness engenders. Plus, revealing these vulnerabilities through open discussions is far more interesting and illuminating to the public from a pedagogical standpoint, and further disrupts the fiction of any neutral position.

In society, as in museums, the stubbornness of white supremacy is staggering, and is protected by commitments to purported neutrality. The institutional response at this moment in history can no longer be grounded in listening alone; it must take action. Harris makes a few suggestions for what we might collectively address as a public, and I would also say to answer these questions is equally essential for institutions:

> 1) What is the artist's role in confronting or contributing to cultural and social amnesia? 2) How do we effectively intervene in the continual re-traumatization ... of Black bodies and bodies of color given the horrific political climate in which we find ourselves? 3) How do we cultivate a sphere of pleasure and joy that provide sustenance and strength while engaging in a beautiful struggle? (to quote Ta-Nehisi Coates).[30]

These are subjects to which cultural spaces can certainly relate, and with which they can contend, but they must abandon the veneer of neutrality that so often interferes with the potential for

deeper reckonings. Tackling these questions, in the face of the prevalent cultural amnesia described by Harris, is a place from which action may be taken to begin the undoing of the racist structures within the museum, which certainly include but are not limited to representation in galleries and collections. It means we, particularly white museum workers, must conduct the "racial kindergarten" or "race 101" conversations in predominantly white spaces so that this work is not exclusively left to Black artists, workers, and audiences; moreover, it demands that we build knowledge *within* institutions so that the histories of past demands are known and acted upon, or the reasons that they were not acted upon are understood. This, in turn, also means confronting questions of who holds decision-making powers and who governs these spaces, how they are operated on a daily basis, and by whom—because in the end, whether or not to address these demands falls within the purview of those who operate and govern the institutions themselves. Today, artists and art workers alike are increasingly demanding the types of actions that might make an impact on how biases operate, particularly as inequities have been so blatantly revealed by the realities of the COVID-19 pandemic; these will be addressed in depth in chapter 7.

The Whitney and the group of cultural organizations responsible for the Guston exhibition bear responsibility beyond discourse to some action toward repair and care, especially in these moments of heightened self-awareness, that must go beyond self-preservation. Here I am greatly influenced by Mierle Laderman Ukeles's work around what she called maintenance art, and specifically, *Birthing Tikkun Olam* (2008), a participatory installation in which the public was invited to make a "covenant" to repair something in the world.[31] Participants' pledges were not only recorded in a "Book of Agreements" but were also exchanged for a handheld mirror, symbolic of entering into an agreement with Ukeles in the making of the work. As the artist explained, "Tikkun is Hebrew for 'heal' and even 'transform.' 'Tikkun work' means that you can heal, restore,

re-invent, re-create, even transform something in the world that is degraded, broken, hearts that are shattered."[32] Cannot the spirit of these ideas be enacted in cultural space, particularly in the wake of events such as those that surrounded the 2017 Biennial? Aren't they necessary? Cannot artists and thinkers and writers and curators and art workers make cultural spaces into locations of care, if not communal joy?

~

Sam Durant is an American artist known for his work in readdressing history as it is commonly interpreted and retold in the mainstream. Durant spends a great deal of intellectual and artistic time questioning these conventional narratives, particularly the reification of white hegemony. Many of his works delve into stories that are perceived as foundational to "American history," revealing how, from nonwhite perspectives, this history reads radically differently. For instance, he has talked about an early experience as a young person, growing up near Boston, Massachusetts, hearing the story of Plymouth Rock during an American Indian Movement (AIM) protest. He noted that the protestors' portrayal was quite a different history of that site and the Thanksgiving holiday than the one with which he was familiar: "From a Native American perspective," he remarked, "it is hardly a celebration."[33] As a white artist who has devoted years to researching and making multimedia installations and sculptures about what he clearly sees as crucial "missing" narratives in generally-accepted histories, Durant clearly aims to redress these crimes of omission. One example of such work is the research Durant devoted to the work of Emory Douglas, who was the Black Panther Party's Minister of Culture. The two met in 2002 and for the next five years worked to produce a book on Douglas's artwork that was published in 2007. An exhibition was also organized, curated by Durant, for the Museum of Contemporary Art, Los Angeles, which then traveled to New York's New Museum. This is an artist who takes his research seriously.

What might be surprising, then, is the hot water in which Durant found himself in 2017. The work in question, *Scaffold* (2012), had been first exhibited in Kassel, Germany, at the renowned quinquennial art exhibition documenta, the thirteenth edition of which was curated by Carolyn Christov-Barkagiev. The work was installed outside, in a park, and comprised a two-story wood-and-steel construction vaguely reminiscent of a chunky play structure, particularly in its parkland location.

The sources for the shapes that compose this sculpture, however, were much more fraught than its presence implied. Durant had mimicked and combined the designs of gallows used in seven US government–sanctioned executions carried out from 1859 through 2006. Through this hybrid form, Durant hoped to reveal the racial implications of the US criminal justice system over time. Specifically, the sculpture depicted the gallows for the executions of seven different condemned people or groups:

> abolitionist John Brown (1859); the Lincoln Conspirators (1865), which included the first woman executed in US history; the Haymarket Martyrs (1886), which followed a labor uprising and bombing in Chicago; Rainey Bethea (1936), the last legally conducted public execution in US history; Billy Bailey (1996), the last execution by hanging (not public) in the US; and Saddam Hussein (2006), for war crimes at a joint Iraqi/US facility.

The seventh gallows references the one used for the Mankato, Minnesota, execution of the "Dakota thirty-eight" in 1862, a nadir of Native American life under colonial violence. As Durant remarks in his artist's statement, "The Mankato Massacre represents the largest mass execution in the history of the United States, in which 38 Dakota men were executed by order of President Lincoln in the same week that the Emancipation Proclamation was signed."[34]

When the work was installed in 2017 at the Walker Art Center's newly reconstructed Sculpture Garden in Minneapolis, it was this last representation that hit hard. The artwork was met with intense public outcry led by many local Indigenous groups. Their anger was directed at both the artist and the institution for not having the foresight to understand that exhibiting a work depicting the history of pain and trauma inflicted on Dakota ancestors by the US government, and still resonant in their lives today, would reenact that suffering yet again. Indigenous scholar Kate Beane, who is herself Dakota and works as a community liaison for the Minnesota Historical Society, told *Hyperallergic*:

> When I first saw it, I had this huge anxious feeling and broke down in tears. I don't think the Walker or the artist took into consideration what kind of impact a structure like that would have on a community of people who have been impacted by historical trauma. We do this over and over and over again. We get a lot of backlash about it and it's tiring work. And then something like this still happens.[35]

For protestors, not only was this painful history inappropriate for the Sculpture Garden in Minneapolis, which is situated on unceded Dakota land; to some, it was also inappropriate for a white artist to use such symbolism in his work at all.

For a museum to underestimate or be blindsided by such a response in 2017 is unacceptable. It is another example of cultural amnesia that repeatedly reinscribes intergenerational racial and ethnic pain. The Walker has long operated in Minneapolis, and in this context it should have been abundantly clear that some community work needed to be done in advance of such an installation. Things might have gone quite differently if there had been a space of trust and discussion between the museum and the Indigenous communities that surround it. Even better would have been internal discussion instigated by a truly

diverse staff and board, followed by community engagement on the subject. The absence of such conversation is sadly unsurprising in most museum contexts, where community work has mostly been intended to either provide the museum's knowledge to the community or bring them to the museum, rather than to receive their wisdom and input.

While it is clear that the institution made mistakes, what followed is both fascinating and significant with regard to the ways responses to the controversy were "managed." Then-director Olga Viso and Durant each separately made thoughtful public statements that directly addressed the anger and frustrations of critics—and, *extremely importantly*, they apologized. This was not an empty public relations non-apology either; it demonstrated vulnerability and courage. Viso posted the following public statement on the Walker's Facebook page and website:

> Prompted by the outpouring of community feedback, the artist Sam Durant is open to many outcomes including the removal of the sculpture. He has told me, "It's just wood and metal – nothing compared to the lives and histories of the Dakota people."
>
> I am in agreement with the artist that the best way to move forward is to have Scaffold dismantled in some manner and to listen and learn from the Elders. The details of how and when will be determined by Traditional Spiritual Dakota Elders at a meeting scheduled with the Walker and the artist on Wednesday, May 31 with the support of a mediator selected by the Elders. This is the first step in a long process of healing.

Following the mediated discussions, the Walker removed *Scaffold*. While this period of discussion may have been foreshortened to contend with the heavy criticism brought to bear by activists, some of whom had just been forcibly removed from Standing Rock where they were protesting the Dakota Access Pipeline, I still believe it was a more productive response than that of the

Whitney in the Dana Schutz controversy, in part because they made unambiguous apologies, and then went even further, taking some dramatic steps towards undoing pain, towards repair.

Durant followed up his apology by giving the intellectual rights to *Scaffold* to the Dakota people. "I have no intention of making a representation of that again," said Durant. "They asked me, 'How do we know you won't do this again?' I said, 'That makes perfect sense. It's yours. You decide what happens to it.'"[36] And they decided to burn it.

This result was not uncontroversial in the art world; after all, museums are meant to care for and protect the works they collect, right? Yet Viso, in an interview with the *Los Angeles Times*, said, "All of these things have nuances and complexities that need to be taken into consideration . . . We all feel that we moved to a place of mutual respect and consideration. The work still has power. It lives in archives, in oral histories and the actions of people that live on and were part of this." *Scaffold*'s destruction embodies another example of what Malik Gaines, in the midst of the controversy over *Open Casket*, articulated as the possibility for destruction to be liberatory, enlightening, or spiritually revealing. Here, Durant's decision is clear, and it has a specific function aimed at repair.

When I spoke with Durant in 2019, his comments revealed another facet to the controversy, one that emerged after it became clear that any discussion of keeping the work up had been foreclosed. He remains deeply disappointed that no one at the Walker involved directly in the planning for *Scaffold* was sufficiently sensitive to its audiences to have flagged possible negative reactions to the installation of the work, or thought to initiate a series of community conversations about the work before it was installed. He also noted that there wasn't a consensus for the work's removal by the protestors, and, he imagines, had there been some grounding in community work (in which he could have been centrally involved, as he has been in other of

his projects), perhaps the piece would have had a very different reception. Given the circumstances, Durant felt that the only appropriate thing to do was to dismantle the work, and to further assure the elders, by transferring the intellectual property of the piece to them, that he would never install it again. He told me, "I needed to make a gesture personally to recognize and acknowledge the pain and suffering that people felt when they saw [Scaffold]. I also recognized that this is not a work that was inside the museum that you could avoid. That it was something that . . . was outside [in the Sculpture Park]. It was unavoidable."[37]

Beyond the apology issued by both the artist and the museum, there is another noteworthy element to this scenario. It is Durant's clear and unambiguous statement that his imagined audience for this work, indeed for most of his work, is white people—white people who don't necessarily question their acquired knowledge as incomplete. As such, his apology is embedded in this assumption about the audience. Importantly, in his public statement he says,

I made Scaffold as a learning space for people like me, white people who have not suffered the effects of a white supremacist society and who may not consciously know that it exists. It has been my belief that white artists need to address issues of white supremacy and its institutional manifestations. Whites created the concept of race and have used it to maintain dominance for centuries, whites must be involved in its dismantling.

But he doesn't stop there. He goes further to say,

However, your protests have shown me that I made a grave miscalculation in how my work can be received by those in a particular community. In focusing on my position as a white artist making work for that audience I failed to understand what the inclusion of the Dakota 38 in the sculpture could

mean for Dakota people. I offer my deepest apologies for my thoughtlessness. I should have reached out to the Dakota community the moment I knew that the sculpture would be exhibited at the Walker Art Center in proximity to Mankato.[38]

This acknowledgment is nuanced and poignant, particularly regarding the impact the work had on an audience Durant hadn't actively considered when making it—a contrast to the Schutz example.[39]

This invariably leads to the question of whether Durant, as a white person, ever had the "right" to create a work portraying Indigenous people's pain, much as with the questions around Schutz's *Open Casket*. The key difference is that Durant is known for work that explicitly engages histories of inequity, racism, and white supremacy. While Schutz's work is plugged into a cultural moment, as a person, as a mother, as a painter, she did not seem to be engaged in these questions in a particularly sustained or public way. This matters. Making mistakes is something we all do. But it is how we respond to such mistakes when they are identified that makes all the difference, and I have to think that the more we are engaged with the issues embedded in and surrounding the work we are doing, the better we might be able to actually hear critiques and offer reparative actions.

It is likely that Sam Durant and the Walker's experience was certainly no cakewalk for any of the constituencies involved; it evolved from a site of pain and exploitation to one that set the stage of repair between the museum and a historically marginalized community of Indigenous people. The steps taken toward caring about actual people's reception of the work opened the door to the possibility of greater understanding between an institution, an artist, and the museum's publics. Priority was given to the decision-making structures that could begin to right the wrongs that had previously led to the installation of this work without a larger conversation. And if we are to take seriously

claims for museums as sites for free expression and the exchange of ideas, we must be open to this kind of reconciliation between communities whose realities are based on very different histories and experiences in the world. In such circumstances, the situation goes from "How could they possibly?!" to "Wow, we didn't see that coming!" to "Well, shall we try to do something about it together?" This is starkly opposed to a situation in which the institution, faced with mounting demands from protestors, retreats into its protective public relations shell, a retreat from the courage that vulnerability requires by mounting a defense of media-speak, and obviating, or eliding completely, the conditions for genuine, productive discourse and action. Unfortunately, the latter is the far more common condition. This requires intentional reform and undoing.

What was different with *Scaffold* was the willingness of both Viso and Durant to listen, hear, *and then act* on their newly appreciated knowledge. This scenario is also connected to the matrix of decisions that institutions make daily about their responsibilities. And the reason this is a special circumstance, in my view, is that the "playbook" for how a museum should best care for an artwork was thrown out the window in order to respond to actual human pain. Particularly with works that connect so directly to social conditions, care for an artwork must include care for its audiences. This is what was missing in the planning for both *Scaffold* and *Open Casket*, and it is what Viso and Durant proceeded to do after the fact. Late is decidedly better than never, and such a move requires bravery and willingness to admit fault and to reconsider institutional "best practices" when responding to criticism or controversy. This is the radical work that remains to be done inside museum spaces, given their histories of exclusion and erasure. And it is one way to understand protest as an act of radical care, one that has the potential to make museums better for more people, especially if the targets of critique can receive it differently and respond with the same generosity with which the critique is given.

Just a few months after *Scaffold* was removed, Olga Viso resigned her post as director of the Walker Art Center. While there was speculation that her resignation was not solely related to the *Scaffold* controversy, it certainly played a role in her decision to leave. And, from the perspective of the learning in which she engaged with Durant and the Dakota elders, this is truly a setback for the institution and their relationship with the Native peoples of Minneapolis. She had begun to create a space where trust could potentially grow between the Walker and the Indigenous communities. In fact, when her announcement to depart was made public, the renowned Minneapolis-based Anishinaabe author and member of the Turtle Mountain Band of Chippewa Indians Louise Erdrich wrote a public letter in which she said:

> Acquiring "Scaffold" didn't magically happen because Olga said so. It was a joint process, and the board was of course involved. Olga took the heat and remained steady. She committed herself to healing and learning. I am positive that if Olga were male, she would not be serving the board at the Walker as its scapegoat.
>
> Olga has raised the Walker to a new level of excellence, and she has also forged its first real ongoing alliances among the local Native community. I have been at meetings where she listened—truly listened—to painful truths. The education she was willing to receive cannot be easily acquired.[40]

Erdrich is pointing out that there was learning and teaching involved in the conversations with Viso. In the absence of Indigenous people holding senior leadership roles at the Walker, this shift in the directorship leaves it once again to people of color to do the work of educating non-native people during moments of crisis. And this, in the end, is why diversity matters, and why it goes far beyond ticking boxes on grant applications, and employee head-counts. Having a diverse group of staff and board members thinking about the day-to-day operations

and governance of our institutions daily makes our institutions better. There is no substitute.

Disability studies provides particularly generative ways to rethink society's embedded ideas about perceived individual limitations. Painter and activist Sunaura Taylor connects the value of those constraints to provide yet other ways of encountering the world:

> Disabled individuals have fought for our equality, our sameness, while also arguing that there is value in our differences and in our limitations. Disability activists do not argue that disabled individuals are valuable *despite* our disabilities; rather, value lies in the very variation of embodiment, cognition, and experience that disability encompasses. Disability may include elements of lack and inability, but it also fosters other ways of knowing and being.[41]

Taylor highlights a central tenet of disability theory: that it is not "specifically intelligence, rationality, agility, physical [and I might add emotional] independence, or bipedal nature that give us dignity and value."[42] If individuality and independence were de-emphasized in society, might then the collective and interdependence be elevated? Overconfidence in ability can be a parallel to overconfidence in the individual, conditions further cemented by late capitalism's obsessions with singular human exceptionalism. Further, diversification, particularly inside institutions, must wade past racial fantasy and tokenization. As curator, art historian, and art worker La Tanya Autry has said, she demands "understanding, strategizing actions, and organizing for building something better together." She adds, "Notice that I used the word 'together' as I refuse anti-Blackness' incessant calls for exceptional, lone Black saviors/martyrs."[43]

As the population of the United States continues its evolution toward a minority-white demographic, wherein the majority of the nation will comprise people of color by 2045,[44] there is a

logical call by various publics, some government agencies, as well as major foundations, to increase diversity, equity, and inclusion not only in the programmatic content of the museum, but also in the staffing and decision-making processes, from the people who work in the museum's galleries, to their boards of trustees. Philanthropic leaders including Darren Walker, president of the Ford Foundation, and Elizabeth Alexander, president of the Mellon Foundation have both made diversity and confronting inequity priorities across their funding areas, including their ongoing and substantial support of the arts. There is a growing recognition that the centering of whiteness, and the history of that centering, alongside the neutering or dismissal of the outside critic, are fundamental reasons that museums have not been, and can never be, neutral spaces. And it is the fact that this condition remains largely unacknowledged and un-confronted that alienates audiences, and that keeps museums in a space of "elite-ness" that is highly trackable by race, class, legal status, education, and so many other factors of identity and life. Museums are fundamentally spaces that enact both specific histories and present realities of oppression, repression, and pain, while simultaneously claiming to offer respite, beauty, communion, and art for all. Therefore, if we as a society want to make museums and cultural institutions more inclusive, equitable, and diverse, we must acknowledge how this reality has impacted and continues to impact the evolution of museological and pedagogical practices. Museums and cultural institutions can feel radically different to publics that do not identify as white, upper-middle-class, college-educated, frequent museumgoers. To know this, and to try to understand its mechanisms, may be the first step to undoing the elite status of these valuable institutions.

3

Show Me the Money

When, in the space of five days, five people I love recommend a book, I read it. Anand Giridharadas's *Winners Take All: The Elite Charade of Changing the World* (2018) is an important and scathing reframing of the "doing good by doing well" adage. Giridharadas takes an unvarnished look at philanthropy, mostly in the United States, linking it inextricably with the evolution of nineteenth-century capitalism through to the present (i.e., robber barons to hedge fund masterminds); he identifies an international elite of entrepreneurs, business leaders, and "thought leaders" that comprise "MarketWorld"—also known as those who make decisions about where and how much philanthropic money is leveraged to make the world a better place.[1]

Giridharadas's premise is that the anti-government ethos seeded during the presidential administration of Ronald Reagan was brought into sharp focus during the Clinton years, culminating in the election of Donald Trump, largely by a disenchanted populace convinced that government could not or would not help, and was simultaneously hostile to the priorities of the private sector whose ways of approaching problems had never engaged them.

The Clinton era saw the emergence of the "public–private partnership," a rallying cry to solve the social problems that governments didn't seem to have the bandwidth, political fortitude, or desire to take on. Giridharadas interprets this alliance as the culmination of the rhetoric of government inefficiency, fused with overconfidence in private-sector know-how, to solve social issues. Reagan's trickle-down economics and small

government cheerleading, followed by Clintonian business-friendly policies (read: the North American Free Trade Agreement, deregulation of financial products, and so on) evolved into a seemingly unstoppable erosion of confidence that government, big or small, could contribute anything meaningful towards a confrontation with the most vexing social, economic, and environmental issues. And so, rather than vast public programs in the spirit of Lyndon B. Johnson's Great Society or Franklin D. Roosevelt's New Deal, the private sector took the wheel. Seen from a contemporary's vantage, this outsized faith in privatization failed the very real needs of people and the planet. It also provided fertile ground on which to divide groups that would typically share financial and social affinities based on a politics of "left behind–ism," fostering political fear mongering of the unknown, all in the shadow of government shrinkage of the very programs that people, particularly poor people, need most, in favor of profit-driven "private" solutions. Of course, advanced neoliberalism is not only a US phenomenon; the agendas of UK prime ministers Margaret Thatcher and Tony Blair paralleled those of Reagan and Clinton, and the creation of the European Union and Eurozone economic policy, as well as Germany's key role in supporting economic austerity policy over the last several decades, are prime examples of this ideology, never mind the economic shifts in China's economic policies beginning as early as the late 1970s. "MarketWorld" is global.

So, how does all this relate to museums? Cultural institutions have followed a parallel trajectory that is inextricably yoked to the economic histories Giridharadas describes, resulting in an ossified public imaginary of museums and cultural institutions. Giridharadas lays out how MarketWorld debates are choreographed, or even "curated," in a careful coordination of logics of confinement through the extraction of divergent positions and approaches to shared problems. The results are devastating: a truncated conversation, with relevant voices absent, and thus silenced. He describes a panel at the Clinton Global Initiative,

a powerful convening organization founded in 2005 by President Bill Clinton, wherein the topic was "women's equality." But, Giridharadas points out, "they seemed to be limiting the topic to jobs and the growth of their sectors. They were talking about feminism on the condition that they stick to the profitable wing of it." His point is that this kind of window-dressing, lean-in feminism in fact didn't aim at structural change, but rather ignored the deep-seated changes that are necessary, and worse, "tipped the scale in the direction of the winners once again, ensuring that the friendly, win-win way of solving public problems would remain dominant."[2]

This example emphasizes how when the interests of Market-World are taken as a given, they inherently limit the scope of the conversation, the amount of conflict that might be tolerated, engendered, or even recognized, and even the range of ideas generated and potential solutions posed. Likewise in the imaginary of the museum. If, to survive, the museum must focus on perpetual growth (in its physical plant, collections, budget), the superstardom of its director and curator(s), attendance and social media likes, and maintenance of its always-precarious financial position (regardless of scale), how can the limited human resources who make these organizations function even begin to think creatively about the whats and the whys of the museum?

Of course, the museum in late capitalism has answers for this, the most tangible and *de rigueur* of which is the strategic plan, with its objectives, tactics, and a host of business-world mechanisms meant to pre-answer questions of mission and vision. Museum workers can then be directed to fulfill checklists of to-dos rather than imagining, co-creating, and implementing projects that question our very moment, that invite the kind of discourse that could truly support a more engaged civil society and possibly even create space for profound structural change.

The point that these performative exercises miss is one endemic to the undue focus on high-profile individuals within

the museum structure. Rather than see themselves for what they are—inherently collective enterprises—institutions have become dependent on executive directors and head curators to survive, financially and otherwise, while the "staff" keeps the place running day to day. Burn out is prevalent, as is disenchantment and frustration at all levels. Not to mention the ubiquity of inequitable systems that determine who is hired for these positions, rampant pay inequity, and who controls the governance and decision-making structures.

To recover from this delirium we all must admit that culture has a problem. Can we reconsider the museum as a collective enterprise? Can such a space accommodate a wider set of ideas of what art can be and how it is presented and interacted with? Can museums be spaces for collective cultural imagination that provide a training ground for listening to one another, speaking contemporary truths, reevaluating the ways in which we understand history? Isn't this everyone's culture, with all its contradictions and paradoxes? How might we reignite a sense of possibility and elbow out the constrictions imposed by current ways of doing things?

~

On November 27, 2018, a *Hyperallergic* headline read "A Whitney Museum Vice Chairman Owns a Manufacturer Supplying Tear Gas at the Border." "Warren B. Kanders," it reported, "a vice chairman at the Whitney Museum of American Art, purchased defense manufacturer 'Safariland' in 2012 for $124 million." What followed has been by turns galvanizing, disquieting, and outrageous all at once. The chain of events spurred by this article has had a major impact on what roles museums can and do play in society, and how their governance and funding bodies are scrutinized.

The author of this article, Jasmine Weber, summed up straightforward facts about the business of Kanders at a moment when public fury about the US government's actions at the US–Mexico border was at a high point. Just two days earlier,

US Border Patrol agents had shot tear gas at Central American asylum seekers, including children, in an attempt to halt their access to the Tijuana–San Diego border. This move followed ongoing stories about asylum seekers and other migrant families being illegally, not to mention cruelly, detained and separated under the Trump administration's "zero-tolerance" policy, resulting in thousands of children being jailed at detention centers across the country, among them toddlers, some of whose parents had already been hastily deported. As of October 2020, over 500 of these children have been lost to this cruel bureaucracy, never having been reunited with their parents.[3]

Weber's article states that the company belonging to Kanders, Safariland, LLC, sells military supplies—including tear gas, riot gear, batons, and impact munitions—as well as military and police training services under the tagline "Less lethal solutions," to various police forces across the United States and to the federal Department of Homeland Security.

During the three days that followed the article's publication outrage at Kanders and the Whitney exploded on social media. Simultaneously, over one hundred Whitney Museum staff members signed a letter to the museum's staff leadership, calling for a meaningful conversation about the responsibility of the institution toward its staff and its audiences. The letter was intended to be an internal document; it was leaked to the media. In the ensuing eight months, the fact that a Whitney Board member was the purveyor of teargas being used at the border, catalyzed not only a series of public protests of the Whitney, but also a penetrating debate about how and by whom museums are governed and funded. Protests, town hall meetings, social media tirades, and innumerable articles and opinion pieces in the art press and mainstream media alike brought to the fore questions about the inherent paradoxes and contradictions between the stated values of institutions and their staffs and the ways in which they are governed and financed. Among the most urgent questions articulated were: Is it possible for museums to change?

Is there a financially sustainable way of doing things differently? Could museums remain relevant if they didn't address these paradoxes directly? Could they continue to operate and function financially if they did? Would questioning one trustee's affiliations result in a domino effect of deep dives into all patrons' wealth? Would that, in turn, spur resignations of such trustees and other donors? Would museums survive if their current trustees fled to avoid such scrutiny? What would the future hold for patronage, philanthropy, museum accountability, and operations if such an upheaval were to take place?

What follows is a reproduction of the staff's thoughtful letter with its introduction, as it appeared in *Hyperallergic* on November 30, 2018.

Below is a statement signed by members of the Whitney's staff who disagree with leadership's decision to remain silent in response to the Hyperallergic article published November 27, 2018, regarding Warren Kanders. We would like leadership to prioritize an internal statement to staff by Monday, December 3rd, followed by a public statement.

We approach this action from a place of deep care for the institution, and our intention is for this to be a productive and open conversation. This is not the only article, the only event, the only policy on which staff and leadership do not see eye to eye, and we hope to build constructive bridges for the future.

To the leadership of the Whitney Museum:

We are writing to convey our outrage upon learning that Whitney Vice Chairman Warren Kanders' company, Safariland, is the supplier of the tear gas recently used to attack asylum seekers at the US border, and our frustration and confusion at the Whitney's decision to remain silent on this matter. We understand this is not new information to leadership or likely to the rest of the Board, but many of us learned

of the connection via the Hyperallergic article published November 27, 2018. We also understand the nuanced and vital relationship any nonprofit has to its Board. But we believe that this recently aired knowledge about Mr. Kanders' business is demonstrative of the systemic injustice at the forefront of the Whitney's ongoing struggle to attract and retain a diverse staff and audience. And because we feel strongly about this, we believe it is our responsibility to speak to this injustice directly, even as the Whitney has chosen not to. To remain silent is to be complicit.

First and foremost, some of us are deeply connected to the communities that are being directly impacted and targeted by the tear gassing at the border. For the Whitney not to acknowledge that this news may impact its staff is to assume we are separate from the issue, that it is happening somewhere else to some other people. Many of us feel the violence inflicted upon the refugees—and against mostly-POC protesters in Ferguson, and mostly-Indigenous protesters of the Dakota Access Pipeline, just two of many other instances of militarized tear gassing of unarmed citizens—much more personally than it seems to affect leadership. For many of us, the communities at the border, in Ferguson, in the Dakotas, are our communities. We read the Hyperallergic article and felt not annoyed, not intellectually upset—we felt sick to our stomachs, we shed tears, we felt unsafe.

As of Thursday morning, November 29, we have received no official internal communication addressing the Hyperallergic article. A small group of us were informed of the Whitney's policy not to comment on the personal business of Trustees, but this is public knowledge, not a private matter of Mr. Kanders'. Setting aside the personal reactions of staff, this choice makes it difficult for staff to function well professionally. Should protests from the public or questions from visitors arise, our visitor-facing staff will be the ones answering them. Leadership choosing not to give a public (or even

internal) statement displaces the labor to our visitor-facing staff, who are, generally speaking, our most diverse and lowest paid staff. You will recall similar complaints surrounding the Dana Schutz protests—and we are disappointed that the response by the leadership of this institution remains the same.

So many of us are working towards a more equitable and inclusive institution. We work to bring in artists who are immigrants and artists of color to the collection. We create programming for youth and families who are affected by current immigration policy. Upon learning of Kanders's business dealings, many of us working on these initiatives feel uncomfortable in our positions. We cannot claim to serve these communities while accepting funding from individuals whose actions are at odds with that mission. This work which we are so proud of does not wash away these connections.

The Whitney has historically followed artists' lead in finding our way through thorny decisions. Now we encourage the Whitney to follow the lead of its staff.

Here are our current demands:

- For leadership to convey our concerns to the Board, including that they consider asking for Warren Kanders' resignation.
- A public statement from the Whitney in response to the Hyperallergic article
- A museum wide staff forum for employees to discuss this and other issues, and related policies moving forward
- The development and distribution of a clear policy around Trustee participation.
 - NB: Here, we intend to clarify what qualifies or disqualifies a wealthy philanthropic individual for the Board. Is there a moral line? If so, what is that line? If this was an instance of a #metoo scandal, would we call for resignation? If this was an instance of overt racism, would we call for resignation? We believe the line should be that

we not be afflicted with any Board member whose work
or actions are at odds with the museum's mission.

We acknowledge the difficult position in which these demands
will place leadership, and consequently the unfortunate strain
any ramifications will put on our staff. But we believe in speak-
ing truth to power, we believe in cultural institutions as
community leaders and as sanctuary spaces, and we believe
that there is a better way. To achieve true institutional health,
measured not on the quality of our exhibitions or the number
of tickets sales, but the genuine satisfaction of our audiences
and staff, we need to address these uncomfortable issues. We
need to interrogate our tendencies to look the other way. We are
reminded of the words of Dr. Martin Luther King Jr., who said:
"I have almost reached the regrettable conclusion that the
Negro's great stumbling block in the stride toward freedom is
not the White Citizens Councilor or the Ku Klux Klanner but
the white moderate who is more devoted to order than to
justice; who prefers a negative peace which is the absence of
tension to a positive peace which is the presence of justice."
Continuing to accept funding—even, or perhaps especially,
transformative funding—from individuals who are knowingly
complicit in the injustices committed on our own land and
across our borders is negative peace. We demand positive
peace.
Thank you, and we look forward to a productive dialogue
and definitive change.[4]

The Whitney staff's letter begins with a deliberate introduction
signaling that the request for discussion not only came from a
simultaneous place of outrage *and* care for the institution, but
also arose from staff members' feelings that their personal
values were at odds with what the museum implicitly endorsed
by having Kanders as a vice chairman. The letter is highly
nuanced as it contends with the paradoxical relationship of the

museum to its board and its programming. They struggle with the internal complicity between the Whitney's need for funding from Kanders, and the apparent conflict with the values they work to embody daily. In no uncertain terms, they lay out the perceived contradiction between the reason the Whitney strives for a diversity of staff members and programs, as well as the audiences it seeks to engage, and very problematic structures that supply the sources of the funds that make this work possible, particularly when they refer to the US–Mexico border, Ferguson, and the Dakota people.

This wasn't just a question of following the money; the staff was asking a deeper question of its leadership: How can we go out there and do what we do to help dismantle the systems of oppression that we claim art and education can achieve, when our own ability to do this work at the Whitney is funded and governed by those very structures?

While the museum's policy may be not to "comment on the personal business of Trustees," the staff demanded that they do just that, recognizing that this would not make things easy or comfortable for leadership. However, what is clear is that they hoped that the Whitney itself, which its director, Adam Weinberg calls a "safe place for unsafe ideas," would be sufficiently concerned with the safety of its staff and publics to examine even its most fundamental underpinnings.

This letter represented a very real set of challenges for the leadership team at the Whitney and its board, and that this dynamic deserves careful consideration. These are not easy knots to untangle—indeed, it would be far easier not to bother to try. Particularly under the spotlight of publicness created by the leak of the letter to the media. However, the group of staff members who signed the letter articulate a deep desire for their work to matter and to take seriously the claims that they and their institution make around diversity, inclusion, and equity. They also want their place of work, the museum, to be clear and transparent about its values, by understanding the whats

and the whys of its structure. Since the day of its publication, I have read the letter as a deep questioning of how museums are constructed and for whom in the imagination of the public, as well as the imaginations of the staff, leadership, and board.

Weinberg responded to the staff letter with one of his own. His remarks are clearly desirous of bringing the board and staff together, into alignment. The staff letter was addressed to him, and his reply is addressed to both the trustees and his team, willing the two to find common cause. He goes back into the founding history of the institution in order to establish some common ground. Then Weinberg states:

> Even as we are idealistic and missionary in our belief in artists—as established by our founder Gertrude Vanderbilt Whitney—the Whitney is first and foremost a museum. It cannot right all the ills of an unjust world, nor is that its role. Yet, I contend that the Whitney has a critical and urgent part to play in making sure that unheard and unwanted voices are recognized. Through our openness and independence we can foreground often marginalized, unconventional and seemingly unacceptable ideas not presented in other sites in our culture.

This is precisely what the staff's letter is challenging; the ability to even function as a museum that cares about culture by fore-grounding "often marginalized, unconventional and seemingly unacceptable ideas," without recognizing their structural rela-tionship to power. The most dispiriting part of his letter, however, comes in the subsequent paragraph:

> As members of the Whitney community, we each have our critical and complementary roles: trustees do not hire staff, select exhibitions, organize programs or make acquisitions, and staff does not appoint or remove board members ... Even as we contend with often profound contradictions within our culture, we must live within the laws of society and observe the

"rules" of our Museum—mutual respect, fairness, tolerance and freedom of expression and, speaking personally, a commitment to kindness.

Here, the statement draws several inviolable lines that remind the staff to "stay in their lane"—a position they have already rejected, with their own "commitment to kindness" in the form of their call for a discussion of how these paradoxes can continue to coexist. The staff is positing: If we are a museum of contemporary art and culture, how can we not confront the contradictions present within our own structure? The museum's director is responding that the structures are what they are, and that they should be willing to play by the rules.

Concurrent with what I am certain were days of deep concern and discussion by all segments of the museum's staff, leadership, and board, the situation was about to get even more complicated. Beginning in late November 2018, Decolonize This Place (DTP), a collective of artists and activists, began building a campaign, in their words, in solidarity with the staff of the museum. The campaign began with a variety of public statements, and an initial protest, followed by a town hall meeting of about 200 people, including some Whitney staff. A set of weekly actions was then planned for the nine weeks preceding the public opening of the 2019 Whitney Biennial on May 19. Each Friday evening from March 22 through May 17, during free public admission to the museum, DTP, along with a host of collaborators, brought protestors to the Whitney's lobby. For the fourth week of continuous action, DTP and various coalitions planned a potluck, in which they offered pizza and dumplings to both protestors and museum staff alike, a milder symbolic action aimed at lightening the staff's burden. Each week they drew connections between the funding of the museum, its board, and the anti-racist, pro-Indigenous, pro-Palestinian, wage equity, and de-gentrification work with which the artist-activist collective is engaged. The lobby of the museum

was often filled with protestors bearing banners and chanting. Sometimes unaffiliated publics joined in; others took it all in, and then moved on to see the works in the galleries. It is commendable that the Whitney did not choose to evict the protestors from the lobby, or from its galleries during the Schutz protests, but it is also clear that doing so would have brought more negative attention to the situation rather than less.

Alongside this campaign, a more subtle action was launched: artist-activists surreptitiously replaced the general "About the Whitney" brochure available at the museum with a look-alike pamphlet exactly replicating the house style. This four-by-eleven-inch brochure, however, did not offer highlights of the collection, or history of the museum. Rather, it detailed the origins of the controversy in a straightforward and compelling style, opening with the bold, all-caps text "WELCOME TO THE CRISIS AT THE WHITNEY," accompanied by the following:

> Infuriating, outrageous, immoral, unethical. Warren B. Kanders, vice chair of the Whitney Board of Trustees has become the focus of protests after reports emerged that his company, The Safariland Group, manufactures the tear gas used against asylum seekers at the Tijuana border. We were horrified to learn that it has also been used at Standing Rock, in Ferguson, and in Gaza.
>
> We invite you to learn why nearly 100 Whitney museum staff members wrote a letter calling for the consideration of Kanders' resignation, new ethical and moral guidelines for trustee participation, and a museum-wide forum to address staff concerns.[5]

While the imposter was noticed shortly after it was distributed, I admire the meticulous care taken by its creators, not only in replicating the size and style of the original brochure, but also in repurposing the original formatting to convey the complex

reasons for the protests. Interestingly, it also adopted the Socratic pedagogies often used within museum spaces to elicit engagement from publics by asking questions like "Why Kanders?," "Why Labor?," and "Why Museums?"

The imposter brochure conveys a great deal of information, ranging from the rationale of protestors and the business involvements of trustees beyond Kanders, to labor and land issues. The project was conceived of and executed by the (De)Institutional Research Team—(D)IRT—a collective of artists, academics, activists, and cultural workers. One aspect of the brochure that is particularly compelling is its clarity: in no uncertain terms, it lays out the specific issues protesters have with Kanders, including his relationship to state violence and reputational whitewashing via Whitney board membership. It also connects these issues with labor inequity within the museum, both for staff and artists, as well as the letter written by staff to museum leadership:

> These relationships reveal many layers of complicity between artists, institutions, corporations, and wealthy individuals, and can often be uncomfortable to discuss.
>
> But this is what happens when we hold each other accountable. We recognize that museums are also sites of struggle and serve to legitimize certain cultural forms and the voices of select artists, along with the reputations and credibility of patrons like Kanders, even when their values and actions may be in direct opposition. This tension is one of the central reasons why art washing poses such a problem for the role of art and the artist at the Whitney.[6]

Importantly, the group brings up the problem of "singling out" one particular board member, when others are perhaps also problematically connected to profits from unsavory involvement in the military industrial complex, not to mention real estate, financial institutions, and other industries widely represented on museum boards that rely on inequity to make extraordinary

sums of money. In fact, this has been the critique leveled at most of the anti-Kanders protests: If a purity test is applied for board membership, how on earth will enough funds be raised to support cultural spaces? (More on this soon.)

(D)IRT's low-key guerrilla act, the other side of the DTP protest coin, offered the Whitney's publics as well as its staff ways to understand the confrontations happening around them, albeit briefly.

Meanwhile, months earlier, the Whitney was gearing up to announce the list of artists to be included in the 2019 Biennial, curated by Rujeko Hockley and Jane Panetta. Just before the list of participating artists was released to the *New York Times*, artist Michael Rakowitz was talking to curators of the exhibition about his decision to withdraw from the show.[7] It was not his wish that his withdrawal be made public, never mind the basis of the eventual *New York Times* headline about the show announcing the other seventy-five participants; as he told me later, his withdrawal was based on the politics of the museum, rather than the exhibition itself. Via the subsequent publicity around his choice, he was called out, in my opinion unfairly, for using his privilege as a more established artist to make a statement; other, less established artists, his critics argued, needed the boost that inclusion in the biennial would give their careers. Beyond the fact that Rakowitz did not seek publicity for his decision, it seemed to me that observers felt Rakowitz expected others to follow him—which was not the case. I think Rakowitz used his power in an important way, and faced questions parallel to those I was sometimes asked after I left the Queens Museum, in particular, whether I was disappointed that staff didn't resign in protest. I defended their need and/or desire to remain, as I knew that my privilege, particularly that of being married to someone who had a job with health insurance, made me less vulnerable than some of my colleagues.

It is worth noting that at the opening of the 2019 Biennial, artists Nicole Eisenman and Mel Chin (only Eisenman's work

was included in the exhibition) were distributing anti–tear gas stickers to the hundreds of attendees. Further, the curators had included in the exhibition a work by the research collective Forensic Architecture, a collaboration with Praxis Films. The artwork was itself a scathing video investigation into Kanders and Safariland. Interestingly, as an artwork, this project could sit within the Whitney galleries (albeit uncomfortably), in one register making otherwise-invisible connections for museum-goers between the governance and financial support of the Whitney and their experience of the biennial, and in another providing a—perhaps fleeting—air of self-critique for the Whitney Museum itself. The allowance held a certain gravity; however, its inclusion did not necessarily signal the Whitney's willingness to attend to the internal, structural realities of the museum, at least not in this particular historical moment, which has recognized that self-critique of the institution must go beyond gallery walls.

The specific impacts of both DTP's and (D)IRT's initiatives on structural shifts is difficult to ascertain; however, their combined subtlety and relentlessness certainly added to the pressure initiated by the staff letter. The last straw came in July 2019. While Rakowitz had declined the invitation to participate in the Whitney Biennial exhibition from the outset, on July 19, Korakrit Arunanondchai, Meriem Bennani, Nicole Eisenman, and Nicholas Galanin jointly asked that the Whitney remove their works from the exhibition, two months after its opening: "The Museum's continued failure to respond in any meaningful way to growing pressure from artists and activists has made our participation untenable," they said in a statement. "The Museum's inertia has turned the screw, and we refuse further complicity with Kanders and his technologies of violence."[8] Over the following days, additional artists joined the request for their works to be withdrawn, including Christine Sun Kim, Eddie Arroyo, and Agustina Woodgate, as well as Forensic Architecture.

On July 25, Warren Kanders resigned from the Whitney's board, stating, "The targeted campaign of attacks against me and my company that has been waged these past several months has threatened to undermine the important work of the Whitney . . . I joined this board to help the museum prosper. I do not wish to play a role, however inadvertent, in its demise." He went on, "The politicized and oftentimes toxic environment in which we find ourselves across all spheres of public discourse, including the art community, puts the work of this board in great jeopardy."[9]

This result was not triggered by any single act: it followed a constellation of events, including the publication of the *Hyperallergic* article, the release of the staff letter, a long series of external protests, the production of the look-alike pamphlet, the critical work of Forensic Architecture in the Biennial itself, and artists' actions, both singular and collective, among other events and conversations unknown to me. Each occurrence had its own effects, while adding to the wave of pressure. It is significant that the groups and individuals whose events and decisions brought about this change functioned in parallel to one another, but were not necessarily coordinated. Certainly there was contact and overlap, but it required a culmination of events to result in Kanders's resignation. The Sackler case I examined in chapter 1 is parallel yet different. An important tipping point there was the desire of the National Portrait Gallery in London to host a major exhibition of Nan Goldin's work, which she refused to allow unless they rejected Sackler funds. Goldin used as leverage her substantial social and political capital as a famous artist. This too happened in the Whitney example when the group of artists demanded the removal of their works from the biennial in July 2019. Indeed, we cannot underestimate the power artists possess to instigate change, whether inside the exhibition or institution, outside the galleries, or in the streets.

While some see these circumstances as aberrations or blips in a smoothly functioning system of support, and others see them

as a threat to the future of cultural funding altogether, I view them as harbingers of what is possible: they are openings for our imaginations to locate a different ecosystem of support for what we would like to see embodied by our cultural spaces, particularly given what Kanders himself labeled as the toxic environment in which our civic and cultural debates unfold. Further, protest of a cultural institution can and should be understood in terms of extreme care for what it does. No one would bother to protest if the institution were irrelevant. So perhaps insiders, art workers, directors, board members, public relations firms and staff, should read and respond to protest differently and see it as a useful mirror for collective self-reflection. Shouldn't our cultural spaces be able to hold exactly these kinds of challenging conversations and actions?

After resigning, Kanders gave an interview to the *Financial Times* in which he derided the Whitney's leadership as "weak," revealing his own thin skin, particularly given his line of business, and his bitterness at the unfolding of events. He said, the Whitney "had very weak leaders . . . who quite frankly did not want to engage and always felt it would go away;" the article goes on to say the he claimed "an 'uninformed' fringe group was allowed to have unmerited influence, he claims."[10] Kanders demands that his interests be put above those of the civic and cultural space of the museum and continues to make himself out to be the victim, rather than those who are on the receiving end of his tear gas.[11]

Just prior to the request by Eisenman et al. for their works to be removed from the Whitney Biennial, artists and cultural workers Hannah Black, Ciarán Finlayson, and Tobi Haslett wrote a letter, published in *Artforum*, that articulated what is at stake in these discussions:

> We know that it's hard: hard to survive, hard to act. It's hard to remain sensitive to horror in an art world bored by its own obscenity. The rapacious rich are amused by our piety, and

demand that we be pious about their amusements. Against a backdrop of prestigious inertia and exhausted critique, it can be hard to marshal our most vital feelings: our anger, our love, and our grief. We know that this society is riven by inequities and brutal paradoxes. Faced with this specific profiteer of state violence, we also find ourselves in a place to act. It is not a pristine place. But we must learn—again, or for the first time—to say no.[12]

Here it is again, the acknowledgment from artists and activists of the fact that there is no pristine condition. What alternative can there be but to act? The complicity of all within this circuit of art, money, education, public interface, private wealth, activism, and philanthropy can be overwhelmingly complex, but this is no reason to demure when a specific circumstance makes us look up and "see" the inequities all over again.

These indirect conversations between artists and the private individuals who support cultural space and artistic productions is now mostly taking place in the abstracted space of the media, rather than through the museum itself. It is clear that this is an outcome of the uncomfortable position in which the museum finds itself, mediating between the two types of power it needs: that of the artist, and that of the funder. But this dualism leaves out the museum itself as a structure of power that comprises a group of individuals acting collectively to do its work on a daily basis. Who does this work, and how it gets done, is a matter of great consequence. And so is how it is paid for.

The confrontation with the ways cultural spaces are funded is among the thorniest aspects of undoing unjust ideological frameworks embedded in museums, in part because the power relationships embedded in them—especially in the United States—mirrors the yawning gap in wealth and privilege between an increasingly exclusive minority and the vast majority of society.

That culture is dependent on this small group, as magnanimous and generous as it might be, is structurally problematic, in ways that go beyond the particularities of cases like the Sacklers and Warren Kanders. As anyone involved in fundraising knows, whether for profit (venture capital funding for a startup, or raising a private equity fund) or nonprofit, diverse sources of capital are essential to ensure that the interests of one group or individual do not achieve outsized influence, whether overtly or by default. When there is only one source or class of funds, that source gets to dictate their terms, sometimes even imposing priorities and directions to be taken.

Diversification is a challenge, particularly in the United States, where public funding for the arts—an important counterweight to private donors—is especially anemic. The United States has no federal agency devoted to culture, and the severely underfunded National Endowment for the Arts (NEA) is perennially on the budgetary chopping block, so it is no surprise that support comes largely from the private sector. The arts could not exist without it. My argument is not for a public takeover of cultural funding, but for a rebalancing of culture's sources of funds, so that we may undo the inequities embedded in the museum's systems of operation and maintain the independence of organizations from the vicissitudes of political gamesmanship.

The United States declared its independence as a nation in 1776 largely in response to excess taxation from the British Crown, so it makes sense that the history of federal tax-funded expenditure is rife with allergic responses. Shortly after the Sixteenth Amendment to the US Constitution successfully established a federal income tax in 1913 (a full 124 years after the Constitution's adoption), wealthy individuals could make deductions from pre-tax income based on philanthropic giving.[13] In a 2019 article for *Business History Review*, economist Nicolas J. Duquette writes:

> The contribution deduction was created to protect voluntary giving to public goods by rich industrialists who had made

their fortunes in business. After World War II, these business founders discovered that under postwar tax rates, they were better off giving away their wealth than consuming it directly. This incentive precipitated a surge in charitable giving and foundation establishment that transformed American civil society and led to a new public controversy over the appropriate role of donors in policymaking and the legitimate uses of the contribution deduction. The backlash to these reforms created both the modern identity of a "nonprofit sector" encompassing diverse organizations of wildly different sizes and missions and a new conservative politics that emphasized philanthropy and voluntarism over public provision of social services.[14]

Perhaps it is useful to take a closer look at the meaning behind the slogan US Congresswoman Alexandria Ocasio-Cortez has popularized, "Every billionaire is a policy failure." The argument goes that philanthropy is both inefficient and incapable of solving the world's biggest challenges. To make the kind of necessary structural shifts, for example with respect to climate change, resources and policy need to be mobilized at a national level (as well as internationally) in a coherent and aggressive plan. President Franklin D. Roosevelt's New Deal is perhaps the most well-known example of such an approach in the United States. And although the resources and federal policies and expenditures marshaled for the US entry into World War II are generally recognized as having had the most direct impact on ending the Great Depression in the United States, the New Deal illustrates a similar scale of coordinated mass mobilization of resources that is not possible via dispersed and individual philanthropy.

The New Deal was the umbrella for the Works Progress Administration, which, between 1935 and 1943, became deeply involved in US culture and infused significant sums to sustain it. Over this short nine-year span, the WPA spent an estimated

$670 million employing artists and commissioning art, a sum that represented only 5 percent of its $13.4 billion budget, and yet it provided sustaining, paid work for artists from a broad swath of experiences and backgrounds, yielding artworks of extraordinary breadth and depth, including historic public artworks across the nation.[15] In today's dollars, this type of expenditure would equal approximately $12 billion—more than $1 billion per year for nine years. Federal spending on this scale on cultural production seems unfathomable today, but at one point in US history, this was not only possible but implemented. Compare these sums to the NEA's current paltry annual budget of about $150 million,[16] and you begin to understand why cultural institutions are so dependent on private philanthropy. Today, a WPA level of financial commitment from the federal government might not only save artists and cultural institutions across the nation in the aftermath of the devastating economic impact of COVID-19, but could also instigate a much-needed rebalancing of powers.

Anand Giridharadas, whose *Winners Take All* I discussed earlier, is a philanthropy skeptic. One of his main criticisms is that it is a fundamentally flawed approach to rely on those who have collectively created the circumstances of inequity to also repair them—to do so is simply not in their interest, nor could it be realized without them giving far more funds than they are willing to part with.[17] And what if the priorities of philanthropic agents shift over time to other interests? How is the long-term work sustained over the decades that are often necessary to make an impact?

Plus, there is another, perhaps more pressing paradox of philanthropy that has a direct impact on democracy: if volunteerism is prioritized, government and civil society may feel relieved from the obligation to provide the kinds of programs— from education and social services to culture, health, and environmental advocacy—that a diverse public requires. The problem grows when these services are then privately funded by

the ideologies and acts that created the conditions of inequity in the first place. Whether the robber barons of the Gilded Age—Rockefeller, Carnegie, Vanderbilt, and others whose names continue to grace the walls of myriad institutions—or the more recent examples of the Kochs and the Sacklers, the ethical compromises remain. Cultural spaces are supported by funders congratulated for their generosity, notwithstanding the role their wealth acquisition has played in violence and destruction and the perpetuation of an inequitable status quo. Meanwhile, this largesse functions as a public cleansing of the misdeeds necessary for the amassing of such wealth, known as "artwashing" (a term used to describe both this scenario and the relationship between art and gentrification; think of Warren Kanders, as one example).

Not all donors necessarily have such objectionable sources of wealth, but without robust support from the public sector, there is no counterweight to private interests.[18] Ideally, the public sector would provide substantial funding for the annual operations for cultural institutions, meaning the people who pay taxes would be supporting and engaging with the institutions, as well as have a stake in their operations.[19]

How to finance such public support is a question that can be answered in a number of different registers. The first is to look to models that have been proposed or exist elsewhere. One potential source of cultural funds is the progressive taxation model proposed by Senator Elizabeth Warren during her Presidential Campaign. This "Ultra-Millionaire Tax," according to the Warren website,

taxes the wealth of the richest Americans. It applies only to households with a net worth of $50 million or more—roughly the wealthiest 75,000 households, or the top 0.1%. Households would pay an annual 2% tax on every dollar of net worth above $50 million and a 6% tax on every dollar of net worth above $1 billion. Because wealth is so concentrated,

this small tax on roughly 75,000 households will bring in
$3.75 trillion in revenue over a ten-year period.[20]

This tax, as she discussed in the October 2019 Democratic
Presidential Primary Debate, could pay for many things, includ-
ing free universal childcare and public college education,
cancellation of student loan debt for 95 percent of debtors, and
a $50 billion investment in historically Black colleges and
universities, among other needs of a fiscally starved public
sector.[21] Given the scale of the income from such a tax, might
a small percentage be negotiated for cultural use? Would such a
targeted "wealth tax" cannibalize donors' gifts to institutions,
leaving culture with less funding than before? Without political
courage we will never find out, but it seems that a very small
tax on vast wealth can simultaneously raise significant tax reve-
nue, and leave behind wealth that is only slightly less vast.

The funding model of the British Broadcasting Corporation,
contested as it is, is interesting because it imposes a licensing fee
on all British households, companies, or other entities that utilize
any equipment that can receive or record live television. In 2019,
that fee was £154 (or about US$200) and paid for the BBC's
television, radio, and online content.[22] This "fee for service"
model is a compelling one to contemplate in the US context,
beyond the usual admission fees.

The UK's National Lottery Heritage Fund is perhaps a more
provocative, if flawed, model. Annually, 20 percent of lottery
income apportioned to National Lottery projects is distributed
to arts organizations via the Arts Council England, Arts Council
of Northern Ireland, Scottish Arts Council, and Arts Council of
Wales. In 2019, this amounted to about £331 million (approxi-
mately US$432 million, more than double the NEA's annual
budget).[23] While the income is significant and goes a long way
to fund the arts publicly in the UK, the lottery is essentially a
regressive tax; studies have shown that poor people buy more
lottery tickets than the affluent, and spend more on it as a

percentage of household income.[24] The expenditures required to meet goals of improving cultural institutions' ability to serve traditionally marginalized communities shouldn't be borne by these very same people.

Another approach emerges from Minnesota, where in 2008 voters passed the "Legacy Amendment" to the state constitution, increasing the state sales tax by 0.375 percent.[25] The revenues generated connect culture and land management, natural habitat conservation and museums, ultimately providing nearly 20 percent of the revenue from this tax to cultural initiatives. The key to the amendment's successful passage was its linkage of the interests of those committed to cultural support with those of environmentalists, hunters, and land guardians to forge a broad-based constituency. It was this group of stakeholders that united artists, environmentalists, and hunting advocates, who pressured elected officials to make the increase. While sales taxes are also regressive by nature, they are less so than lotteries. The approach in Minnesota is also laudable for its transparency in allocating significant public funds to a group of publicly under-funded endeavors whose stakeholders collaborated creatively to achieve a common goal.

Alternatively, sourcing funds for public support for culture may be achieved by a more radical approach: by rejecting the assumption that we have to find a source in the first place. Today the confluence of money, politics, ideology, and power drive how decisions are made regarding what is "funded" and how by the public sector, creating a very specific ecology. While most US government activity is paid for by general tax revenues,[26] some things are indirectly "funded" by encouraging private spending through tax deductions, known as "tax expenditures"; these include charitable deduction to encourage philanthropy, R&D tax credits to encourage basic research, mortgage interest deduction to encourage home ownership, and reserve depletion allowances that promote domestic oil and gas extraction. Alternatively, undesirable activities are taxed as a

means of discouragement, by making items or behaviors more expensive (such as cigarette sales taxes). Other activities, particularly those that are politically motivated, are simply not funded at all and are paid for through deficit spending, such as the massive tax cuts for the wealthy and corporations of the past two decades (such as those championed by Bush in 2001 and 2003, and Trump in 2017), and the open-ended wars in Afghanistan and Iraq. US national discourse has privileged military spending and tax cuts for the wealthiest as the only national initiatives deserving of this unique benefit. Could we imagine such a cultural funding by mandate, rather than via tax-deduction incentivization? The funding required would be miniscule compared to the enormous combined expense of "trickle down" tax cuts and decades of military engagement. Will US politics ever be capable of turning away from these kleptocratic initiatives to a more democratic sense of shared responsibility for care for one another? One that materializes through culture, through education, through social services?

Let's hold this idea while we examine what is actually meant by "public funding" because, in some sense, the public—meaning taxpayers—*are* funding culture. The path of their support, however, is more indirect than the explicitly revenue-generating examples above. While many smaller organizations are significantly supported by local arts councils, city agencies, and state sources of funding, large institutions on the scale of the Museum of Modern Art in New York City (which are still private organizations, despite being nonprofits that exist for the "public good") apply for and receive very little direct public support. This is well and good, as MoMA and similarly scaled museums have access to the deepest pockets on the planet through their donor bases, leaving less well-endowed organizations to reap public support.

But is this what is actually happening? Such a narrow understanding about cultural funding fails to recognize an extremely important aspect of what the public sector is actually granting

to private institutions like MoMA. Look no further than the tax deductions that board members, donors via family foundations, and other supporters receive for the many millions of dollars they give annually. This tax-expenditure structure is essential for the system of private support of culture. It is a lever necessary in order to raise the funds to make cultural space possible in the United States. And yet, we have failed to see this as a benefit provided by the public not only to the arts, but also to wealthy people. After all, the taxes that would otherwise be collected without those deductions will never reach public coffers—hence the term "tax expenditure." And further, by offering this benefit to private individuals and foundations, the public forfeits any say it might have in how those deducted funds might have been expended. The tax benefit goes to the donor, for doing good, for making the gift, which is appropriate; but in this exchange, the decision of where or what should be funded with that support is taken out of the public sphere to become the purview of the donor.

The publicly granted tax-deduction incentive for charitable giving yields enormous support for "public institutions," while driving access to decision making into private, powerful, and privileged hands. This is precisely the "policy failure" Alexandria Ocasio-Cortez is referring to, but it is long embedded in how culture operates in the United States. Perhaps in tandem with recognizing the reality of the public support given to the wealthy funders of cultural institutions via the tax deduction, additional requirements should be mandated in exchange for tax exempt nonprofit status, including low admissions charges, increased public amenities such as childcare, living wages for staff, transparency of funding sources, and other priorities the public might express.

It is also the case that cultural investment is not merely a "soft" benefit; it has real economic impact that more than offsets deficit-spending investment. From urban centers to rural outposts, cultural workers make vital contributions to the

economy. As author and environmentalist Rebecca Solnit has said, "More Americans work in museums than work in coal, but coalminers are treated as sacred beings owed huge subsidies and the sacrifice of the climate, and museum workers—well, no one is talking about their jobs as a totem of our national identity."[27] Indeed, the arts constitute a formidable and oft-ignored segment of the US economy.[28]

The relationship between the influence of public and private funding on museum operations is undoubtedly linked to their board structures and membership. Two of the most fundamental functions of nonprofit boards are their general fiduciary responsibility and their selection of a director.[29] This first function is essential to ensuring that the organization is in good, long-term fiscal health, complies with government rules and regulations, is fulfilling its mission, and that the board's own decision making is done with care while putting the needs of the organization before any personal interests. Boards are comprised of volunteers, mostly people with the means and inclination to financially support the institution, as well as people who may have special skills that are useful to the institution in a variety of ways. Given the financial components of the fiduciary responsibilities, many boards wish to include members with legal experience, as well as financial savvy, both resources logical to desire to include in this body. Further, many organizations that receive significant public funding include ex officio members who are appointed by mayors, governors, or city councils to serve as the public's voice on the board.

This all sounds quite sensible, but relationships with boards are not without significant challenges. As Helen Molesworth, a leading curator of contemporary art, said recently, "There has likely never been a moment when the boards and staffs of museums are further apart and at greater odds than today."[30] This is a point she elaborated on in her review of the "new MoMA" in 2020's January *Artforum* issue where she writes,

the infiltration of the not-for-profit world (comprising institutions that were previously imagined to exist outside of the market by virtue of the fact that they served a societal need such as education) by the logic of the for-profit world (what else accounts for the imperative to create "blockbuster" exhibitions? Why else would we see a rash of half-billion-dollar museum projects?) has led to a divergence between the values of those who give and those who work. Given these developments, how surprised can we be to find ourselves with a gap between donors and workers that feels almost insurmountable?[31]

Under these circumstances, what are the ways to ensure healthy, productive relationships between board and staff? How is equity amongst members cultivated, between those contributing radically differently to the organization whether in scale of financial contributions or time? Is the link between giving capacity and board membership fundamentally flawed? How might we rethink this relationship to avoid the double binds represented in the Sackler and Kanders examples?

The most prevalent issue at museums, beyond fundraising, is the lack of mutual understanding between the director (and the staff) and the members of the board is what exactly each member is expected to do individually, and what they are meant to accomplish as a collective whole, as evidenced by the differences between the substance of the letters exchanged between the staff of the Whitney, its director, and Warren Kanders. Of course, these divisions play out in far more mundane and subtle ways on a more regular basis within organizations and manifest in antagonistic perceptions—with staff thinking that trustees "don't get it" and trustees feeling that the staff sees them as bottomless piggy banks. This is clearly an untenable relationship and one that must be addressed to mend the field.

While board and staff relations vary institutionally depending on the mission and scale of the organization, most institutions

would benefit from clarification of expectations, and not only in terms of financial commitments. Just as the board creates a job description for the institution's director, so too should the board chair, alongside the executive committee and the director, create and discuss individual job descriptions with each trustee. In the same way that the director works with their staff to create goals that link to the planning done by the team, so too should each board member know and understand their role in making possible the annual and longer-term goals of the board. In part, the fiduciary function of the board is thus embedded in the ability of the board to self-evaluate and to hold itself accountable to its goals.

It is commonplace to note that the museum's director "serves at the pleasure of the board." One of the nonprofit board's greatest responsibilities is hiring the director, which requires a thorough understanding of the needs of the organization, its mission, its operations, its finances, and its goals for the future. In some ways, there is a chicken-and-egg problem here, because while the institutional mission doesn't typically shift from one directorship to the next, a change in leadership can certainly shift its priorities and goals. Indeed, boards are often looking for a "visionary" to take the institution to the next level, which *requires* such shifts. Sometimes these goals are clear from the job description; more often, following the hiring of a new chief executive, these goals evolve to accommodate the vision of the director. This is a natural flow, but also requires a reevaluation of each board member's relationship to this vision, as well as their individual "job descriptions" for their board service. Clearly, the board chair plays an essential role in working with the board on these shifts, but the labor involved often falls to the director, setting up an uneasy relationship, as trustees look primarily to the director for guidance on their roles, while the director "serves at their pleasure" and is therefore reliant on this "pleasure" both for their livelihood and for the support needed to implement their vision.

Further, the volunteer nature of the board seat means that, at best, the full board gathers quarterly, perhaps with an annual board retreat, and hopefully with adequately attended committee meetings in between, and even these minimal gatherings can seem overwhelming to the museum's staff. The scale of the nonprofit typically determines the degree of self-management of the board. The further a board moves from supporting the operations of small organizations to becoming more focused on fundraising and development efforts, the more they typically rely on the institution's staff to keep the ball rolling on board initiatives. The delicacy of negotiating a job description with a volunteer cannot be overstated. In my opinion, this can only be truly negotiated in a peer-to-peer relationship between board members, and not by the director, to whom it so often falls to cultivate such relationships. Indeed, this is part of the unwieldy weight borne by the contemporary museum director; in addition to the management of a team of professionals running the museum, there is often an equal amount of work to ensure board functioning and manage relationships, as well as to meet fundraising expectations, truly straining any capacity for "visionary" thinking or planning.

Talk to any director of a financially precarious museum or cultural space and you will hear that many nonprofit board members make the highly erroneous assumption that nonprofit leaders are unsavvy when it comes to managing the financial matters of the organization. By and large I have found that this is a misconception, and that often the skills nonprofit managers display in their deployment of meager resources is exceedingly inventive—indeed nothing short of miraculous. Of course, this misconception is tied to the fundamental reality that nonprofits are *meant* to spend their income on programs rather than achieve profitability. This misunderstanding of fiscal management manifests in some strange ways over the years, particularly in board members' insistence that institutions attempt to do things that are not

only impossible, but also that they would never apply to their own business endeavors.

I witnessed this first-hand at an institution's board meeting where it was proposed that each trustee make a one-time increase in their annual board dues in order to rectify the acute under-payment of many museum staffers. A confluence of factors had led to a staff that across its departments were among the worst paid for comparably sized museums, risking wide-scale depar-tures amid miserable morale. While many trustees initially questioned their role in ending this institutional threat, an intrepid trustee cogently outlined that none of them would treat their own employees so cavalierly, and each of them willingly invested in the retention of their teams by paying market wages— why should a museum be any different? Framed in such a fashion, the restorative initiative was readily adopted.

Equity in participation among board members is often highly difficult to achieve. One unspoken reality of the nonprofit board is that giving more money to the institution entitles that person a greater say in its governance. When money is paired with actual or perceived time spent on board issues, the influence rises. In the first case, this tends to neuter the voices of those who are appointed to boards to serve in the public's interest— that is, those who have not given their own money to support the organization. Oftentimes, other board members do not fully recognize their participation, or undervalue it, even when the government agency or other entity they represent may provide much larger annual sums than they do as individuals.

All of these factors, in addition to the absolute necessity to diversify museum board leadership experientially, ethnically, racially, and economically, lead me to question how tightly board membership should be tied to personal financial contributions. Even though I fully recognize the need for significant, individual fundraising support within the contemporary US museum, there must be other ways to recognize and reward major donations without making such gifts the sole qualification for being a

fiduciary. Again, this is not how donors populate the boards of their own businesses. For-profit boards are not assembled by looking at customer lists, but by recruiting industry and business expertise. In a museum, given the board's capacity as an advisory and fiduciary body, it is difficult to reconcile the absence of other museum or institutional colleagues or community representatives as board members. For example, the Walker Art Center's acquisition committee would have greatly benefited from the membership of a Dakota elder prior to the acquisition of Sam Durant's *Scaffold* (or an Indigenous person at the helm of the museum, or among the senior staff). But current realities rarely make space for such membership.

Is there something the nonprofit world can learn from for-profit boards? Is there a way to recruit community members and other stakeholders to boards *while* maintaining their credibility and ability to influence decision making? Tokenism is not acceptable; what needs to be created is a way to achieve equity in influence and engagement between board members, regardless of their financial contributions. Further, the expertise I have often felt lacking on boards is *actual museum experience*. Would it be possible or desirable to recruit other museum directors, or senior managers, as board members? Should such professionals and other stakeholders be compensated for their time as they might be on a for-profit board? How would their voices and opinions be heard in relation to other members?

Interestingly, it is not uncommon to have artists as members on museum boards. This can be highly effective, if the artist is someone whose work other board members adore and whose intellect they respect. Unfortunately, artists are often asked to serve on art- and programming-related committees, rather than those central to governance such as the finance and nominating committees, where their perspectives would be more likely to contrast with those of donor trustees. Sometimes the inclusion of artists on boards can lead to conflict, such as the bind in which the Museum of Contemporary Art, Los Angeles, found

itself in 2018. Issues emerged when the work of Mark Grotjahn, an artist who was also a board member, was selected for a retrospective exhibition organized at the museum; he was simultaneously to be honored at its gala, which is among the museum's most important annual fundraisers. The layers of conflict of interest and internecine relationships between museum programming and board function were many, including the fact that many board members were collectors of Grotjahn's work, and his retrospective would undoubtedly increase the value of the works they owned. In the end, this debacle resulted in the cancellation of the fundraising gala altogether, and the highly dubious firing of Helen Molesworth, who had served as chief curator of the museum. This then triggered the dismissal of the director, Philippe Vergne, who, along with the board, had created this conflict-of-interest house of cards.[32]

One organization whose attributes could be useful for advancing thinking about boards is the artist- and curator-initiated nonprofit Art+Feminism, an advocacy group that organizes events around the globe to address gender inequity in *Wikipedia* entries related to the arts. They focus on adding and correcting information to existing pages, as well as creating new entries, all while sponsoring their own edit-a-thons and providing the tools needed for others to organize events in their geographies. Since 2014, over 14,000 people worldwide have participated in more than 1,200 Art+Feminism edit-a-thons.[33] The result has been a measurable increase in the number of articles on women, gender nonconforming, and trans artists in a wide range of communities. For example, when Art+Feminism started organizing events in Lima, Peru, in 2015, there were only ten *Wikipedia* entries for Peruvian cultural figures. By 2020, this number had increased more than fivefold. These incremental increases, each with a hyper-local focus, have allowed global access to information about, for example, the Indigenous Peruvian artist Lastenia Canayo García (or Pecon Quena in her native language), who now has a robust entry. One particularly interesting logic of

Art+Feminism's structure is their insistence on making decisions between the board and management via consensus. Both the consensus decision-making concept and a sunset clause for the organization itself are laid out in their bylaws, requiring the board and staff to look at the big picture annually, not only in terms of their individual roles, but also to evaluate the impact of the organization as a whole, and whether it is useful or needed in its current form.

So many institutions are founded for great, necessary purposes. They struggle to get started and become formalized; they succeed; they do the work they set out to do. Sometimes they are able to develop sustainable practices that create depth and breadth to their work. And sometimes they fall into self-perpetuating cycles. An important board function is to understand the *why* behind the *what*, and indeed some organizations run their course. To recognize this is not a failure of the institution, but rather, its success.

Many more nonprofits should take the courageous step of unwinding when the work is complete. While this is impractical for larger museums with sprawling collections, the self-evaluation of the board and its work remains essential. Indeed, perpetual growth is as impossible and counterproductive for the nonprofit as it is for the for-profit.

4

Unlearning, Undoing, Remaking

Curator and theorist Ariella Aïsha Azoulay's book *Potential History: Unlearning Imperialism* confronts the tough realities faced by those who endeavor to reclaim cultural spaces, focusing her analysis on efforts to undo imperialism. She addresses the technologies of imperialism, including how photographs, archives, and documents are preserved to tell particular histories and are often used by colonial power to reinforce its version of reality. Even seemingly "neutral," apolitical, or formally focused photos and their captions or descriptions can reinforce the imperial conquerors' understanding of the world, merely by being organized within imperial frames or epistemologies. One of her key examples is a series of photos housed at the International Committee of the Red Cross's (ICRC) archives depicting the displacement of Palestinians following the creation of the State of Israel in 1948. Azoulay relies upon these images for her analysis in part to critique the ways the archive regulates its holdings. The ICRC denied her request to print and exhibit these images *unless she used their captions*, which she found radically lacking in their descriptions of the events and therefore a reinforcement of the imperial state-making project.[1] Her solution was to trace the photos, translating them into drawings with new captions that could operate as independent objects outside of the archive. In this configuration, the images could also operate against categorization and a linear progression of time. One of the most moving aspects of Azoulay's argument is the way she bends time; rather than "salvaging victims" from the archive by telling their stories through a contemporary lens, she

insists on occupying a common space outside of the distance of time to become "allies in a common struggle," imagining oneself standing next to those pictured in the archive as co-resisters from different points in history.[2] Of course, many of the technologies or documents used in imperial or colonial storytelling are held by museums. Therefore, resistance against these categories, as well as the pressure of the forward progress of modernism, Azoulay suggests, can be a mode of unlearning imperialism. The museum is as apt a location as any to attempt this work.

In conjoining the ways in which museums and archives operate, Azoulay argues that in order to unlearn them we must "make perceptible the violence exercised outside the space that the archive claims as its own, violence that renders obsolete other forms of being together in the wake of its materialization."[3] This means acknowledging the archive/museum as a space with a particular point of view, one that must be expanded and shifted so that a broader swath of culture can connect within it over time. In fact, time plays a big role in what Azoulay addresses in her book. To see time as sequential and ordered, in a modernist sense, removes any space for liminality, or for the possibility of connections that jump through time in an irregular or glitchy way. She speaks of the "rigid tale of advancement," making an example of the accepted schedule of the workday:

A time line of the length of the workday emerges as a sign of progress and imperial modernity concealing the fact that the reproduction of people to a measurable labor power was forced upon people in the name of this modernity. After all, before the imperial movement of destruction, people were not forced to work for their living, and their active life (*vita activa*) was not reduced to a relentless race. It is only by relating to them as already reduced to their labor power, through the omission of the original violence of coercing people to become laborers,

that any improvement in their condition can be made a milestone in the path to their progressive liberation."[4]

Museums, of course, use timelines regularly to illuminate collections and to describe movements or categories of artmaking. Students of art learn these sequential chunks of time and rehearse them in school; they represent a common language, reference points within the functioning of the museum. As useful as they might be in helping to make sense of eons of artistic production, in my view, and I would venture in Azoulay's too, these ideologies are too narrowly wrought. They seek to make order via a violence of exclusion, and even through the denial of crucial overlaps among artists' ideas and works that is so often the reality of the ideas and relationships behind the artwork and the artists who made them. There is revelation to be had, the kind that most excites me, in this space of what has been left out and what overlaps uncomfortably. We are seeing the impulse to locate such moments today in the "discovery" or "recuperation" of an artist who may be little known precisely because they did not "fit" within a category. Consider, for instance, Geta Brătescu, a conceptual artist whose work featured in the Romanian Pavilion at the 2017 Venice Biennale. The exhibition brought international attention to the artist, whose decades of works are as varied as they are brilliant, running the gamut from handmade textiles and lo-fi collages made of found materials, to impeccable drawings of personal experiments in color, space, and form, to experimental film, photography, and performance. Her estate is now represented by mega-gallery Hauser & Wirth. Or, consider an artist like my dear friend Mel Chin, whose artistic practice is so varied we decided to call his sprawling survey *All Over the Place*—as indeed it was, both literally and figuratively.[5] His range is extraordinary, from finely wrought, large-scale sculpture like his monumental furniture-like spider, *Cabinet of Craving* (2012), which skewers Western colonialism in China with its surreal juxtaposition of

objects, and the room-sized installation *The Funk & Wag from A to Z* (2012), featuring his re-alphabetization of meticulously collaged cutouts of illustrations from the entire 1953–56 *Funk & Wagnall's Encyclopedia*, to his socially engaged project *Flint Fit* (2017/18), a tri-state artwork that involved local water activists in Flint, Michigan; well-known Michigan-born fashion designer Tracy Reese, in New York; a community center in Flint devoted to training women in commercial sewing; a manufacturer in North Carolina that made fabric from plastic water bottles; and a museum in Queens. The vast breadth of Chin's work—and an increasing number of artists are working in this way—defies all categories, making it challenging for institutions or the marketplace to slot him into a predetermined place. This hasn't stopped Chin, but it hasn't been easy for him to marshal the resources to continue to do his thing, so I was especially thrilled when he deservedly received the prestigious MacArthur "Genius" Grant in 2019, which includes a no-strings-attached award of $625,000.

New York's Museum of Modern Art underwent a significant expansion completed in 2019, which afforded the opportunity to re-envision the presentation of its renowned collection. This reimagining of the collection galleries offers an example of preliminary efforts by established institutions to undo their biases. Some of the most revealing and exciting moments of this first iteration of re-envisioning the collection came when the traditional art history timeline was interrupted. For example, while the first organizing principle of the reinstallation concerned three broad time periods that maintain the ever-progressing forward march of art history, things become most provocative when tangents and glitches emerge. Each of the major time spans—1880s–1940s, 1940s–1970s, and 1970s–present—occupied one of three floors. These chronological chunks serve as a backbone, and it is in the moments when they are not treated as gospel that great stuff happens. Two of my favorite instances are the gallery entitled "At the Border of Art and Life" on the fourth

floor, and artist Amy Sillman's selections from the collection, which appeared from May to October 2020 on the fifth.[6] "At the Border of Art and Life" brought a carnival of works into a small-scale gallery, which is painted orange-red, with works hung salon style. The space is packed with Fluxus works from Japan to Latin America, and foregrounds the thinking of by Fluxus's leading man, George Maciunas, alongside Yoko Ono's works featuring simple instructions typed on paper from the early 1960s, Rirkrit Tiravanija's *Untitled (apron and Thai pork sausage)* (1993), a brown paper apron with a sausage decal on the chest, and Pope.L's *Mal Content* (1992) comprising a newspaper image of Malcolm X. covered in peanut butter, leaving only his open mouth visible. All of these connect the poetics (and flailings) of daily life, often centering the quotidian as a vehicle for meaning making as well as for political expression.

Sillman's selections, collectively titled *The Shape of Shape*, relayed a great deal about her own work as a painter, as well as an interest in shape (as opposed to line and color), which might be interpreted as another tangent to modernism's twenty-twenty vision of itself. For the exhibition, Sillman chose over seventy sculptures, objects, photographs, and paintings, installed on bleacher-like steps that ringed the rectangular gallery on three sides. Through its density, the exhibition made space for odd imbrications and surprising coincidences of form and content across decades; the lovely formal relationship between a Louise Nevelson black-on-black relief of stacked geometric forms and Senga Nengudi's black-and-white performance photo of a figure wearing a black, oversized globe-like head covering atop blocky, black garments, for example; or Ulrike Müller's geometric conversation with an Edvard Munch lithograph of bear-like forms. While the unexpected adjacencies of these works are thrilling for art historians and curators, there is also plenty of space for non–art expert publics to have some fun too.

As Azoulay offers, the collapsing of categories (like the divisions between experimental film and photography, or sculpture

and painting, or "outsider" art and every "other" kind) is an intentionally anti-imperialist move because it attempts to add complexity, via other layers and stories, to dominant ideas that exclude what doesn't "fit." I look forward to further iterations of MoMA's promised cycle of reinstallations of the collection, and only hope that the inclination toward undoing exclusions and interrupting time-honored narratives continues apace, creating greater opportunity to highlight shadowed corners and ideas outside of the dominant narratives of the past, as well as to yield new exhibition-making strategies that might evolve in parallel.

Zooming outward from the specifics of MoMA, Azoulay contends that "institutions . . . seek to put an end to existing activities, formations, and structures. They seek to impose their own principles and structures as the foundation of transcendental forms that have no history other than their concrete instantiations."[7] And, I would add that this is exactly why museums are not neutral; in fact, they came about precisely to create the "freeze frame" that captures the moment as the story is told via a particular institutional lens. It is past time to reintroduce the fluidity of histories, both oft-told and too often unheard.

While MoMA has made significant programmatic shifts, in many senses, it is far easier to make change through the exhibition and public-event content of the museum than it is to shift its underlying structures. Institutions often make their first forays into undoing structural bias through their programming, as it is most publicly evident. The Brooklyn Museum, for example, has made great strides in this work with commitments to all manner of marginalized artistic production, from their collections to exhibitions and programs that feature the under-represented and under-seen. What is more difficult is the deeper undoing that Azoulay keys into, that which takes this commitment past the art and into the structures of decision making, operations, and governance. For these I would like to suggest frameworks and speculations that begin with some thinking

about institutional undoing, as this has clearly become an urgent matter in coming to terms with the violent history of the United States.

One place to begin is by engaging with some of the ways in which Indigenous peoples have confronted the Western containers of culture, because the violences of this history are not simply part of the past; indeed they continue to operate virulently in the present. National and tribal museums of Indigenous art are sites of great pain for the nations represented. Historian Amy Lonetree's groundbreaking book *Decolonizing Museums: Representing Native America in National and Tribal Museums* is a study of three museums that attempt to contend with the histories of genocide and cruelty suffered by the people who live on the land we now call the United States. An important aspect of Lonetree's analysis lies in the ways in which she connects the anthropologically driven roots of the amassment of Indigenous materials to the ongoing trauma of colonization. She writes: "In the late nineteenth and early twentieth centuries, many anthropologists made their careers on systematically collecting American Indian material culture ... A majority of these objects were collected during the period when Indians were supposed to vanish from the American landscape—'the Dark Ages of Native history.'"[8]

Indeed, one of the reasons anthropologists thought extinction was around the corner was because the ways of life that produced the objects they collected were undergoing intentional and systematic extermination. The staggering reality is that many survived, and as Lonetree emphasizes in her work, the loss and pain of this low point of Indigenous life should be confronted and named, unequivocally and consciously, in partnership with and driven by Native people, to create cultural spaces of healing and reflection. She looks closely at the Ziibiwing Center of Anishinaabe Culture & Lifeways, a community center that comprises a research facility, meeting rooms, storage for

collections of tribal objects, a shop, a temporary exhibit gallery, and permanent exhibition space that features "the history, philosophy, and culture of the Saginaw Chippewa community—told from their perspective."[9] In her analysis, Lonetree points out:

> Its unflinching treatment of colonization provides the context that makes the survival of the Saginaw Chippewa so amazing and worthy of celebration. And it devotes a considerable amount of floor space to addressing important contemporary issues and tribal survivance. Because it allows no silences around the forces that sought to destroy the Saginaw Chippewa—because it tackles head-on the very painful aspects of the tribe's history—it is then able to address the ongoing legacies of historical unresolved grief that are so prevalent throughout Native America.[10]

There are learnings to be unpacked from the ways in which this work has been done in culturally specific spaces that are essential to the desired shifts within other museums and cultural institutions. In *Survivance: Narratives of Native Presence*, an anthology edited by Anishinaabe critic and writer Gerald Vizenor, Vizenor coined the neologism in the title of his book to describe a specific merging of survival and resistance that "creates a sense of native presence over absence, nihility, and victimry" that Lonetree references. He surfaces an important idea here: that *in spite of* what has been wrought by colonialism, violence, and oppression, Indigenous survivance embodies a grace that is represented by all manner of Indigenous culture and thought. To me, there's a kernel of this thinking that seems to run parallel to arguments made by Black studies scholars, including Christina Sharpe's powerful writings about "wake work," in relation to histories of enslavement in the United States, and Saidiya Hartman's insistence on the transient moments of beauty and joy missing from the archives of lives

lived under this same oppressive system. Hartman, in *Wayward Lives, Beautiful Experiments*, offers a category-defying series of portraits of Black women. They are selected not for their fame but for their ordinariness, whether as domestic or sex workers, straight or queer, coupled or unattached, attempting life in all its dimensions during the Progressive Era in Philadelphia and Harlem. The backbone of the book is Black feminism, and the pathways it suggests for surviving the brutality of white supremacy, patriarchy, and state violence, while leading creative lives not reduced by these constraints. She writes:

> What better articulates the long history of struggle, the ceaseless practice of black radicalism and refusal, the tumult and upheaval of open rebellion than the acts of collaboration and improvisation that unfold within the space of enclosure? The chorus is the vehicle for another kind of story, not of the great man or the tragic hero, but one in which all modalities play a part, where the headless group incites change, where mutual aid provides the resource for collective action, not leader and mass, where untranslatable songs and seeming nonsense make good the promise of revolution. The chorus propels transformation. It is an incubator of possibility, an assembly sustain dreams of the otherwise. *Somewhere down the line the numbers increase, the tribe increases.* The chorus increases. *So how do you keep on?* She can't help it . . . *The struggle is eternal. Somebody else carries on.*[11]

Sharpe, Vizenor, and Hartman all evoke this condition of *in spite of* that makes space for excellences and joys—precisely that which dominant Eurocentric histories have ignored and excluded.

This is not only an attitudinal shift but also provides a path by which the past might repair the present, making it a viable space for curative work and opening it to redoing as a practice rather than as an endpoint. One touchstone for this type of interactive, process-oriented work came up daily during a

curatorial residency I completed in Australia (courtesy of the nonprofit arts organization Artspace). Australia and the United States share violent colonial pasts that wrought racial violence, death, forced migration, land dispossession, and attempts at cultural and existential erasure. Given these parallel histories and relationships, I wanted to know and understand more about how Australians and their institutions contend with colonial histories and present realities, hoping they might provide some meaningful paths toward centering survivance, decolonization, and Indigenization.

On my second day in Sydney, still bleary and feeling literally upside down, I walked into the Art Gallery of New South Wales (NSW), an institution located within a colonial-era building with deep collections and sprawling galleries. Sometimes being a first-time visitor to a place opens my eyes to things I wouldn't see in a more familiar space. As I traversed the admissions-free threshold of the gallery, I noted on my right a suite of galleries devoted to nineteenth-century Australian art. I walked inside and took some time to wander the multiple adjoining spaces devoted to this period.

The art on view was stunning, ranging from lush nineteenth-century landscape paintings by Louis Buvelot, Nicholas Chevalier, and William Piguenit, to painted scenes of nineteenth-century life by Rupert Bunny, Tom Roberts, and Arthur Streeton, to nearly a dozen Bertram Mackennal bronze and marble sculptures of Greco-Roman classical figures. As I wandered through the space, getting a sense for the storytelling, the very first thing that came to mind was the obviousness of the exclusion of art made by anyone who was not a white European Australian (there were a handful of works included by white European Australian women). This is by no means uncommon in the United States, but somehow it was more visible to me in an unfamiliar cultural context.

At the center of the first gallery sat a contemporary sculpture that intervenes in this story: a larger-than-life rendering of the

eighteenth-century explorer James Cook perched on a table, as if surveying the space. The stainless-steel artwork was sculpted by Michael Parekowhai, a New Zealand artist of Māori and Pakeha descent, and is remarkable in its scale and placement, as well as for the fact that it is both the only artwork in the space produced in the twenty-first century and the only one by someone Indigenous identified. The work has a powerful presence, simultaneously reflecting all of the surrounding images of European perspectives on the land that Captain Cook is credited with "discovering," while in effect sucking all of these images into the figure through their distorted reflections. It is as though the body of Captain Cook is the vehicle through which these particular Indigenous visions of Country are made manifest.[12]

While Parekowhai's artwork dominates in this gallery space, it remains an incomplete gesture. Art made by Aboriginal and Torres Strait Islander people is generally exhibited in the Yiribana Gallery located a few levels down via escalator. These problematic conditions of presentation, representation, and storytelling are not foreign to the curators and administrators at the Art Gallery of NSW. Quite the opposite. While their current building and installations may tell a different story, they have undertaken serious efforts to undo and redo these conditions. The gallery, alongside other museums and cultural spaces in Australia, is working actively to confront the maddeningly racist and exclusionary biases of historical narratives around art and within institutions. In a nation that bears similar origin stories of colonization to the United States, it has been instructive to attempt to study the ways in which each is only beginning to decolonize and/or Indigenize their cultural spaces, or even to find languages to discuss possible futures.

The land acknowledgment is a necessary entry point to confronting settler-colonialism in our present. While such statements have emerged relatively recently in the United States, as was clear from my residency, they are a completely regular and essential part of any event or gathering in Australian cultural

contexts. In fact, it is part of cultural workers' knowledge base to know not only what the lands were called before they were renamed by colonial settlers, but also what language groups lived and continue to live on such lands. Given that these practices are only burgeoning in the United States, and that their implementation sometimes feels like virtue signaling if the institution is not dedicated to deeper structural work, I had a lot of questions about this work in Australia.[13]

I have learned a great deal about the practice from conversations with incredibly generous people, including artist Tony Albert; Maud Page, deputy director and director of collections at the Art Gallery of NSW; Coby Edgar, curator at the Art Gallery of NSW; and Liz-Ann Macgregor, director of the Museum of Contemporary Art Australia (MCA). Yes, land acknowledgments can come across as perfunctory, especially when they are embedded in email signatures or rushed through at the beginning of an event, but they are significant as a first strike against the erasure of First Nations peoples. What is evolving in Australia is a more personal approach to acknowledgment. Rather than one, administratively sanctioned acknowledgment, many individual cultural workers within institutions are adding their own nuance to these statements, creating personal inflections that can be extremely moving and provocative. For instance, at a panel discussion related to the 2020 Biennale of Sydney—the first to be curated by an Indigenous man, artist Brook Andrew— Kimberly Moulton, a Yorta Yorta woman and senior curator of South Eastern Aboriginal collections at Museums Victoria, made the following simple opening: "Before we begin I wanted to acknowledge the Gadigal people. We have been guests on their lands . . . me for a week, others a bit longer. They've taken care of us. So just thinking and reflecting on the ancestors and the people still here."[14] This centering and elevation of awareness of the physical territory upon which institutions and peoples stand, as well as the people who have populated them for tens of thousands of years, is a significant step toward repair, particularly

when it is done with care and sincerity, as well as an institutional connection with research, policy, and structural change.

So how does the structural change occur? Both the MCA and the Art Gallery of NSW have waded into this work. Both have engaged a community of Aboriginal and Torres Strait people who volunteer to serve on advisory boards or committees. These include both staff members of each institution and others dedicated to this work in the field. Both advisory boards have developed polices that outline targets for each institution as well as how this work is centered within the strategic planning of the museum.

As a former museum director who has had uneven experiences with these kinds of advisory groups, I wondered how they work, what issues are presented to these committees, and when they might be engaged in institutional questions beyond those pertaining to programming of Aboriginal and Torres Strait Islander art.

The MCA, just a fifteen-minute walk from the Art Gallery of NSW in Sydney, has a long history of work with Aboriginal and Torres Strait peoples to integrate not only acknowledgments but also practices into the fabric of the institution. Take, for example, a visit to the MCA's website. When the home page opens, a black screen informs visitors that "The Museum of Contemporary Art Australia acknowledges the Gadigal people of the Eora Nation, the traditional owners of the land and waters upon which the MCA stands." You click the X at the top left of the screen to continue into the site. In the main menu listings, one of five options is a link titled "First Peoples of Australia," wherein the MCA restates the land acknowledgment and provides access to the Aboriginal and Torres Strait Islander Policy, and the Indigenous Advisory Group (IAG), as well as recognizing First Peoples who have collaborated with the museum in the past and the present on the board, on advisory committees, and via special projects, and individuals on staff who identify as Aboriginal or Torres Strait People. It is certainly

a wealth of information, but I was curious about the questions and policies on which the Advisory Group were consulted, and what issues were raised most often by staff and visitors who were referred to these resources.

I spoke with the MCA's director, Elizabeth Ann Macgregor, who relayed that the MCA's Indigenous and Torres Strait Islander Policy was developed with the IAG, led by their staff. She said, "The chair of the group is an MCA board member and reports on the issues that the IAG discusses to the board once a year. Our policy is . . . embedded in our organization. As a result of its implementation, we now have 5 percent Indigenous staff, but all staff have responsibility for ownership of the policy. We think of it as a way of Indigenizing our practice."[15] This is a clear instance in which diversification through the intentional input of Indigenous thinking clearly informs the museum's governance and policy, as well as its program. A significant element of the Art Gallery of NSW's history is that it was the first Australian museum to acknowledge objects by Aboriginal and Torres Strait Islander people as "art," which it did by commissioning a series of Pukumani grave markers made by senior Tiwi artists from Milikapiti (aka Snake Bay) on Melville Island in 1958. Two years ago, the gallery started its Aboriginal and Torres Strait Islander Advisory Board, led by artist Tony Albert. He serves as the convener of this group as a volunteer; not only do they meet about eight times per year, but Albert also has individual meetings with internal museum departments outside of curatorial and public programming, and has become involved with discussions about how fundraising and marketing work could be more inclusive or centering of First Nations values. I am certain, having met Albert, that the gallery is a much stronger institution for his involvement.

Maud Page, deputy director and director of collections at the Art Gallery of NSW, stressed that the work they were doing was intentionally slow, in order to build relationships and make decisions collectively with buy-in at all levels of the institution, from

staff to advisory board to gallery board. She also spoke of the importance of shared responsibility for inventing the *how* and *what* of their processes, as well as for getting it done. As she put it, they want to be careful that "Indigenous protocols are followed, meanwhile ensuring that additional labor isn't unnecessarily visited on Indigenous staff, while non-Indigenous staff and board members navigate issues without instigating an atmosphere of being afraid to make mistakes."[16]

Each organization I visited and spoke with is making strides, both big and small, with respect to the cultural production and representation of Aboriginal and Torres Strait Islander peoples not only in the collections and exhibitions programs, but also in the ways the spaces operate. The biggest challenge is, of course, this structural work that undergirds all of the mechanics of the institution. It is here that we in the United States might learn from the work currently underway and yet to be done in Australia. And it is also here that there remains the largest effort to be made, one that is certainly iterative, a work in progress, and definitively always incomplete. The most important thing is to begin in earnest.

This brings us to yet another complex reality that relates to all of the above: namely, that the work to advance greater equity happens both in stealth and in public. Protests, boycotts, and public letters are important, not only to raise public awareness, but also to bring allies outside of institutions together. Simultaneously, there is the quieter work that happens inside cultural spaces: the slower, more dogged ways individual people use their own powers of influence, whether by raising tough questions in meetings or by implementing organizational shifts (even if only within a particular department or program). These modes of working often hold an uncomfortable relationship with one another, partly because those agitating from the outside want a seat at the table inside—one from which they are excluded if they are doing a good job in making noise

externally. On the inside, art workers fear external protest will shine a light on their labors in ways that might lead to its undoing, internal retribution, or even the loss of their jobs. And yet, they are both necessary, and they demonstrate the ways in which museums and cultural institutions are not monolithic buildings or just another abstraction, but rather collections of people who do things together. Yes, they often work with objects, but their staffs also make decisions every day that are impacted and guided by values and ideas. It is essential to recognize the radical potential for change embedded in decisions that are made day to day by art workers at every level of the institution. This concerns not only programming, but also which cleaning company we hire, how we write and to whom we circulate a job description, who gains access to budget documents, how internships are managed; indeed, there are nearly endless opportunities to participate in the redoing of the museum's internal structures. Cultural workers and publics should not underestimate the power of working to make change on these various scales simultaneously, whether or not these efforts are coordinated. One example of the impact of such alignments can be readily seen in the Kanders protests at the Whitney, discussed in the previous chapter, which involved staff objections, outside protests by artists and activists, and protest by artists whose work was on view at the museum.

Another example of such alignment of protest occurred at New York's American Museum of Natural History (AMNH), beginning in 2015. Among the most popular museums in New York City, and the fifth-most-attended museum in the United States,[17] AMNH is a resource for all varieties of learning about natural history, anthropology, and astronomy. The museum is visited by millions of local schoolchildren, New Yorkers, and visitors to the city, and is a classic example of how museums are at once deeply trusted sources of information, and yet also play host to embedded racism, colonialism, and climate crisis denial, not only in their displays, but also in their boards and governance

structures. As I will show, the non-neutrality of museums is uncomfortably visible in such an environment.

Two different sets of tactics by two different artist/activist collectives have ushered change to this institution in fascinating ways, on highly different registers. The first example relates to the statue of Theodore Roosevelt that sits directly in front of the museum's main entrance where it has stood for the better part of a century, and was a focal point for protests initiated by a consortium of Indigenous rights groups, prison abolitionists, as well as climate and anti-capitalism activists, including Decolonize This Place (DTP). Inspired by a "counter-tour" led by Black Youth Project 100 in 2015, for the last several years protesters have come together to conduct new counter-tours of the AMNH each year on Columbus Day, aiming to replace the annual federal holiday with Indigenous People's Day, and to engage the museum in creating a Decolonization Commission. The counter-tours proceed through the museum's galleries, with the goal, according to DTP's website, of connecting "the legacies of white supremacy, settler-colonialism, and heteropatriarchy monumentalized in the displays, language, and aesthetics of the museum."[18]

The Columbus Day actions began and ended at the Roosevelt statue, which stands on a plinth on the grand staircase at the main entrance to the museum on Central Park West. Roosevelt was known as a naturalist and for his writings on natural history, and his father, Theodore Roosevelt Sr., was among the founders of the museum. Theodore Roosevelt Jr. was also known for his belief in white supremacy and eugenics. Gary Gerstle, Mellon Professor of American History at the University of Cambridge, describes Roosevelt's racism as follows:

> Well, he had very well-developed and racist views towards both Indians and blacks. He regarded Indians as savages. He respected them because they were ardent warriors. But he expected that they would be eliminated, exterminated from America in contest with the white men who were settling the

continent, to the people who he hailed as backwoodsmen. And he required the Indians to be there to be the strenuous opponent through which Americans could prove their valor. But he was very clear that in a modern America that he was building, he expected they would be exterminated either through battle or through simply the inability to adjust to modern life.[19]

The sculpture was commissioned in 1925 by the City of New York and installed on the site in 1940 (the AMNH is located on land owned by the city, which owns the statue as well). The work features Roosevelt seated high on a horse looking into the distance. To his left, standing beneath him on the ground, is a figure of an African man. To Roosevelt's right is an Indigenous man, also standing on the ground. Both are Roosevelt's fellow travelers, of a kind, but the iconography is clear. Roosevelt physically looms above them, surveying the terrain before them from a higher plane. The statue thus positions a famous, wealthy white man in a position of power, while he is escorted by men whose race and culture are examined in the natural science museum before which they stand. While Roosevelt's relationship to the museum has been framed as that of an explorer and gatherer of science and knowledge, the nameless African and Indigenous men who appear by his side are his subjects of examination; he is the explorer-scholar, while they are the material he studies. The dehumanization embedded in this relationship is relayed seamlessly in the statue's representation. The portrait is further implicated by Roosevelt's connections to the history of the conservation, eugenics,[20] and Progressive movements that are also indelibly part of the history of the United States and the AMNH.

The horrifying perfection of this portrait, not only of Roosevelt specifically, but of the cruelty toward the peoples exploited to found the United States, is a painful and powerful contemporary reality.[21] This is not an image of past oppression, but rather one of ongoing injustice.

In 2017, following national calls for the evaluation of public statuary, including those of Confederate leaders that became flash points for violence in Charlottesville, Virginia, New York City Mayor Bill de Blasio convened the Mayoral Advisory Commission on City Art, Monuments, and Markers to assess public statuary throughout the five boroughs. The results of the report only slated one statue for removal, and it wasn't the Roosevelt sculpture. In fact, the commission was deeply divided about how to proceed with this work. A significant faction thought additional historical research was necessary to reach a more considered recommendation (the commission was limited to ninety days), but within this group several members strongly advocated for the statue's removal on the basis of its racist iconography; another segment of the group advocated for relocation of the statue; and a few advocated for greater on-site contextualization.[22]

Given this mixed recommendation, the AMNH came up with its own ways to address the conundrum, at least temporarily, in the summer of 2019. This preliminary result was the creation of an exhibition at the AMNH and a page on its website, both detailing the contradictions embedded in the representation of Roosevelt on its doorstep. The introduction to this effort first noted why a statue of Roosevelt would be placed at the steps of the museum, describing him as a naturalist and connecting his history with the museum to his father's involvement in its founding. This was followed by some framing questions:

At the same time, the statue itself communicates a racial hierarchy that the museum and members of the public have long found disturbing. What is the meaning of this statue? And how should we view this historic sculpture today? . . . To understand the statue, we must recognize our country's enduring legacy of racial discrimination—as well as Roosevelt's troubling views on race. We must also acknowledge the museum's own imperfect history. Such an effort does not excuse the past

but it can create a foundation for honest, respectful, open dialogue.[23]

Some, including me, believed this too mild a corrective, while others balked at the idea of removing the sculpture altogether.[24] And for a while, the sculpture remained. While the pedagogy surrounding it, at minimum, may have yielded some counterweight to its oppressive iconography. It is unacceptable to subject millions of people to the racist and brutal ideologies expressed by such a sculpture, particularly in a position of exaltation at the entrance to this institution of study and learning. And the exhibit inside the museum did not do enough to counter the messages of the object and its citing. I continue to agree with the position that the monument should be removed; if it is to be displayed elsewhere, it must be contextualized within an ecology of learnings that are intentionally anti-racist.

On June 21, 2020, in the midst of the mobilization of millions of people calling for racial justice across the United States in the wake of George Floyd's murder, the American Museum of Natural History shifted its position. It requested that the city remove this depiction of Roosevelt that had stood at its doorstep for eighty years, stating: "While the Statue is owned by the City, the Museum recognizes the importance of taking a position at this time. We believe that the Statue should no longer remain and have requested that it be moved."[25] The City has subsequently agreed to its removal although as of this writing, there is no set date for deinstallation. Indeed, museums are not neutral.

Beyond the sculpture's status vis-à-vis the city, the protests surrounding it and other parallel actions that began in 2016 have forged new ways to address the problematic symbolism of such artwork—symbolism that mirrors the organizing logics at work inside the museum. While the AMNH has not agreed to participate in DTP's Decolonizing Commission, the annual recurrence of the counter-tour has become an accepted, if not explicitly

authorized, occurrence; in some years it has attracted nearly 1,000 participants.

Simultaneous to the DTP actions, another collective project has been working a different set of strategies. In 2014, a collective of artists, scientists, historians, theorists, and activists known as Not an Alternative launched a museum initiative called The Natural History Museum. This is an ongoing project, comprising roving exhibitions and programs that aim to more deeply connect nature and science to the sociopolitical realities of contemporary life.[26] In addition to the educational and public programming offered by The Natural History Museum, the collective also initiates and participates in campaigns of fundamental importance to the retention of science, accountability in natural history museums, and to advocacy for bold climate action.

In 2015, The Natural History Museum circulated a letter, signed by dozens of scientists, that targeted science and natural history museums, demanding they cut all ties to fossil fuels. The letter received overwhelming international attention,[27] and as a result, further signatories from the research and academic sectors, as well as government officials, joined the call. With this leverage, The Natural History Museum was then able to demand that David Koch, a well-known fossil fuels executive and climate change denier who provided significant funding to initiatives to delegitimize climate science,[28] to resign or be removed from the board of the AMNH. Five hundred fifty thousand people signed the petition. On December 9, 2015, after twenty-three years of service, David Koch resigned from the AMNH board. While the AMNH and Koch both insisted that he simply decided not to renew his board seat, his resignation was a major victory for the campaign to reject the membership of climate crisis deniers and obfuscators on the boards of natural history and science museums.

However, the victory over Koch wasn't the endgame. From there, The Natural History Museum further pressed AMNH to

join the more than half a dozen museums, from the Field Museum in Chicago to the Australian Academy of Science, to divest their endowment portfolios of fossil fuel companies. Within a year of Koch's departure, the AMNH announced it had significantly reduced its $650 million endowment's exposure to fossil fuel investments, and that it had no direct investments in fossil fuels.[29] Beka Economopoulos, executive director of The Natural History Museum, said at the time:

> As anti-science forces have gained unprecedented power in the White House and Congress, the role of our most trusted institutions of science is more important than ever. We applaud the American Museum of Natural History for slashing investments in the very companies that have spread climate science disinformation for decades. We hope this encourages other science museums to stand up for science and cut ties to fossil fuels.[30]

This example of climate science deniers in positions of power on the boards of natural science museums dramatically reveals yet another way in which museums have never been neutral spaces. Even if those museums must maintain some semblance of independence for their research to be credible, the conflicts within persist. It is remarkable, then, what a group of determined artists and activists has been able to do: they have managed not only to expose the internal conflicts these relationships cause, but also to communicate their problematic nature to the public so that change has taken place.

5

The Neutrality Problem

Zooming out of the details of how museums get caught up in and respond to controversy and protest, I'd like to map some ways I've thought about neutrality to wrap my mind around what it means more broadly, in the larger world outside of cultural institutions. Is the myth of neutrality something that is extant everywhere? Can we get to the bottom of "the neutral"?

To start, what does it mean with respect to journalism? In the age of "fake news" and Trumpism, maybe this is a way of understanding our realities. And here writer and critic Rebecca Solnit's thoughts are helpful: "We tend to treat people on the fringe as ideologues and those in the center as neutral, as though the decision not to own a car is political and the decision to own one is not, as though to support a war is neutral and to oppose it is not."[1]

Further, when she and I talked in 2018 as I was beginning research for this book, she told me: "My best journalism professor was Ben Bagdikian, ombudsman for the *Washington Post* during Watergate and the Pentagon Papers. He had this wonderful line: 'You can't be objective, but you can be fair.' That came just before my immersion in postmodernism, in which there is no neutral position. Bagdikian's approach had a huge influence on me, because in journalism, you do pretend to be neutral, like God. And we're not God and God isn't neutral either. Neither are the goddesses . . . Fairness and accuracy and honesty are about disclosing where you stand, rather than pretending that you don't have a horse in the race."[2]

A staunch leader in this battle to make the problematics of neutrality visible is La Tanya Autry, a cultural organizer in the

visual arts, who is also a curator and art historian. In 2017, she and Mike Murawski (another art worker and author who until recently held an institutional position as director of learning at the Portland Museum of Art) started a nonprofit organization #MuseumsAreNotNeutral to put a fine point on the fact that museums are politically, socially, and economically constructed spaces and therefore cannot be neutral.[3] Not only does Autry write regularly on this subject, but she has amassed an invaluable bibliography of resources publicly available as a Google doc on Autry's website Art Stuff Matters, and she and Murawski also sell a #MuseumsAreNotNeutral T-shirt, which unites like-minded art workers; as of August 2020 they had sold over 2,000 shirts, generating over $20,000 in donations to social justice causes.

The first time Autry and I met to discuss the subject, she said something potent: "I always go back to reading Dr. King's 'Letter from Birmingham Jail' in which he talks about white moderates as the group most obstructive to racial justice during the civil rights era . . . rhetoric like 'Oh, go slow. You're pushing too fast . . .' is directly parallel to the ways attempts to make change [within cultural spaces as well as in society in general] today say 'Don't be an activist. Don't be a protestor.'"[4] This corollary is particularly exasperating given that Dr. King's words were written more than a half century ago, in 1963.

On another register that relates more specifically to institutional rejections of the impossibility of neutrality, Robert Jensen, in his essay "The Myth of the Neutral Professional," writes:

> There are issues that can occur if the notion of neutrality in memory institutions does not continually get challenged. For instance, if a memory institution is perceived as being neutral, then actions like adding First Nations stories of oppression to the collection to rectify past imbalances of perspectives can be framed as not an action of balance, but rather a political act.

This could lead memory institutions to avoid necessary actions because they are "risky" and they do not want to be political.[5]

In a society of white-supremacist, capitalist hetero-patriarchy, in institutions of white, Western primacy, any actively decolonial, pro-Black, pro-Latinx, pro-immigrant, pro–working class, pro-trans, pro-queer, pro-disabled, pro-family (by all definitions), and self-reflective feminist positions, are regarded as political by default. They are perceived as aggressive, defiant, a challenge to the status quo, rather than as facets of reality that are coequal to the dominant story. Even recognition of the presence of an alternative to the dominant becomes an adversarial act, a challenge for that very dominance.

As I was formulating a working web of definitions of neutrality, writer, poet, artist, and cultural critic Wayne Koestenbaum recommended that I read Roland Barthes's annotated lectures delivered as a course at the Collège de France in 1977 and 1978 on "The Neutral." I immediately got a copy. Koestenbaum, via Barthes, challenged me to think of the neutral as another type of space, one that has infinite flexibility; a dimension where meaning remains elastic and full of possibility. Sleep, silence, and tact are all examples of stances that embody this neutrality—and they are indeed full of potential. This vein of thinking runs in direct contradiction to my own sense that a neutral condition is quite literally impossible to achieve. I struggled through the chapters until I came to Barthes's description of his shopping spree for colored inks. He writes:

> I go out to buy some paints (Sennelier inks) ⇨ bottles of pigment: following my taste for the names (golden yellow, sky blue, brilliant green, purple, sun yellow, cartham pink—a rather intense pink), I buy sixteen bottles. In putting them away, I knock one over: in sponging up, I make a new mess: little domestic complications . . . And now, I am going to give you the official name of the spilled color, a name printed on

the small bottle . . . it was the color called Neutral . . . Well I was both punished and disappointed: punished because Neutral spatters and stains (it's a type of dull gray-black); disappointed because Neutral is a color like the others, and for sale (therefore Neutral is not unmarketable): the unclassifiable is classified ⇨ all the more reason for us to back to discourse, which, at least, cannot say what the Neutral is.[6]

Even in his attempt to keep the neutral empty and full of potential, it becomes a color, an ink that can be spilled, that can make a mess. It seems the neutral isn't nothing; it is something, after all. Barthes insists on it as a space of possibility, an idea I wish was true in the context of the museum. But history and daily experience get in the way.

Later in the same chapter, another moment: this time the neutral stands in for possibility. Barthes wants neutrality to be a space before meaning, anticipating meaning and perhaps even prefiguring other realities: "This integrally and almost exhaustively nuanced space is the shimmer . . . the Neutral is the shimmer: that whose aspect, perhaps whose meaning, is subtly modified *according to the angle of the subject's gaze*."[7]

And so, what is the "angle of the subject's gaze"? Is it our positionality? The ways we approach the neutral? The ways in which meaning is inflected by our own histories, traumas, experiences, and identities? No matter how much one insists on a "pre-discursive" space, these elements of ourselves are not dissolvable, immaterial, or vacant. Even as babes we have our ancestors' experiences embedded in our DNA. Black studies scholar Christina Sharpe's brilliant book *In the Wake* elegantly weaves her critical theories with the ways in which chattel slavery and the realities of forced migrations across the Middle Passage are epigenetically passed to descendants, whose bodies and minds entwine with their genes every day. She writes, quoting Michel-Rolph Trouillot: "In the wake, the past that is not past reappears, always to rupture the present. The Past—or,

more accurately, pastness—is a position. Thus, in no way can we identify the past as past."[8] This isn't bad or good, it just is. It demands recognition. It means something. And it makes it harder to imagine something before meaning. She goes on to say the following of descendants of formerly enslaved Black Americans:

> Despite knowing otherwise, we are often disciplined into thinking through and along lines that reinscribe our own annihilation, reinforcing and reproducing what Sylvia Wynter has called our "narratively condemned status." We must become undisciplined. The work we do requires new modes and methods of research and teaching; new ways of entering and leaving the archives of slavery ... I've been thinking of this gathering, this collecting and reading toward a new analytic, as the wake and wake work ... I am interested in how we imagine ways of knowing that past, in excess of the fictions of the archive, but not only that. I am interested too in the ways we recognize the many manifestations of that fiction and that excess, that past not yet past, in the present."[9]

If imagining the ways histories are known, and how this impacts the present and future, then it matters from what position those histories are written or passed on; they are inherently biased. And the alternate narrative threads that Sharpe suggests taking up might contradict, undermine, and rebel against those that are currently imagined, making the present and the future a far more generous and generative space.

Let's look at neutrality from yet another perspective, that of international relations. Curator and senior director of the Vera List Center for Art and Politics Carin Kuoni, who is Swiss, told me about a diplomat friend of hers. She relayed the ways in which diplomats sometimes create "neutral" spaces in order to bring two parties together. Take, for example, two nations in conflict about trade negotiations or a border issue. Sometimes, bringing

them to Geneva, to a room in a third space, creates the possibility for the two parties to achieve a checklist of agreed-upon resolutions. Even if they are nonbinding, even if they are never adopted or even voted upon in their home nations, these resolutions exist as a type of goal, or aspiration for the end of the conflict; they thus perform a useful function as a possible future.

The example of a diplomatic resolution is interesting to me, in part, because it shifts the idea of the neutral from a preexisting condition to one of future potential. In this case, both parties in the conflict believed, to some extent, that the space being created in Geneva was neutral, to the point that it could contain their conflict without favoring either party. For this specific purpose, it might not have mattered that in spite of its rhetoric, Switzerland's neutrality, particularly in European conflicts, has historically often resulted in the perpetuation of the status quo. As long as this specific space, at a particular moment in time, could be neutral to the parties in conflict, it could work.[10]

But this takes some imagination.

Ram Manikkalingam is the director of Dialogue Advisory Group (DAG), which he founded after working at the United Nations. While the UN certainly is a forum for the resolution of some forms of international conflict, Manikkalingam felt that in situations concerning violence, and particularly in circumstances of significant power imbalances between the factions, the UN could not go far enough. Their position in attempting an "unbiased" position in co-representing hundreds of nations simply didn't allow the necessary flexibility. He wrote to me:

[DAG tries] to ask how we get to a decent solution and whether our initial efforts contribute to such a solution or not. We also have a practical humanitarian ethic where we say that generally reducing violence helps the weaker side and of course also helps ordinary people who are more likely to suffer from it than the wealthy. We do not take a moral stand on violence. We are not pacifists. And we understand that certain actors

will resort to violence to achieve their goals. But they [could] come to us when they get stuck in their violent political project and are looking for means to get out of it.

We also make a distinction between judging and understanding. So unlike Human Rights activists whose job is to judge a situation and condemn the bad guys, our job is to understand motivations and use them to push people towards better behavior. We are quite comfortable working more with one side than another. And that does not imply our affinity for a particular side, but simply our understanding where we would have the most impact. And we are quite comfortable with being tainted with a particular side. For example, in Spain we were attacked by the right wing for being too close to the ETA – the Basque separatist group – and in a way we were because our job was to build trust to disarm them. In Libya we were being attacked for being too close to the Islamist armed groups in Tripoli – and we were because they were the groups no one was engaging with. But it does not necessarily come from any feeling that those groups are the underdogs or that justice is on their side. It is simply a practical matter. They have power, and need to be involved in any sustainable solution.[11]

Manikkalingam brings up the ways in which unequal power relationships create circumstances that demand non-neutrality. It is fascinating to me that this is the guiding principle to their engagement with a crisis or a violent situation. They are building trust and engagement with the less powerful side in order to make dialogue even possible. It isn't about "equal" footing, but rather placing a thumb on the scale to do the necessary groundwork to even attempt communication.

"It is simply a practical matter. They have power, and need to be involved in any sustainable solution."

The artist Jeanne van Heeswijk thinks particularly compellingly about, in her language, the space of the Not Yet.[12] For her, and

for me as well, the Not Yet is a collectively imagined future. Van Heeswijk and I have discussed this at length, particularly during her exhibition at BAK in Utrecht, that I co-organized with her and an extraordinary cohort of collaborators. She talks about "training for the not yet" or "practicing the not yet." What does this look like? It is that which we imagine doing together—something that requires we put our subjectivity, our individual desires and selves, at risk. In such an imaginary, we do not abandon individuality, but create a space to enact it with one another in the shared task of finding common ground. It might even mean losing what we think to be important, in order to sit in a space of togetherness. Is it worth taking these risks to together if it means we might locate the common? Can we cocreate a space that is generous enough for nonhomogeneous, even fractured, activities and personas? Can we make space, in fact, for the emergence of conflict? To actually be "in the wake" together, to acknowledge the violence of the past and present, and what this necessitates of the future? Can we learn to listen closely enough that we can hear what others might need and adapt accordingly? Can we withhold our desire to share ideas and ideals long enough to allow entry to others, in order to, in van Heeswijk's words, "understand what might emerge from the fact that all these differences are there together"? It likely means sitting in this space of openness and nonresolution for longer than we are accustomed. We must hold off on declarations of victory, avoid pronunciations of success! It goes against so many ingrained instincts, but to access this space of the not yet, we must not foreclose its possibility. So we postpone. We atomize, we confront one another and vacillate, and hold firm in this ambiguity. In this struggle, can we hope to be the spilled inks, in Barthes's image, that mingle together? A space of potential?

Every day we negotiate with ourselves to navigate the world in its joy and pain and boredom. Maybe we let ourselves be misunderstood and become more comfortable with unresolved

communication. After all, we likely fail to communicate through language, voice, gesture, and touch more often than we succeed. So what does this mean for the neutral? Could it perhaps be imagined as a space of possibility that can hold multiple positions simultaneously, rather than evoking the values and ideals of one particular group or position? I'm particularly thinking of artist Chlöe Bass's assessment of her own positionality:

> I'm an observer. This is not a neutral position by any stretch (again: there is no neutral position). But my hope is that I can look toward most intimate situations as a way of formulating frameworks for thinking through a thing, rather than quickly forming positions about them. My activism is getting people to see, understand, communicate, and remember, all in the service of how we can live better together. The most important aspect of my position is to remain accountable to the ways in which my own current vision, past experience, and future hopes work in service of what I preach, and to start a difficult reconciliation and evaluation process with myself if, or when, they don't. I question why anyone would need the advice of a therapist who's unable to assess her own life with some measure of rigor or clarity.[13]

A call for a public cultural sphere—one that centers equity and imagination, our collective and individual humanity in all its complexity, and invites the polis to struggle together to see and hear one another—is a dream. There is a very real need for this kind of public space today, and because the cultural sphere is where I spend a lot of my time, I hope there is a way for us to enact it. This isn't about institutions versus publics. We are both. We can reclaim our space.

6

Going Forward

Neutrality is a veil that conceals the ways in which power is wielded and maintained, making its workings invisible; it is "just the way things are." This is the status quo that requires resistance. And just as various groups and individuals work to unveil this myth of neutrality, we all must also *see* the public's role in our "public institutions"; we all must recognize that the public is powerful, even in the context of late capitalism, when power seems ever more concentrated in the hands of a few. We must forge ahead, engaging in a far more inclusive conversation about what our collective desires are for cultural and civic spaces, how these might be enacted in myriad ways throughout a diverse ecology of museums, and what this might mean for public support in all its forms.

In light of the examples and considerations outlined in previous chapters, the need to undo and redo our cultural spaces becomes both clear and even urgent, and each institution will need to interpret and craft its role in these changes according to a variety of signposts. In so doing, they can help to cultivate care for society and culture, in all its exquisite difference, divergence, and oddity. It is necessary to make these changes now, in the present, in ways that reject the relegation of all potential healing to a possible or unachievable future, but rather begin to embody this future now. We need to:

1) collectively imagine a path toward (re-)making the spaces we want to experience;

2) reexamine the structures that uphold museums, from governance and fiduciary commitments, to programmatic and staffing structures, toward different ways of working;

3) consider the reality that art and museums already shape (and are shaped by) society, and acknowledge that by shifting the ways culture works, society can shift as well; and

4) recognize that if we desire a cultural commons that supports a complex, vibrant populace, we have to engage that populace in culture and the structures that enable it.

But how do we get there?

I do not have the whole answer. If I did, it would certainly be the wrong answer because while I have a lot of experience in this field, this experience is mine alone, and while others might share aspects of it, we must intentionally go beyond the "insiders" to make this enterprise successful. I have been fortunate to have spent hours talking and arguing with many artists and thinkers with jubilant and radical practices, some of which may help us find the way.

Among the first steps is to connect a variety of networks that already exist with one another so that we frame the questions differently. The people who work inside institutions are pushed to the breaking point as it stands, with understaffing prevalent amidst an unrelenting pace of new programming, so to make this collective imagination viable, we need to radically slow down. Recalibration of the sources of funds for cultural spaces is essential; in particular, we must ensure that public funds balance private philanthropy. We need to identify the various people who must be part of this conversation, both internally and externally. The work must be done collectively, bottom up, but at the same time we must connect meaningfully with allies and coconspirators at the "top" who can help marshal the resources necessary to implement from the bottom-up the strategies and ideas that have been proven to work. Thus, we must engage in a process in which we both agree and do not agree, one that engenders a

productive agonism, shifting from ideas of the *what* to ones of the *how*. In political theorist Chantal Mouffe's words, we can

> find ways to use [cultural institutions] to foster political forms of identification and make existing conflicts productive. By staging a confrontation between conflicting positions, museums and art institutions could make a decisive contribution to the proliferation of new public spaces open to agonistic forms of participation where radical democratic alternatives to neoliberalism could, once again, be imagined and cultivated.[1]

In other words, we need to imagine our desires together.

In 2019 I embarked upon an experiment to do some of this work through a partnership with the Brooklyn Public Library (BPL) and *Hyperallergic* called the Art and Society Census, launching in December 2020 and ongoing through the spring of 2021. The Census gathers as broad a public as possible to address several key questions about what people desire from cultural institutions and experiences. The questionnaire is broadly framed with questions like: Describe a cultural experience that got under your skin. (What made it important to you?); What do you desire from culture that you don't see happening? (Who's in the audience, what art form is presented? Who chose it? Is it unexpected, or did you plan to see it? Is it in a public space? Is it family friendly, or just for grown-ups? Free, close to home, or somewhere unfamiliar?). These are the general parameters of the questions; they have been fine-tuned and tested by the breadth of staff at the Brooklyn Public Library, from librarians to volunteers, and have been distributed via more than sixty BPL branches throughout Brooklyn, via the library's connections to Brooklyn's public schools, and via the online arts magazine *Hyperallergic*'s networks, and via the City of New York's Cultural Affairs Department. It is centrally important that not only culture insiders but the people of New York are invited to participate in this discussion, on their own terms. We

hope to receive thousands of answers, which we will sort, tabulate, and analyze, reviewing the results with a working group comprising BPL staff and members of the public. Next, there will be a series of public discussions and workshops, each addressing the central issues raised via the questionnaires, intentionally centering the voices of the respondents rather than those of the experts inside cultural institutions. This is an important first step toward the development of a conversation about culture that is, at minimum, borough wide. We want to see what unfolds: what is desired, how a broad public envisions cultural institutions and their offerings, what they love or hate about them, what they desire most. In some senses, actually hearing and seeing these desires is the very first step in making recommendations for shifts, not only in the programmatic approaches cultural spaces might take, but also in the ways in which they engage with their publics and, quite literally, how they function.

The Census also has a very practical aim. In 2021, New York City's primaries for both Mayoral and City Council races will be moved to June. We hope the recommendations and proposals suggested through the working groups might provide a scaffolding for arts policy that can be delivered to the winners of the primary in advance of the election. It is within this period that we can influence the thinking of the candidates for public office with a bottom-up set of desires produced by their constituents.

The Art and Society Census is partially inspired by artists Maia Chao and Josephine Devanbu, who launched the pilot of an ingenious project that approaches questions of who participates in museum culture, called Look at Art. Get Paid. (LAAGP). Begun in 2016 at the Rhode Island School of Design (RISD) Museum, the initiative is a socially engaged art project that pays people who wouldn't otherwise visit art museums to visit one as guest critics of the art *and* the institution, flipping the script between the institution and its public, the educator and the educated, the paying and the paid. As of the fall of 2019, they were also in the planning phases to expand this pilot

program from the RISD Museum to additional museums in Massachusetts.

Most intriguing about this project at the RISD Museum is its direct approach: to ask people what they think, to do so ethically by paying people for their time, and to take seriously what museums can learn from people outside the field. It fundamentally reverses a dynamic that is so stubbornly baked into museum methodology, namely the museum's commitment to a constant broadcast of information, facts, ideas, and content that the public may or may not desire to absorb. All of this pushing out of information leaves little room for publics to contribute to the museum from their experiences and know-ledges; and importantly, it vastly reduces any chance for the exchange of information or ideas. In reversing this dynamic, LAAGP helps identify the real, and sometimes unexpected, stumbling blocks to visitor access and engagement at the RISD Museum. Among the project's first priorities was to center people of color living in the museum's home of Providence, Rhode Island, given the whiteness of the institution with which they were partnered.

LAAGP's findings are largely related to representation, language access, and alienation, as manifested on multiple levels. As Chao and Debanvu told me:

> There was a general feeling amongst critics that the museum is "addressing a certain kind of person"—namely white people and people with money. Throughout our conversations, the topic of belonging featured prominently, and one critic said, "maybe this place isn't for me." Another critic articulated that they just didn't feel like they had "bandwidth for another white space." When discussing what changes the critics would like to see, most agreed the museum would have to better represent POC [people of color] in their collection, improve language accessibility, advertise in their neighborhoods, and make the experience less intimidating ... Critiques were wide-ranging,

but many critics discussed the lack of effective signage; the silence and stillness of the galleries; their desire to touch the art; the arbitrary and stiff social codes for looking at art; their general discomfort in the space; and their acute awareness of being surveilled . . . Representation was a major area of concern for guest critics . . . Language issues came in really strong.[2]

Some critics made specific programmatic suggestions, such as museum-hosted community cookouts; a sign maker suggested he could help with their signage issues. LAAGP used these suggestions to facilitate their ultimate goal, which isn't to convert people into museumgoers but rather *to provide entry points for those who wish to participate*. These critics are now working with local artists to implement their suggestions at the RISD Museum.

One of the most striking comments they relayed came from critic Samanda Martínez, who said, "Están cuidando más a las imágenes que a nosotros. [They're taking better care of the paintings than they are of us.]" For any museum professional, this is a heartbreaking statement, particularly if it was said of their institution, and one that might motivate real change. Ms. Martínez, along with the other guest critics, noted how the security and cameras denoted the value of what was held in the museum, but also inferred that this indicated it might need protection from them; some noted the lack of other "inner city" visitors and artists of color among the work on view, or the lack of Spanish language labels, guides, or advertisements in their neighborhoods. Alongside this was the perception that the museum welcomes publics who already know its protocols— how to dress, enter, and act inside the museum—but that it doesn't necessarily try to make the space more comfortable for those who don't.[3] The reality, LAAGP points out, is that most museums and cultural organizations are aware of these barriers to entry, but that efforts to resolve them are typically not

institutional priorities; rather, they are left at the bottom of to-do lists by overwhelmed, disheartened, and/or unmotivated and uninterested staff. The hope is that the kind of personal feedback provided by these guest critics can personalize such alienation, to the extent that it inspires substantive change. The very people who make up the institutions under critique know the barriers to entry. This, paired with the fact that they might have an idea of how to address these barriers but also need the direct engagement with their publics to do so, is an essential reality.

What appeals to me about the approach of LAAGP, and the Art and Society Census, is, on one hand, that there exist obvious, simple solutions that might be identified by actually asking direct questions to publics. But, on the other, I am also fascinated by how those answers might shift the approaches museum directors, administrators, programmers, and curators take in imagining their work. I'm not particularly interested in the premise that museums should directly implement programmatic ideas via crowdsourcing (although I'm certainly open to great ideas emerging from that process). Rather, I believe that museum workers and artists can be inspired by the information and perspectives expressed through such projects to allow whole new worlds to open up that address the entire experience of entering the museum.

These are only a handful of examples of how care can be enacted in cultural space. One other that I want to highlight is the Vancouver-based Open Access Foundation for Art & Culture (OAFAC) which artist Carmen Papallia, one of the organization's founders, told me is creating "new cultural standard[s] for accessibility by nurturing creative and justice-oriented accessibility practices." They do this through a variety of programs and initiatives that set out specific protocols, and pedagogical approaches that center access and the specific needs of disabled people. They work in collaboration with cultural organizations of all sizes, driven by an advisory committee that comprises an

"intergenerational, cross-disability group of artists, activists, and cultural workers that meet around the topic of accessibility and meaningful inclusion from diverse backgrounds and experiences." The resulting projects, like taking accessibility "best practices" and applying them structurally throughout organizations, are necessarily intersectional in their application, and go far beyond typical accessibility protocols.[4] I look forward to hearing more about their burgeoning work.

From an institutional perspective, I firmly believe that *the single most important and impactful way to make changes is to radically slow down*. The pace of cultural production is simply too fast. We have to ask ourselves: How many exhibitions are truly necessary or even desirable in a single year? How many public programs? More is sometimes just more, and not better. Already-thin human resources are stretched beyond their capacities to function at the speed with which cultural organizations install new exhibitions, invent new projects and plan events, talks, performances, and so on. How do we do all of these things better? Not just faster, not just more, but better and deeper?

Slowing down is crucial because it allows us to take more time to make important decisions. In so doing, we engage more people in the process: it allows us to liaise with more staff members, talk to additional stakeholders, do more of the work that would make cultural space more inclusive.

Take for example the situation in which the Walker Art Center and Sam Durant found themselves during the installation of *Scaffold* (described in chapter 2), just before the reopening of the center's Sculpture Park in downtown Minneapolis. Imagine that prior to the acquisition of the work there had been more *time* to think through questions about which people in the larger public might have a particular stake in the piece, in its conceptual and historical reference points and its possible readings. Who would be particularly interested in these ideas?

Conversations with Dakota people could have taken place to contemplate the questions posed by the artwork prior to its installation and, indeed, perhaps prior to its acquisition by the museum.

Imagine further that the time had been taken to cultivate Indigenous voices in the first place, in recognition of the fact that the Walker sits on unceded Dakota land. Imagine that those conversations created conditions of a willingness to engage, if not trust. Rather than another committee to meet with or box to tick, this scenario could establish entirely different processes of decision making. Imagine the personal, emotional, financial, institutional impact investment in such decisions and processes might produce, and how programming around the work could flow from there. Given how it transpired in real life, I'd wager that many of the people involved in the aftermath would have been deeply interested in an alternative process—even if they came to the conclusion that this wasn't the right artwork for the Walker. That surely would have been preferable to the pain (and mess) of the actual events.

Imagine, too, if conversations took place at the board level about the acquisition of such a work, including Indigenous elders who served on the board itself. Imagine paying those elders for their time and expertise, like corporate boards do their board directors. The occasions on which philanthropists and community members of all kinds could learn together would multiply. Imagine how the direction of the institution might shift if board members represented all different kinds of interests and held positions of power not by dint of the funds they were able to contribute, but on account of their expertise and community roles. Perhaps those making such contributions would be even more interested in attending meetings, and in learning other ways of imagining what it is to be a fiduciary, or of determining what the qualifications are for a "good" board member. The tenor of these questions would shift by virtue of expanded and recalibrated participation. The people who would be interested

in donating the time or money required to be involved on such a board might evolve.

I am highly influenced by artist Simone Leigh's *Free People's Medical Clinic* (2014), which proposed, on many registers of medicinal and restorative practice, that critical theory, alongside gathering in an intentional space, could be medicine, could be curative. Her project was produced by arts organization Creative Time[5] and the Weeksville Heritage Center, a museum in Brooklyn that commemorates one of America's first free Black communities. Leigh converted the former home of Dr. Josephine English—the first African American woman licensed to practice gynecology and obstetrics in New York State, who delivered all of Betty Shabazz and Malcolm X's children—into a temporary clinic. Borrowing the name of her project from the Black Panther Party's efforts to foster community healthcare, Leigh celebrated under-recognized and unseen Black healers, including the United Order of Tents, a secret society of Black women founded during the US Civil War. The project materialized a desire to provide care in the form of acupuncture, yoga, massage, and other restorative practices, but it also offered practical workshops (such as Navigating the Affordable Care Act and HIV Screening), classes with joy-inducing potential (including a Black Folk Dance class), and community-specific activities (like Black Magic, which was limited to Queer/Trans audiences).[6] Subsequent to this project, during an exhibition and residency at the New Museum, Leigh devised *The Waiting Room* (2016), in which she continued to address Black subjectivity by offering the opportunity to a newly formed group, Black Women Artists for Black Lives Matter. BWA for BLM used the space to manifest performances and discussions in the wake of the intensity of anti-Black violence in the United States, particularly as it was manifested in 2015. These ways of thoughtfully navigating needs, desires, care, and celebration within a cultural space are deeply inspiring, and map potentialities not only for radical inclusion, but also for the ways in which transformation might

require, at key junctures, the exclusion of the dominant culture to achieve a restorative condition.

I close this chapter with some reflections on the ideas of Dutch artist Jonas Staal, which I hope will be as useful to you as they are to me. An interest in assemblies and gatherings is central to his work, from the *New World Summit* (2012), a series of conferences planned in various geographies to gather stateless and marginalized peoples (some of whom are considered "terrorists" for their beleaguered relationships to their own states), to his work in building an actual public parliament building with the Syrian revolution in Rojava. Indeed, there are many intriguing aspects to this artist's practice. However, it is his work on propaganda I want to highlight here. In his 2019 book *Propaganda Art in the Twenty-First Century*, he lays out how propaganda has been used over time to consolidate power and wealth for the gain of a few. Staal's provocative proposition is that we consider how, via a multitude of creative processes, we might imagine (and perhaps invent) a propaganda that is fundamentally committed to equity and mutual liberation. What might that look like?

Staal argues that a reengagement in studies of propaganda and propaganda art would help us reveal the covert propagandas that remain invisible to us, such as the manifestations of the myth of neutrality within cultural spaces described in this book. He makes a compelling case that propaganda today serves as a crucial tool to engage in "hybrid, conflictual, and transform-ative" practices that open "categories of belonging and identity that bypass the capitalist and patriarchal state as the hegemony of identity formation." He further writes:

Reactivating propaganda and propaganda art studies can be only one part of the answer to our present-day crises, conflicts, and deepening precarity. Yes, we need to understand who authors our world in our name, but we also need to gain

control over the means of production through which our realities are constructed in order to make new ones . . . Understanding that a master narrative is false does not stop it from having effect. It demands a new master narrative of our own: a story about where we come from, who we are, and who we can become.[7]

I participated in one of Staal's manifestations of "who we can become" in late November 2016—a time when the realities of Donald Trump's presidential victory were setting in, and when the revolution in Rojava seemed so full of possibility. Rojava, now often called the Democratic Federation for Northern Syria, is an experiment in radically inclusive, participatory, equity-based, democracy, which began in 2013 in an attempt to consolidate Kurds, Christians, Arabs, and other minorities against Bashar al-Assad's regime and the Islamic State.[8] In support of this burgeoning autonomous zone, for two days in 2016, Staal and his studio convened Temporary Embassy for Rojava inside the ornate city hall of Oslo, Norway. It was, as Stall said, "a stateless embassy for a stateless democracy: aiming to contribute to a transdemocratic politics beyond the traditional boundaries of the nation-state."[9] We sat within a perforated domed structure built of a plywood lattice and brightly colored flags, invited by Staal and co-ambassadors Asya Abdullah (co-chair of the Democratic Union Party, PYD), Sînem Mohammed (European representative of the Democratic Self-Administration of Rojava, DSA), Salih Muslim (co-chair of the PYD), Bassam Said Ishak (President of the Syrian National Council, SNC), and Aldar Xalîl (executive council member of the Movement for a Democratic Society, TEV-DEM). They presided over presentations held at a circular table at the center of the pavilion, ranging from practical discussions on participatory democracy to cultural policy and imagination. Staal's project was an attempt to make real and tangible the collective desires of those assembled: indeed, it entailed the physical

construction of a temporary political body of an unrecognized state (*within* a civic building of an internationally recognized state, no less), in which Rojavan revolutionaries engaged in radical self-governance, could connect with thinkers and imaginers of all stripes. Beyond the physical site and formal presentations, the time spent in common and the resulting discussions—in various languages, across difference, over shared meals, amid dancing and late nights—brought us together to prove to ourselves that we could exist in a different world, and perhaps even make it together.

This is what cultural space can do and be; it can become a location, a scaffold to explore the potential of such ideas and how diverse publics might participate in the reimagination of who, what, and how contemporary society functions, how it treats its members, and how and what it creates and destroys. Artistic production can help us make sense of it all. This historical moment demands museums and cultural space actively participate in the change so necessary to create a more equitable world. Once again, museums are not neutral.

7

Liberation Serif

We all grow up and inherit a certain vocabulary. We then have got to examine this vocabulary.

—Hannah Arendt

On June 10, 2020, I opened a new document to begin writing and the default font was Liberation Serif. It isn't a font I'd ever encountered before, but if the word processing ghosts had signed up for the revolution, who was I to interfere? Indeed, liberation is a demand of protestors on the streets, of those of us within organizations, and of so many in between who seek to shift the culture into more equitable realms. The depth of organizing and breadth of engagement gives me hope. This is the first moment in my lifetime that I feel there is truly a space to make the radical change society so desperately needs.

The widespread arrival of the COVID-19 virus to the United States in the early weeks of 2020 has brought a great deal into high relief: it has cast new light on the primary relationships in our collective lives, as well as the ills of inequity that separate, with an enormous and increasing gulf, those who are well and those who are sick, those who can work from home and those who cannot, those who can retreat and those who must venture forth, those who live and those who die. These realities are stark, unfair, and driven by late capitalism, white supremacy, colonialism, cis-heteropatriarchy, and discrimination of every variety. They also belie the connectivity and interdependence inherent in the globalized world—an interdependence that the virus's emergence has so dramatized.

On May 25, George Floyd was murdered by the Minneapolis Police Department. Floyd, along with Breonna Taylor, Ahmaud Arbery, Tony McDade, David McAtee, and too many others before them and since, were cut down by white supremacy in the form of a militarized police force that has been out of control for decades, in a country that has dedicated centuries to the ever-evolving systemic oppression of Black and Brown people. And this toxicity is not limited to the deaths of these individuals, and the suffering of their families and communities; it is also poison to the culture that is killing itself by perpetrating such egregious harm.

I hadn't slept soundly since the pandemic began. While daytime was devoted to everything from supporting my son's schooling to laundry and housework, to museum problem-solving and Zoom meetings (I had agreed to serve as the interim director of the Leslie-Lohman Museum of Art a few days after New York went into quarantine in March 2020). Midnight to 3 a.m. was anxiety's witching hour. My friend, artist, healer, and performer Wendell Cooper employs a visualization that is one of the few things that helped clear my flighty mind and move me toward sleep. It goes something like this:

Imagine an emotion or a sensibility that you would like to embody, like peace, or calm, or joy. Imagine that sensibility as a fine golden mist, filling the room, glittering in the sunlight. Breathe deeply, inviting this vapor into your lungs to permeate your body. Imagine it traveling through your sinuses and into the flesh of your cheeks and bones of your jaw, up into the spaces between your skull and brain, down your throat and neck, into your chest and belly, traversing your collarbones over the curve of your shoulders, into your arms and elbow joints, wrists, and fingers, permeating not only muscles and tendons and other soft tissue, but your very bones. The shimmering mist flows down your back in a cascade over your

hips, coiling into your pelvis. It flows into your legs, knees, and eddies into your feet and toes. You are filled, through the breath and the vapor, with the attribute you desired. It is you.

This meditation usually brings sleep and rest to my addled brain and nervous system. I also recognize, with some horror, the ways it mirrors viral transmission, at least to my medically untrained self. The breath, essential to life, also brings COVID-19 into our bodies; the lungs are often the site it hits hardest, wreaking havoc for weeks and perhaps permanently. If only we could stop breathing we could stop the spread.

The breath of life, then, no matter where we live or how, is undoubtedly what connects us, and the pandemic allows us to see how the necessity of breath makes us interdependent. My exhale becomes your inhale and vice versa. And yet all breath and all life does not matter equally on this planet. And society reflects this reality, including cultural spaces and museums. Given the access and power I have within the cultural realm, this is my chosen space to make change, with the hope that these efforts not only take root, but that they also might provide a model for the ways in which such change can occur on broader societal scales.

When the body I inhabit with daily un-self-awareness becomes vulnerable (or perhaps when I simply see its vulnerability in greater focus), the strange textures and materials of what I am made of are overwhelming. Months ago I saw an image of a scan of lungs infected with COVID-19, a miasma of deep purple signaling the intensity of damage to this essential tissue. Compared with a flu patient's lavender tinges, and a completely healthy, not-purple set of lungs, the infected pair were ravaged in violet, insistent, and un-abating. The color, dangerously dense in some areas, threatens death and spread. These images have stuck in my brain, invading other thoughts. Breath is also what was robbed from George Floyd. He was pinned to the ground for an endless seven minutes and forty-six seconds as

police officer Derek Chauvin pushed his knee into his neck, in broad daylight, violently taking his life. "I can't breathe" is a refrain of horror that has been urgently uttered both by the victims of COVID-19 and by Black people including Eric Garner, George Floyd, and innumerable others, as they are choked to death by police. Black people have been subjected to the asphyxiation of lynching in all its forms, historical and contemporary, for too long. "I can't breathe" has also become a rallying cry in protests and on banners calling for justice. Further, the demographics of victims of COVID-19 replicate the injustice in the disproportional death of Black people from the disease. Breath, one of the most basic involuntary functions of the human body to keep it alive, is being taken away from Black people at intolerable rates. Police action across the United States, and the structural circumstances that lead to disproportionately high numbers of Black death due to COVID-19, tell us that it does not matter. And yet it does matter.

We all hold power, no matter our position in society or within the organizations in which we work. It is how we use these spaces that matters. Do we consider our interdependence as a primary motivation of how we operate, or does it come from a space of individual ideology? Indeed, it is up to us to determine what type of atmosphere we produce, as interconnected and interdependent individuals, as communities, and collectively as humans.

So in this moment of pandemic and uprisings, amid the upheaval and disruption in nearly all aspects of daily life, even as the cruelty of the systems of power in place are made more evident, the rules have the potential to be undone and redone. Whether they will produce an intensification of the violence of our present reality, or a more just one, is up for grabs. On good days, I think the latter is within grasp; on bad days, I see the shadowy, persistent creep of the former. I am certain that if society is to become more equitable, it will require our collective desire and creativity. It will also take vigilance to locate the new

forms white supremacy might take; it took too many years for people to begin to see the ways in which the brutalities of Jim Crow were inscribed within the criminal justice system in the United States. In response to the extraordinary and unrelenting expressions of solidarity across the nation, some changes are underway today, for instance the Minneapolis City Council's plan to dismantle the city's police department and remake it,[1] or various localities' proposed budget cuts to police departments,[2] or even New York State's abolition of the law that shielded from public scrutiny officers who had been subjected to disciplinary measures for misconduct.[3] A few of these changes represent profound shifts, yet too many are reactive reforms that don't go nearly far enough. For what it is worth, protests have even inspired Warren Kanders, the former board member of the Whitney Museum who resigned under pressure from artists and activists, to divest his company Safariland from its tear gas division (which was used at the US-Mexico border and in Ferguson before it was deployed against Black Lives Matter protesters in 2020).[4] Even if there seems to be a de-ossification underway, we must remain vigilant.

Museums and cultural institutions across the nation, and indeed around the globe, have issued statements expressing solidarities with the Movement for Black Lives, but this can only be a starting point, a crumb of thinking that maps to commitments large and small. It is the replication of the systems of white supremacy within culture's very structures that is at the core of the problem with any diversity, equity, and inclusion initiative, and this is a problematic that I hope is made more visible by the many important critiques of how white-led cultural institutions have approached this moment, however honorable their intentions. We cannot make change until we recognize that neutrality within culture is impossible, and then work to undo the structures that surround and protect this mythology by remaking the internal operations, governance,

and programming of museums and cultural institutions. Indeed, if one thing is clear from this transformative era, it is that the nature of our times is grounded in change, and that we must imagine the futures we desire together.

Art workers and artists alike have been making their voices heard in clear and urgent terms. Some of these reckonings are specific to a particular institution, such as A Better Guggenheim in New York, and MCAccountable (Museum of Contemporary Art Chicago); others address cities, like #ForTheCulture's "Open Letter to New York City's Cultural Institutions," or the whole field, like the Instagram account Change the Museum which logs the experiences of museum workers. While the precise accusations and demands are necessarily institutionally-specific within each of these circumstances, perhaps it is helpful to analyze the common elements in the open letters and demands to chart a path forward, beyond the individual institutions' responses (which I dearly hope are forthcoming).

Numerous demands appear time and again in open letters and other documents, and this prevalence means that such observations should be taken under consideration by all art spaces. This is not to say that organizations should be absolved of addressing the demands that have been made of their particular museum, but rather that *in addition to those*, the following compendium constitutes a starting point for wide-ranging work. I now turn to a set of issues that represent a starting point for the collective work that is underway to varying degrees at all museums and cultural institutions. These include: the public security resources contracted by museums that perpetuate racism and xenophobia; inequities in compensation and a panoply of hiring practices that must be reformed and made more transparent and accessible; the resistance to attempts to unionize; how boards recruit, operate, and govern; how museum staffs are organized and defined; how publics are engaged and imagined; and the urgency of diversity initiatives that go beyond tokenism towards

assembling a staff and board of myriad lived experiences to make all of this change real.

Before the 2020 Black Lives Matter protests began demanding the cessation of museum contracts with police departments, I had no idea these existed. It just wasn't something the institutions I worked for engaged in, but it seems to be a widespread practice across the US. Often local police are hired to provide extra security for after-hours events, space rentals, or other special events. Ending these practices seems to me a prerequisite to support anti-racism work by disengaging and divesting from organizations that have proven themselves to be patently anti-Black and xenophobic.

Human resources is another imperative zone. It doesn't sound very sexy, but from the breadth of examples, the impact is outsized; spend ten minutes reading the issues raised on the Change the Museum Instagram account and you will understand the urgency immediately. Clearly, many norms around employment practices and policies are considered "best practices" yet foster inequity.

Among the most universal calls for change revolves around pay, specifically, transparency in compensation. The differences in compensation between directors and more junior staff have been a major point of contention as, for example, according to the *New York Times*, "leaders of a half-dozen major institutions in New York received annual pay packages last year of $1 million or more, even as low-level employees earn as little as $35,000."[5] This means that many employees of New York cultural institutions receive a salary that is 3.5 percent that of their most senior boss. Further, the call for salary transparency was adroitly and tangibly illustrated by writer, independent curator, and activist Kimberly Drew. In her keynote speech at the American Alliance of Museums annual meeting in 2019, she disclosed salaries from her art world jobs: a $10,000 stipend as a fellow at Creative Time; a $30,000 per year position at the Studio Museum in Harlem; a $40,000 job at the for-profit art gallery Lehmann

Maupin; and $80,000 as social media manager at the Metropolitan Museum of Art, which was $5,000 less than her white male predecessor.[6] This reveal inspired a public Google doc that tracks the salaries of anyone willing to share.[7] Clearly compensation is an ongoing top concern among art workers, especially as the economic crisis due to the COVID-19 pandemic has deepened. To address this transparency issue a salary range should be added to all job descriptions—in many museum HR departments this would be received as a revolutionary act. Creating clarity about what a position pays before candidates apply would eliminate the wasteful pain of getting halfway through an interview process and finding there is no way you can afford to accept the job, or as an employer, that the perfect candidate cannot take a job at the rate on offer. This directness has the added advantage of creating a baseline for specific positions and would help avoid the kind of racialized pay discrepancies Drew described in her compensation at the Met.

Hiring practices in general must be revisited, particularly in terms of recruitment and retention. Even calling the cultural sphere "the art world" implies some form of membership or insider status. This is often reflected in the long-established networks, linked to both elite schooling and credentialing as well as particular social circles, that have traditionally brought staff into their positions. I'm not sure there is a comparable field in which the unpaid internship has played so pivotal a role in determining those who work within museums. Speaking personally, I needed a summer job when I finished my first year as an undergraduate and was lucky to have a professor point me toward a paid internship at the Cloisters (a separate museum that holds a portion of the Met's medieval art collections). As a white student attending Swarthmore College, a long-historied, four-year, liberal arts, private institution, I was likely deemed the sort of low-risk hire such internships were intended for, even though I didn't have any art world bona fides or connections. It was my very first museum job. And I can say without hesitation

that it opened doors. Of course, "networking" is a necessary aspect of all job hunts and careers in all fields, but there is a pernicious racial and class bias that persists in the art world.[8]

To undo these circumstances will require an understanding of the barriers to participation that museums have built over time, and undoubtedly must include the implementation of living wages for entry-level positions and the establishment of paid internships. Changing these conditions is nonnegotiable if we want to see a greater diversity of human experience among our museums' decision makers. Further, it is necessary to reach beyond current networks and plug into local queer, Black, Indigenous, immigrant, and other culturally-specific organizations that serve primarily BIPOC communities to broaden applicant pools for all levels of open positions.

A useful practice initiated by my predecessor at the Queens Museum, Tom Finkelpearl (subsequently commissioner of cultural affairs for the City of New York), is the adoption of the Rooney Rule, named for the former chairman of the NFL's Pittsburgh Steelers, Dan Rooney. Rooney noted that while the majority of professional football players were Black, coaches and team staff were invariably majority white. He sought to diversify team staff by mandating the inclusion in final interview rounds of minimum numbers of candidates from historically marginalized communities.[9] This practice forces the broadening of recruitment efforts in tangible and important ways, particularly for white-led organizations. I believe this effort is one reason that the Queens Museum continues to have a racially and ethnically diverse staff.

Unions—both their formation and attempts to stop them— have been another recent flash point. The Atlanta-based magazine *Art Papers*'s summer 2020 issue mapped an extraordinarily detailed timeline of museum employees' efforts to unionize and their status, as well as glossaries of terms and lists of unions that are central to the museum unionization wave that is washing over the United States. Personally, I find this development exciting,

as much as I recognize the complexities it brings to administration. It is an opportunity to work transparently with staff on the conditions collectively desired within workplaces. The "We're a family" assertions of cultural spaces ring hollow when pay scales are so inequitable, and access is so skewed. The "family" claim can be perceived as welcoming and inclusive, but it can also blur boundaries between workers and their managers leads to exploitation or unreasonable expectations, particularly with respect to work outside of office hours and other ways in which staff are asked to go "above and beyond." And these are exactly the types of boundaries that unions can help staff maintain.

To this end, it is bewildering to me that the New Museum in New York City did not embrace the possibility of a conversation with its staff about what unionization would look like for them as a museum. In January 2019, with a group of employees having formed a bargaining unit, they made a push to join a union. This was met with resistance by museum leadership which was materialized in the hiring of the "Kentucky-based Adams Nash Haskell & Sheridan, a firm that specializes in defeating unions, boasting on its website, 'When We Take Action, You Take Control' and promising employers a 'union-free future.'"[10] In the corporate sphere, "management" routinely resists unionization efforts because profits are at stake, and this, though unjust, is understandable in the context of the logics of capitalism, and because earning profits is the central mission of corporations. However, a museum has different priorities, and care for art and artists is only a part of its focus; the workers who realize the museum, who open its doors, clean its galleries and toilets, inform its audiences, must be able to sustain themselves, and hopefully, thrive.

How can a cultural institution be a place to offer care or support to publics if that same care can't be extended to the cultural workers who make the museum possible? Unionization, like protest, is a radical act that can make a museum better. Having an open exchange about art workers' needs and desires,

and how they align (or don't) with museum capacities, financially and otherwise, seems to me an essential part of being a space that advocates for art. And such conversations would have the added impact of bringing an understanding of the institution's financials out of the narrow realm of the board, director, and senior management.

Unions and other direct forums between staff and managers would have been helpful in a number of issues that emerged for museum staff during the COVID-19 pandemic. For example, in July 2020, many were concerned with the frontline staff at museums being put at risk by early reopening. MCAccountable, a group of employees who banded together to relay their demands to the leadership of the Museum of Contemporary Art Chicago, asked potent questions about how front-of-house staff would be put at greater risk because of the public-facing nature of their positions.[11] The dangers workers took on by commuting to their jobs via public transport, in addition to the actual work of interacting with the museum's audiences, were at issue. Given this exposure, the group argued, the MCA's reopening signaled the institution's indifference to these risks by making the "in-person access to artworks more imperative . . . than the health and safety of employees."[12]

Further, questions of pay equity, along with the pandemic's curtailment of operating hours, which led to layoffs at many museums, increased the financial precarity of these frontline positions, many of which are held by BIPOC. These issues are not unique to the MCA, a museum that has done great work, for example, in its pioneering initiative Coyote, a project to make museum websites and collections more accessible to people with low vision, or who are blind. The bigger point is that no matter what a particular institution has done (or not done) in the past, there is a great deal of work ahead that requires attention and care, particularly in these trying conditions of health crisis. It is our day-to-day interactions and vulnerabilities that are at stake, and how these vulnerabilities caused by the larger system of how

our museums operate and are governed; the inequities embedded herein must be confronted.

Internal governance, from unions to boards, is a further space for radical reconsideration. It is essential to assemble boards composed of a diversity of life experiences reflecting the multiple needs of museum work, rather than serve primarily as an acknowledgment of major giving or the potential to give. Boards always need legal and financial expertise, and they also need all manner of other competencies. This could include other museum workers, perhaps compensated, just as they might be on a for-profit board. Could we not imagine a board of skilled advisors that functions as the fiduciary and governing body, with a donor support structure that runs parallel to this? I can, and based on my experience as interim director at the Leslie-Lohman Museum of Art—where the board comprises artists and journalists, as well as well-heeled collectors, and is developing a major giving strategy in parallel to and with the leadership of the board—I know it can work. The Laundromat Project, a New York City–based public arts organization I admire greatly, recently issued an open call for board members, making public a process that is often very much controlled by insiders. What an amazing prospect to nominate a friend, or even oneself, to support a great arts organization by contributing knowledge and talents, and potentially financial resources as well.

Likewise, we ought to reconsider the singularity of the director position. It would be fascinating for institutions to experiment with a co-director or a triad directorship.[13] Rather than an explicit breakdown of tasks, such as between an executive director in charge of money and operations, and an artistic director in charge of programming, it could be a co-creative role. What if the directing of the museum was staffed as the collective endeavor it is, and accountability were shared and negotiated? Perhaps then this position could be more humane to its occupants, while also recalibrating the relationship of director to

board and staff. Indeed, we need greater ease in both. This shared arrangement would mean lower individual director salaries, as well as a greater abundance of time and space for each. Even more importantly, collective leadership strategies can engage more experiences, and greater diversity, in the very many decisions that are made daily within museums.

Recent worker demands also specifically address racism and tokenism within efforts to diversify the ranks of museums, from board and staff to the artists in the program. The urgency to take up needs and desires must come from collective information gathering efforts, like town halls or listening sessions, and be moderated by people who know what they are doing. There are real skills involved in getting a group of people with varying access to power within an institution to speak together about their needs. An assembly of stakeholders has to be defined by each institution. However, an important aspect of this conversation is *not* to ask the assembled group to resolve issues, but rather to use it as a place for the staff to work *from*; to create a place from which a map might be constructed of specific institutional needs. Some museums are large enough to create dedicated full-time positions devoted to following this work as the Met recently did. Smaller organizations need a scaffolding of ideas and objectives to work on by convening rotating task forces or committees. The Leslie Lohman Museum, for example, has created a staff committee to address these questions, plan a town hall, and make specific recommendations. Every institution starts at a different place, and the point of this work is to begin, and to create systems to sustain it.

Perhaps equally important, people will make mistakes, and we need to make room for the courage and vulnerability of real apologies, the acknowledgement of the impacts (as opposed to intentions) of the action, and the mending processes that follow. Here, especially, is where slowing down is essential; delaying an exhibition, or shifting course with respect to a particular

presentation, as in the Guston and Durant cases (even by reconsidering hard-and-fast museum policies), can have a positive result, in spite of the challenges entailed.

Of course, a museum is far more than its board, director, staff, art, and artists; its publics are its reason for being. Equity work must address how audiences are *imagined* within museums, and this is where the secret heroes of the museum story are found. The museum as a space whose purpose is to educate its audiences is a classical formulation so deeply ingrained that it is difficult to see the enormous potential of going beyond such a paradigm. The potential that publics and audiences may be activated by art they encounter at the museum is, to me, a very promising thought. Let's reimagine museum interpretation through the lens of an *exchange* of knowledge with publics, rather than *broadcasting* to them. Such a shift in pedagogy, which some education departments within museums have long embraced, would allow for a far greater multiplicity of voices of interpretation, and would also engage publics by tapping into *their* life experiences and connecting them to the works in the museum.

In some senses, museums are already accomplishing this shift with their publics, perhaps inadvertently, by taking actions that provoke protest. Protest as engagement, in parallel to unionization efforts, can drive us closer together, rather than further apart. It's part of the solution. The protestors and the unionizers are the greatest collaborators to remake museums right now. Their activation is a sign of the importance of cultural space, and they offer concrete steps to collectively make cultural space better for more people. As artist Jeanne van Heeswijk illuminates when she talks about preparing for the "Not Yet," Simone Leigh through her desire for community care, or Jonas Staal in his attempts to form assemblies to collectively imagine the futures of collective desire, culture is a generous space in which to conduct this dreaming and co-creation. To some extent, dreams are what we want to make together in cultural space.

Sometimes those dreams translate into realities, or enable us to make consequential, material changes in our lives.

Over these last few years of research and writing on museums and the myth of their neutrality, I have learned that the single most important thing is to begin. Specifically, to begin by looking inward. This is a journey that requires reading, reflecting, watching films, videos, documentaries, and talking and sharing with friends and strangers alike. Greater justice has been put off for too long to delay actions that lie within reach while this personal work is accomplished. It is never going to be perfect work, but we must see the imperfections as good, as spaces of possibility within which to grow and learn; to sit within this vulnerable space and resist shutting down and canceling simply because that is easier. We also have to rest and laugh and heal—all of us—but that can only happen if we are also willing to sit in the spaces of discomfort so necessary to bring about change, and to accept accountability. The inequities reflected in our systems of culture have been reinscribed for centuries, alongside the ideologies of white supremacy, capitalism, ability, and cis-heteropatriarchy. They can be undone, collectively, with intention, and with a fearlessness that comes from conviction and commitment, and also from an abundance of love. And it is with love that I have offered these critiques and analyses. Museums and the undoing of the myth of neutrality are one necessary step in the creation of an alternate space within which culture can thrive—a culture that relies less on oppression and exclusion to declare its excellence, and more on the care, generosity, and action to create spaces for contemplation, connection, and perhaps even for revolution.

Acknowledgements

As a kid, I read E.L. Konigsburg's children's novel *From the Mixed-Up Files of Mrs. Basil E. Frankweiler* and was entranced with the two siblings' overnight stay at New York's Metropolitan Museum of Art, where they are left alone to wander, hunting, eventually, for a good place to sleep. When my family occasionally came into "the city" from Long Island, I loved riding the zigzagging escalators at the Museum of Modern Art to the gallery with the perfect bench to sit with Monet's *Water Lilies*, or driving up the ramparts of Fort Tryon Park—in my memory, usually in the snow—to visit the medieval galleries of the Cloisters. I don't know how often we made these excursions. Maybe once or twice a year, on winter break from school? It wasn't that often. But they made a deep impression; these destinations were spaces where my life could mingle with some parallel universe that was far more entangled with imagination and possibility, one that offered questions I hadn't thought to ask and visions I hadn't thought to dream. They were about times long ago, as well as some not so very long ago, and simultaneously about the exact present simultaneously, and they mattered.

I was lucky to have these feelings in museums, and to interact with art and objects that moved me, or bewildered me, or made me feel weird in ways I certainly could not put into words at the time, and maybe still cannot. There was something in this experience of a place that contained culture, invention, and beauty, along with alternative conceptions of reality, that was deeply relevant to my kid self. The galleries dedicated to surrealism captured my teenaged brain. The paintings of Giorgio de

Chirico, sculptures of Hans Arp, and collages of Hannah Höch held images and emotions to which I would return often, as I came to desire more of the open-endedness of interpretation they seemed to invite. Beyond their eccentric representations, they were generous artworks: ones that gave such specific details yet were connected only by gossamer threads, so I could sit inside them and narrate my own stories within their uncanny versions of reality.

Decades beyond these foundational experiences, I've become obsessed with our containers of culture. It's an obsession that has fueled more than a few extraordinary experiences working with artists and within organizations, producing cultural offerings that I hope, in some way, have revealed meaning to others. And, I also hope that these meanings have reached beyond those intended by the artists, to the ways the artworks might tap into the public's curiosity in ways that are sticky, appealing, and mysterious. This stickiness is the element in the artwork, or perhaps in the experience of it, that keeps me present and that lets me into a space of re-seeing, or re-understanding, what we think we know or how we think things work, in our imaginations and in the world.

It is this stickiness, sometimes super-tangible, other times super-enigmatic, that makes me want to wander into the museum. So, I became a museum director. I wanted to create environments that make space for this type of interaction between people and art, rooted in something we might recognize, but that fundamentally challenge that thing, or reflect it through an unimagined prism of possibility. And wow, as a culture suffering from so many challenges today, we sure could use more experiences of possibility, more alternative narratives, and spaces that can hold these things in common. Zones that allow us to share our different realities where we can celebrate interdependence, as well as difference, and enact care for one another. If museums contain culture, then surely they can contain these experiences, if we make them better together.

It is with these ideas in mind that I set out to write this book three years ago. During this time I have learned a great deal about myself, my field, friends, and colleagues, mostly through the generoisty of others.

I cannot overstate the gratitude I owe to so very many people for making this book possible.

This project was researched and written on unceded lands of First Nations people, primarily on Lenape as well as Abenaki and Wampanoag territories. I want to acknowledge Indigenous care and presence on this land since time immemorial and offer my gratitude for their stewardship of it past, present, and future.

So much of this book comes directly from the experiences my colleagues and friends shared through our work within the following organizations: NYC's Parks Department, Public Art Fund, The Solomon R. Guggenheim Museum, Dia Art Foundation, Creative Time, Queens Museum, *Hyperallergic*, and the Leslie-Lohman Museum of Art.

I talked with innumerable people both casually and formally while conducting my research, and I want to thank particularly: La Tanya S. Autry, Chloë Bass, Lauren Bon, Rashida Bumbray, Gonzalo Casals, Maia Chao and Josephine Devanbu, Mel Chin, Molly Crabapple, Decolonize This Place, Kimberly Drew, Aruna D'Souza, Sam Durant, Adeola Enigbokan, Charles Esche, Teresita Fernandez, iLiana Fokianaki, Thelma Golden, Jeanne van Heeswjik, Megan Heuer, Maria Hlavjova, Brent Foster Jones, Jason Jones & Beka Economopoulos, Carin Kuoni, Simone Leigh, Mia Locks, Matteo Lucchetti, Josh MacPhee, Ram Manikkalingam, Helen Molesworth, Manon Slome, Rebecca Solnit, Nancy Spector, Jonas Staal, Robin Varghese, Hrag Vartanian, Diya Vij, and Adam Weinberg. Many of their approaches to art and life are incorporated in this book.

Of course, without financial, spiritual, and intellectual support this book would not exist. My first thanks goes to

The Metabolic Studio whose fellowship made it possible. I was also fortunate to be among the Rockefeller Foundation's Bellagio Fellows, and to learn from my compatriots during our summer in Italy together. The Strange Foundation's Decelerator program gave me essential space to think and write, and Alexie Glass, and her curatorial residency at Artspace in Sydney, provided invaluable insights through current conditions in Australia. I was able to write about and reflect on many institutional issues during my time at *Hyperallergic*, and am deeply grateful to The Emily H. Tremaine Foundation and to Hrag Vartanian and Veken Gueyikian for making my Journalism Fellowship for Curators possible. I am also indebted to my editors there, Dessane, Lopez Cassell, Seph Rodney, Elissa Wouk Almino, and Jasmine Weber, for making me a better writer.

Andy Hsiao, my editor at Verso, has been a miraculous champion of this project from the outset, when our mutual friend Naeem Mohaimen introduced us years ago. His editing has managed to strike a balance between being at once provocative and sensitive. It has been great to work with the entire Verso team, especially Duncan Ranslem, Sam Smith, Julia Judge, and Anne Rumberger; thank you for your efforts. I also had excellent research assistance from Gabriela Lopez Dena, Sara Devic, and Dani Castillo, as well as superlative fact checking by Will Tavlin.

Friends have provided myriad support along the way including feedback on the manuscript, particularly Maeve Adams, Elissa Blount Moorehead, Paul Schmelzer, and Zachary Small. I cannot thank you enough for your insights. Other friends offered kindnesses throughout the process of writing, including Ira Silverberg, Misha Lepetic, Trattie Davies, and Jonathan Toews.

My parents, Joanne and Rino Raicovich, and all of our ancestors, made me who I am, and taught me how to enmesh my stubbornness with thoughtfulness and love, and I am grateful to them always.

ACKNOWLEDGEMENTS

Endless gratitude and love goes to my husband Josh Cender, always my first and last reader, without whose support, intelligence, and care life would be unfathomable, and to our son Giacomo, the embodiment of my hope for the present and the future.

Selected Bibliography

Ahmed, Sara. *Living a Feminist Life*. Duke University Press, 2017.

———. "Orientations: Towards a Queer Phenomenology." *Journal of Lesbian and Gay Studies* 12, no. 4 (2006): 543–574.

———. "Whiteness and the General Will: Diversity Work as Willful Work." *Philosophia* 2, no. 1 (2012): 1–20.

Aikens, Nick, ed. *What's the Use? Constellations of Art, History and Knowledge: A Critical Reader*. Valiz, 2016.

Alexander, Edward P. and Mary Alexander. *Museums in Motion: An Introduction to the History and Functions of Museums*. AltaMira Press, 2007.

Alinsky, Saul. *Rules for Radicals: A Pragmatic Primer for Realistic Radicals*. Knopf Doubleday, 2010.

American Alliance of Museums. "A Conversation with Dr. Tonya Matthews, AAM's Interim Director of Inclusion." January 23, 2019.

———. "Latest Art Museum Staff Demographic Survey Shows Increases in African American Curators and Women in Leadership Roles." January 28, 2019.

———. "Museum Facts and Data." Accessed April 29, 2019.

———. "National Endowment for the Arts (NEA)." Accessed October 17, 2020.

American Association of Museums. *Museums for a New Century: A Report of the Commission on Museums for a New Century*. American Association of Museums, 1984.

American Museum of Natural History. "Addressing the Theodore Roosevelt Statue." June 21, 2020.

Anderson, Gail. *Reinventing the Museum: The Evolving Conversation on the Paradigm Shift*. AltaMira, 2012.

Anderson, William C. "When a Lynching Memorial Becomes a Photo Opportunity." *Hyperallergic*. December 27, 2018.

Anila, Swarupa. "Inclusion Requires Fracturing." *Journal of Museum Education* 42, no. 2 (2017): 108–119.

Archives Creative Practice. "Fred Wilson." Accessed March 16, 2020.

Arnstein, Sherry R. "A Ladder of Citizen Participation." *Journal of the American Planning Association* 35, no. 4 (1969): 216–224.

Artforum. "Following Sculpture Garden Controversy, Walker Art Center Forms Indigenous Art Committee." July 20, 2018.

———. "MFA Boston Bans Two Visitors, Implements Staff Bias Training following Racist Incidents." May 28, 2019.

———. "New Museum Pushes Back against Staff's Effort to Unionize." January 11, 2019.

———. "Whitney Museum Faces Mounting Backlash over Vice Chair's Ties to Tear Gas Manufacturer." December 4, 2018.

Arts and Labor. "End the Whitney Biennial 2014." February 24, 2012.

Autry, La Tanya S. "La Tanya S. Autry Case Statement, a Critical Lens on Diversity and Inclusion in Museums: #MuseumsRespondToFerguson." National Council on Public History. Accessed March 17, 2020.

———. "Museums Are Not Neutral." *Artstuffmatters*. Accessed March 17, 2020.

———. "Refusing Tokenization / Racial Fantasy." *Artstuffmatters*. February 14, 2020.

Axel, Nick and Marina O. Verzier, eds. *Work, Body, Leisure*. Het Nieuwe Instituut and Hatje Cantz Verlag, 2018.

Azoulay, Ariella Aïsha. *Potential History: Unlearning Imperialism*. Verso Books, 2019.

Badger, Emily. "Every Library and Museum in America, Mapped." *CityLab*. June 7, 2013.

Barry, Ellen. "Tufts Removes Sackler Name Over Opioids: 'Our Students Find It Objectionable.'" *New York Times*. December 5, 2019.

Barthes, Roland. *The Neutral: Lecture Course at the Collège de France (1977–1978)*. Columbia University Press, 2005.

Bass, Chloë, Seph Rodney, and Jillian Steinhauer. "The Possibilities and Failures of the Racial Imagination." *Hyperallergic*. April 18, 2017.

Battaglia, Andy, Sarah Douglas, and Andrew Russeth. "After Announcement That Olga Viso Will Step Down as Walker Director, Museum Professionals Largely Praise Handling of 'Scaffold' Controversy." *ArtNews*. November 17, 2017.

BBC. "New York's Met Museum to Shun Sackler Family Donations." May 15, 2019.

Bishara, Hakim. "An 'Alternative Museum Guide' Explains the Kanders Controversy to Whitney Biennial Visitors." *Hyperallergic*. May 17, 2019.

Black, Hannah. "Hannah Black's Letter to the Whitney Biennial's Curators: Dana Schutz painting 'Must Go.'" *e-flux*. March 1, 2017.

Black, Hannah, Ciarán Finlayson, and Tobi Haslett. "The Tear Gas Biennial." *Artforum*. July 17, 2019.

Boffey, Daniel. "Rijksmuseum Laments Dutch Failure to Return Stolen Colonial Art." *Guardian*. March 13, 2019.

Brand, Dionne. *The Blue Clerk: Ars Poetica in 59 Versos*. Duke University Press, 2018.

Branigin, Anne. "Of Art and Plunder: Why Black Curators Are Still Shut Out of the Art World—and Why It Matters." *Root*. April 13, 2018.

Brown, Lovisa, Caren Gutierrez, Janine Okmin, and Susan McCullough. "Desegregating Conversations about Race and Identity in Culturally Specific Museums." *Journal of Museum Education* 42, no. 2 (2017): 120–131.

Brown, Kate. "Benin's Looted Bronzes Are All Over the Western World. Here Are 7 Museums That Hold Over 2,000 of the Famed Sculptures." *Artnet News*. July 27, 2018.

Bryant-Greenwell, Kayleigh. "Taking a Stand Against Neutrality: The Role of Social Justice in Museums." *Museum-iD*. Accessed March 17, 2020.

Burton, Johanna, Shannon Jackson, and Dominic Willsdon, eds. *Public Servants: Art and the Crisis of the Common Good*. MIT Press, 2016.

Byrne, John, Elinor Morgan, November Paynter, Aida Sánchez de Serdio, and Adela Železnik, eds. *The Constituent Museum: Constellations of Knowledge, Politics and Mediation: A Generator of Social Change*. Valiz/L'internationale, 2018.

Caldwell, Ellen C. "An Interview with Sam Durant." *Riot Material*. January 29, 2017.

Campt, Tina M. *Listening to Images*. Duke University Press, 2017.

Carr, Julie. "Who Decides What Is Violent in the Museum?" *Hyperallergic*. May 15, 2018.

Carrigan, Margaret, and Victoria Stapley-Brown. "'I Stand in Solidarity with the Staff and Say No': Michael Rakowitz on Why He Turned Down the Whitney Biennial." *Art Newspaper*. February 27, 2019.

Cascone, Sarah. "Demonstrators Fill the Whitney Museum—and Burn Sage—to Protest Its Vice Chairman's Ties to Tear Gas Manufacturer." *ArtNet News*. December 10, 2018.

———. "Native American Author Louise Erdrich Says the Walker Is Making Olga Viso a 'Scapegoat' for the Sam Durant Controversy." *ArtNet News*. November 20, 2017.

————. "The Guggenheim Teams Up with More Than 100 Museums to Fight Trump's Immigration Ban." *ArtNet News*. September 21, 2017.

————. "Walker Art Center's Gallows Sculpture to Be Removed and Burned." *ArtNet News*. May 31, 2017.

————. "Whitney Staff Members Call for the Resignation of the Museum's Vice Chair Over His Ties to a Tear Gas Manufacturer." *ArtNet News*. November 30, 2018.

CBS News. "Minneapolis City Council Members Say They Plan to Vote to Disband the City's Police Department." June 9, 2020.

Centers for Disease Control and Prevention. "Drug Overdose Deaths." Accessed May 22, 2019.

Charnley, Kim, and Gregory Sholette, eds. *Delirium and Resistance: Activist Art and the Crisis of Capitalism*. Pluto Press, 2017.

Chen, Michelle. "Gentrification and Occupation at the Brooklyn Museum." *Nation*. May 11, 2016.

Chow, Andrew R. "Olga Viso, Embattled Leader of Walker Art Center, Steps Down." *New York Times*. November 14, 2017.

Cisnero, Teresa. *Document 0*. ANDpublishing, 2018.

Cooks, Bridget R., "Black Artists and Activism: Harlem on My Mind (1969)." *American Studies*, 48, no. 1, Spring 2007.

Corbett, Rachel, and Julia Halperin. "In a Landslide Decision, Employees at the New Museum Vote to Unionize." *ArtNet News*. January 24, 2019.

Cotter, Holland. "Money, Ethics, Art: Can Museums Police Themselves?" *New York Times*. May 9, 2019.

D'Souza, Aruna. *Whitewalling: Art, Race and Protest in 3 Acts*. Badlands Unlimited, 2018.

Deb, Sopan. "Met and Brooklyn Museums Will Not Use Saudi Money for Programs on the Middle East." *New York Times*. October 18, 2018.

(De)Institutional Research Team. "Whitney Museum Guide." Whitney Museum of American Art. Accessed September 24, 2020.

DiAngelo, Robin. *White Fragility: Why It's So Hard for White People to Talk about Racism*. Beacon Press, 2018.

Dickerson, Caitlin. "Parents of 545 Children Separated at the Border Cannot Be Found." *New York Times*. October 21, 2020.

Dickinson, Sheila. "'A Seed of Healing and Change': Native Americans Respond to Sam Durant's 'Scaffold.'" *ArtNews*. June 5, 2017.

Duncan, Carol. *A Matter of Class: John Cotton Dana, Progressive Reform, and the Newark Museum*. Periscope Publishing, 2009.

Duquette, Nicolas J. "Founders' Fortunes and Philanthropy: A History of the U.S. Charitable-Contribution Deduction." *Business History Review* 93 (2019): 553–584.

Durant, Sam. "Artist Statement Regarding *Scaffold* at the Walker Art Center." SamDurant. May 29, 2017.

Eakin, Hugh. "The Great Giveback." *New York Times*. January 26, 2013.

Eckardt, Stephanie. "Here's One Way to Deal with Problematic Artworks, Like Sam Durant's Scaffold: Burn Them." *W Magazine*. June 1, 2017.

Edgecliffe-Johnson, Andrew. "Tear Gas Company Boss on the Benefits of 'Less-Lethal' Weapons." *Financial Times*. January 12, 2020.

Eldred, Sheila. "Walker Art Center's Reckoning with 'Scaffold' Isn't Over Yet." *New York Times*. September 13, 2017.

Erdich, Louise. "Letter to the Editor." *Star Tribune*. November 15, 2017.

Eunsong, Kim, and Maya Mackrandilal. "The Freedom to Oppress." *Contemptorary*. May 18, 2018.

Eugenics Archive. "T. Roosevelt Letter to C. Davenport about 'Degenerates Reproducing.'" Accessed March 18, 2020.

Eve, Tuck. "Suspending Damage: A Letter to Communities." *Harvard Educational Review* 79, no.3 (2009): 409–427.

Farago, Jason. "The Philip Guston Show Should Be Reinstated." *New York Times*. September 30, 2020.

Farrell, Berry and Maria Medvedeva. *Demographic Transformation and the Future of Museums*. Report. American Association of Museums, 2010.

Federici, Silvia. *Caliban and the Witch: Women, the Body and Primitive Accumulation*. Autonomedia, 2004.

Finkel, Jori. "Sam Durant and Anne Ellegood Reflect on Being in the Hot Seat of Museum Controversies." *Art Newspaper*. February 23, 2018.

Fisher, Michelle. "Parenting and Labor in the Art World: A Call to Arms." *Hyperallergic*. May 6, 2019.

Fokianaki, Iliana. "How I Lost My Marbles; or, Calling for Colonial Patricide." *Frieze*. March 6, 2019.

———. "Performing Citizenship." *Drouth* 60 (2018): 32–35.

Fraser, Andrea. *2016 in Museums, Money, and Politics*. CCA Wattis Institute for Contemporary Arts, Westreich Wagner Publications, and the MIT Press, 2018.

French, Blair and Anne Loxley. *Civic Actions: Artists' Practices beyond the Museum*. Museum of Contemporary Art Limited, 2017.

Frey, William H. "New Projections Point to a Majority Minority Nation in 2044." *Brookings.* December 12, 2014.

———. "The US Will Become 'Minority White' in 2045, Census Projects." *Brookings.* March 14, 2018.

Frieze. "It's Time for Museums to 'Decolonize,' Says Former Walker Art Center Director." May 4, 2018.

Fusco, Coco. "Censorship, Not the Painting, Must Go: On Dana Schutz's Image of Emmett Till." *Hyperallergic.* March 27, 2017.

Giridharadas, Anand. "When Your Money Is So Tainted Museums Don't Want It." *New York Times.* May 16, 2019.

———. *Winners Take All: The Elite Charade of Changing the World.* Knopf Doubleday, 2018.

Goldstein, Andrew. "Why Dana Schutz's Emmett Till Painting Must Stay." *ArtNet.* March 30, 2017.

Goode, Brown G. *Museum History and Museums of History.* Knickerbocker Press, 1889.

Gorman, Sophie. "Louvre Removes Sackler Name amid Controversy over Opioid Crisis." *France24.* July 21, 2019.

Graham, Renée. "On a Class Trip to MFA, an Unexpected Lesson about Racism." *Boston Globe.* May 23, 2019.

Greenberger, Alex. "Following Sam Durant Controversy, Walker Art Center Forms Indigenous Public Art Selection Committee." *ArtNews.* July 19, 2018.

———. "'I Am Not the Problem': Whitney Vice Chair Responds to Open Letter Calling for Action against Him." *ArtNews.* December 3, 2018.

———. "'It's Helpful to Know All Scales': Online Spreadsheet Discloses Museum Workers' Salaries." *ArtNews.* May 31, 2019.

———. "Whitney Museum to Partner with Claudia Rankine's Racial Imaginary Institute for Discussion about Dana Schutz Controversy." *ArtNews.* December 3, 2018.

Guardian staff. "Museums in US Still Failing with Artist Diversity, Study Finds." March 20, 2019.

Gurian, Elaine H. "Modeling Decency, Sir." In *Designing for Empathy: Perspectives on the Museum Experience*, edited by Elif M. Gokcigdem. Rowman & Littlefield / American Alliance of Museums, 2019. Chapter 19.

Hakim, Danny, Roni C. Rabin, and William K. Rashbaum. "Lawsuits Lay Bare Sackler Family's Role in Opioid Crisis." *New York Times.* April 1, 2019.

Hall, Peter D. *"Inventing the Nonprofit Sector" and Other Essays on Philanthropy, Voluntarism, and Nonprofit Organizations*. Johns Hopkins University Press, 2002.

Halperin, Julia. "How the Dana Schutz Controversy—and a Year of Reckoning—Have Changed Museums Forever." *ArtNet*. March 6, 2018.

Haraway, Donna. "Tentacular Thinking: Anthropocene, Capitalocene, Chthulucene." *e-flux*. September 2016.

Harney, Stefano and Fred Moten. *The Undercommons: Fugitive Planning and Black Study*. Minor Compositions, 2013.

Harris, Elizabeth A. "The Met Will Turn Down Sackler Money amid Fury over the Opioid Crisis." *New York Times*. May 15, 2019.

Hartman, Saidiya. *Wayward Lives, Beautiful Experiments: Intimate Histories of Riotous Black Girls, Troublesome Women, and Queer Radicals*. W.W. Norton, 2019.

Hawbaker, KT. "In Declining the Whitney Biennial, Chicago Artist Michael Rakowitz Offers the Ultimate Form of Art Criticism." *Chicago Reader*. April 2, 2019.

Healing Minnesota Stories. "Dakota Elders to Walker Art Center: Tear Down That Scaffold." May 27, 2017.

Helguera, Pablo. *Art Scenes: The Social Scripts of the Art World*. Jorge Pinto Books, 2012.

Herf, Jeffrey. "The Critical Spirit of Herbert Marcuse." *New German Critique* 18 (1979): 24–27.

Herman, Edward and Noam Chomsky. "A Propaganda Model." Noam Chomsky official website. Accessed July 23, 2019.

Hobson, Jeremy. "Teddy Roosevelt's Complicated Legacy 100 Years after His Death." *WBUR*. March 21, 2019.

Janes, Robert R. "The End of Neutrality: A Modest Manifesto." *Informal Learning Review* 135 (2015): 3–8.

Janes, Robert R., and Richard Sandell, eds. *Museum Activism*. Routledge, 2019.

Jaremko-Greenwold, Anya. "Protesters Block, Demand Removal of a Painting of Emmett Till at the Whitney Biennial." *Hyperallergic*. March 22, 2017.

Jensen, Robert. "The myth of the neutral professional." In Alison Lewis, ed. *Questioning Library Neutrality Essays from Progressive Librarian*. Library Juice Press, 2008.

Keating, Dan, and Samuel Granados. "See How Deadly Street Opioids Like 'Elephant Tranquilizer' Have Become." *Washington Post*. October 25, 2017.

Kelley, Robin D.G. *Freedom Dreams: The Black Radical Tradition.* Beacon Press, 2002.

Kennedy, Randy. "White Artist's Painting of Emmett Till at Whitney Biennial Draws Protests." *New York Times.* March 21, 2017.

Knight, Christopher. "Critic's Notebook: MOCA Still Mum about Curator's Firing, Despite Crucial Questions and Too Few Answers." *Los Angeles Times.* March 20, 2018.

Kortun, Vasif. "Questions on Institutions." *SaltOnline.* January 12, 2018.

Krieger, Deborah. "A Visual History of Federal Art Spending in the United States." *Hyperallergic.* March 17, 2014.

Lamy, Marvelyne. "The Museum of Fine Arts, Boston, Racially Profiled My Students." Facebook, May 20, 2019.

Landesman, Tucker J. "Review: *Notes Toward a Performative Theory of Assembly* by Judith Butler." *Antipode.* January 28, 2019.

Leonard, Christopher. "David Koch Was the Ultimate Climate Change Denier." *New York Times.* August 23, 2019.

Lippard, Lucy. *From the Center: Feminist Essays on Women's Art.* Dutton, 1976.

———. *Get the Message? A Decade of Art for Social Change.* E.P. Dutton, 1984.

Little, Becky. "Will the British Museum Ever Return These Stolen Artifacts?" *History.* December 21, 2018.

Lonetree, Amy. *Decolonizing Museums: Representing Native America in National and Tribal Museums.* University of North Carolina Press, 2012.

Madoff, Steven Henry, ed. *What about Activism?* Sternberg Press, 2019.

Magally, Miranda, and Kyle Lane-McKinley. "Artwashing, or, Between Social Practice and Social Reproduction." *A Blade of Grass.* February 1, 2017.

Marshall, Alex. "British Gallery Turns Down $1.3 Million Sackler Donation." *New York Times.* March 19, 2019.

———. "This Art Was Looted 123 Years Ago. Will It Ever Be Returned?," *New York Times,* January 27, 2020.

Mattson, Kevin. "The Librarian as Secular Minister to Democracy: The Life and Ideas of John Cotton." *Libraries and Culture* 35, no. 4 (2000): 514–534.

MCAccountable. "MCAccountable: Our Collective Letter to the Pritzker Director of the Museum of Contemporary Art Chicago." July 16, 2020.

Miranda, Carolina A. "Artist Sam Durant Was Pressured Into Taking Down His 'Scaffold.' Why Doesn't He Feel Censored?" *Los Angeles Times*. June 17, 2017.

Mircan, Mihnea, and Jonas Staal. "Let's Take Back Control! Of Our Imagination." *Stedelijk Studies*. Accessed September 5, 2020.

Mirzoeff, Nick. "How Do We Address a Statue of President Roosevelt That Affirms Racist Hierarchies?" *Hyperallergic*. September 24, 2019.

Mouffe, Chantal. "The Museum Revisited." *Artforum* (Summer 2010).

Moynihan, Colin. "Eight Artists Withdraw from Whitney Biennial Over Board Member's Ties to Tear Gas." *New York Times*. July 19, 2019.

——. "Whitney Biennial Artists Call for Board Member Linked to Tear Gas to Step Down." *New York Times*. April 29, 2019.

MTL Collective. "A Decolonial Perspective on the Crises of Contemporary Art." *October* 165 (2018): 192–227.

Muñoz, José Esteban. *Cruising Utopia: The Then and There of Queer Futurity*. New York University Press, 2009.

Muñoz-Alonso, Lorena. "Dana Schutz's Painting of Emmett Till at Whitney Biennial Sparks Protest." *ArtNet*. March 21, 2017.

Museum of Contemporary Art Australia. "Material Histories." Filmed March 17, 2020 at MCA, Sydney.

National Gallery of Art. "Statement from the Directors." June 27, 2019.

Natural History Museum. "Our Letter Has Gone Viral." March 25, 2015.

Neuendorf, Henri. "Walker Art Center Looks Past Scandal with an Open Call to Native American Artists for a New Public Commission." *ArtNet*. January 17, 2019.

New York City. "Mayoral Advisory Commission on City Art, Monuments, and Markers: Report to the City of New York." Accessed February 2018.

Nicholson, Kate. "The Supreme Court's Take on Cakes Is Nothing but Empty Calories for Creative Industries." *Hyperallergic*. June 6, 2018.

Nicole Rogers, Taylor. "The AOC Adviser behind the 'Every Billionaire Is a Policy Failure' Slogan Says There's a Critical Issue with Depending on the Richest People to Fix the World's Biggest Problems." *Business Insider*. July 16, 2019.

Not an Alternative. "Counter Power as Common Power." *Journal of Aesthetics and Protest* 9. November 2009.

Novick, Ilana, and Hakim Bishara. "Activists Protest at Whitney Museum, Demanding Vice Chairman and Owner of Tear Gas Manufacturer 'Must Go.'" *Hyperallergic*. December 9, 2018.

Oldfield, Elizabeth. "The National Lottery Is a Bad Deal for the Poor." *Theos Think Tank*. August 11, 2011.

Patra, Kevin. "NFL Instituting Changes to Rooney Rule." *NFL official website*. May 18, 2020.

Piper, Kelsey. "The Charitable Deduction Is Mostly for the Rich. A New Study Argues That's By Design." *Vox*. September 3, 2019.

Petrovich, Dushko, and Roger White, eds. *As Radical, As Mother, As Salad, As Shelter: What Should Art Institutions Do Now?* Paper Monument, 2018.

Phillips, Patricia C., et al. *Mierle Laderman Ukeles: Maintenance Art*. Prestel, 2016.

Pogrebin, Robin. "At Queens Museum, Director is as Political as the Art." *New York Times*. October 8, 2017.

———. "Museum Boss Salaries: Reduced but Still an Issue amid Wider Cutbacks." *New York Times*. August 18, 2020.

———. "Politically Outspoken Director of Queens Museum Steps Down." *New York Times*. January 26, 2018.

———. "Warren Kanders Says He Is Getting Out of the Tear Gas Business." *New York Times*. June 9, 2020.

———. "With New Urgency, Museums Cultivate Curators of Color." *New York Times*. August 8, 2018.

Pogrebin, Robin, and Elizabeth A. Harris. "Warren Kanders Quits Whitney Board after Tear Gas Protests." *New York Times*. July 25, 2019.

Rabin, Roni C. "New York Sues Sackler Family Members and Drug Distributors." *New York Times*. March 28, 2019.

The Racial Imaginary. "About." TRII: An Interdisciplinary Cultural Laboratory. Accessed March 17, 2019.

Radden Keefe, Patrick. "The Family That Built an Empire of Pain." *New Yorker*. October 3, 2017.

Raicovich, Laura. "A Unique Program Pays You to Visit Museums as a Guest Critic." *Hyperallergic*. June 27, 2019.

———. "Why Libraries Have a Public Spirit That Most Museums Lack." *Hyperallergic*. November 7, 2019.

Rashbaum, William K., Roni C. Rabin, and Hakim Danny. "Opioid Sales Reps Swarmed New York at Height of Crisis." *New York Times*. April 11, 2019.

Rea, Naomi. "A French Museum Director Pushes Back Against a Radical Report Calling on Macron to Return Looted African Art." *Artnet*. November 28, 2018.

Regan, Sheila. "After Protests from Native American Community, Walker Art Center Will Remove Public Sculpture." *Hyperallergic*. May 29, 2017.

Richardson, Jim. "Should Museums Be Activists?" MuseumNext. October, 2019.

Robinson, Cynthia. "From the Editor-in-Chief." *Journal of Museum Education* 44, no.1 (2019): 1–3.

Rodney, Seph. *The Personalization of the Museum Visit: Art Museums, Discourse, and Visitors*. Routledge, 2019.

Ross, Aaron, and Marine Pennetier. "France Returns 26 Artworks to Benin as Report Urges Restitution." *Reuters*. November 23, 2018.

Ross, Loretta. "I'm a Black Feminist. I Think Call-Out Culture Is Toxic." *New York Times*. August 17, 2019.

Rothstein, Edward. "Natural History Does the Full Pander." *Wall Street Journal*. July 31, 2019.

Russeth, Andrew. "'They Should Be in Jail': Nan Goldin, Anti-Sackler Opioid Activists Take Fight to Guggenheim, Met." *ArtNews*. February 10, 2019.

Rutgers University Libraries. "John Cotton Dana—Newark's First Citizen." Accessed September 24, 2020.

Said, Edward W. *Culture and Imperialism*. Vintage Books, 1994.

Sánchez, Juan Pablo. "How the Parthenon Lost Its Marbles." *National Geographic*. March 4, 2017.

Sarr, Felwine, and Bénédicte Savoy. *The Restitution of African Cultural Heritage: Toward a New Relational Ethics. Report*. November 2018.

Schneider, Tim. "Civics Lessons: Why the Government Shutdown's End Should Be Cold Comfort to US Arts Institutions." *Gray Market Weekly*. January 31, 2019.

———. "The Gray Market: Why the New Museum's Union Reckoning Reflects a Much Bigger Problem (and Other Insights)." *ArtNet*. January 14, 2019.

———. "Western Museums Have a Surplus of Art by White Men. Now Some Are Selling It Off to Correct Their Historical Biases." *ArtNet*. May 15, 2019.

Schwartz, Jeremy. "Tikkun Olam, Unpacked." Reconstructing Judaism. December 1, 2016.

Scott, Andrea K. "Does an Offensive Sculpture Deserve to Be Burned?" *New Yorker*. June 3, 2017.

Searcey, Dionne, John Eligon, and Farah Stockman. "After Protests, Politicians Reconsider Police Budgets and Discipline." *New York Times*. June 8, 2020.

Sentence, Nathan. "Your Neutral Is Not Our Neutral." *Archival Decolonist.* July 3, 2018.

Shaked, Nizan. "After a Director Is Fired and a Work of Art Paused, We Must Demand Social Justice." *Hyperallergic.* October 26, 2018.

Sharpe, Christina. *In the Wake.* Duke University Press, 2016.

———. "'What Does It Mean to Be Black and Look at This?' A Scholar Reflects on the Dana Schutz Controversy." *Hyperallergic.* March 24, 2017.

Sharratt, Chris. "How a Google Spreadsheet Broke the Art World's Culture of Silence." *Frieze.* June 7, 2019.

Siegel, Evan. "Protesters Storm Whitney Museum Over Vice Chairman's 'Tainted' Money." *Daily Beast.* October 12, 2018.

Simmons, John E. *Museums: A History.* Rowman & Littlefield, 2016.

Simon, Nina. *The Participatory Museum.* Museum 2.0, 2010.

Simpson, Leanne B., and Dionne Brand. "Temporary Spaces of Joy and Freedom." *Literary Review Canada,* July 14, 2018.

Slattery, Denis. "New York Lawmakers Vote to Repeal 50-a, Making Police Disciplinary Records Public." *New York Daily News.* June 10, 2020.

Small, Zachary. "A Closer Look into the Whitney Museum's Board." *Hyperallergic.* May 7, 2019.

———. "A New Definition of 'Museum' Sparks International Debate." *Hyperallergic.* August 19, 2019.

Smith, Ashleigh. "Listen to the Interns: The Importance of the 'Budding Scholar' for Museum Decolonization." American Alliance of Museums. January 16, 2019.

Smith, Roberta. "Should Art That Infuriates Be Removed?" *New York Times.* March 27, 2017.

Solnit, Rebecca. *Call Them by Their True Names: American Crises (and Essays).* Haymarket Books, 2018.

———. *Hope in the Dark: Untold Histories, Wild Possibilities.* Haymarket Books, 2016.

———. "To Break the Story, You Must Break the Status Quo," *Lit Hub,* May 26, 2016.

———. *Men Explain Things to Me.* Haymarket Books, 2015.

———. "Whose Story (and Country) Is This?" *LitHub.* April 18, 2018.

Speidel, Klaus. "Dana Schutz's 'Open Casket': A Controversy around a Painting as a Symptom of an Art World Malady." *SpikeArt.* March 24, 2017.

Staal, Jonas. "Assemblism." *e-flux Journal* 80. March 2017.

———. "New World Embassy: Rojava." Jonas Staal official website. Accessed October 17, 2020.

———. *Propaganda Art in the Twenty-First Century.* MIT Press, 2019.

———. "Propaganda (Art) Struggle." *e-flux Journal* 94. October 2018.

Stack, Liam. "Guggenheim Museum Says It Won't Accept Gifts from the Sackler Family." *New York Times.* March 22, 2019.

Stamberg, Susan. "How Andrew Carnegie Turned His Fortune into a Library Legacy." NPR. August 1, 2013.

Star Tribune. "Readers Write: Louise Erdrich on Departing Walker Art Center Director Olga Viso; Plus: Veterans, Sexual Misconduct, Guns." November 15, 2017.

Steinhauer, Jillian. "Sam Durant Doesn't Need Defending." *Hyperallergic.* June 7, 2017.

———. "The Whitney Biennial: 75 Artists Are In, and One Dissenter Steps Out." *New York Times.* February 25, 2019.

Taylor, Sunaura. *Beasts of Burden: Animal and Disability Liberation.* New Press, 2017.

Thompson, Nato. *Seeing Power: Art and Activism in the Twenty-First Century.* Melville House, 2015.

Topaz, Chad M., Bernhard Klingenberg, Daniel Turek, Brianna Heggeseth, Pamela E. Harris, Julie C. Blackwood, Ondine Chavoya, Steven Nelson, and Kevin M. Murphy. "Diversity of Artists in Major U.S. Museums." *PLoS ONE* 14, no. 3 (March 2019).

Tsing, Anna. "Unruly Edges: Mushrooms as Companion Species." *Environmental Humanities* 1 (2012): 141–154.

Tuck, Eve, and K. Wayne Yang. "Decolonization Is Not a Metaphor." *Decolonization: Indigeneity, Education, and Society* 1, no.1 (2012): 1–40.

van Heeswijk, Jeanne. "Preparing for the Not-Yet." In *Slow Reader: A Resource for Design Thinking and Practice*, edited by Ana Paula Pais and Carolyn Strauss. Valiz, 2016. 43–53.

———. "Trainings for the Not-Yet." *JeanneWorks.* Accessed April 9, 2020.

Vartanian, Hrag, Zachary Small, and Jasmine Weber. "Whitney Museum Staffers Demand Answers after Vice Chair's Relationship to Tear Gas Manufacturer Is Revealed." *Hyperallergic.* November 30, 2018.

Verso Books. "Kanders Must Go: An Open Letter from Theorists, Critics, and Scholars." *Verso Blog.* April 29, 2019.

Verwoert, Jan. *Exhaustion Et Exuberance: A Pamphlet for the Exhibition, Art Sheffield 08: Yes, No, an Other Options.* Sheffield Contemporary Art Forum, 2008.

Viso, Olga. "Decolonizing the Art Museum: The Next Wave." *New York Times*. May 1, 2018.

———. "Learning in Public: An Open Letter on Sam Durant's *Scaffold*." Walker Art Center. May 26, 2017.

Walker, Darren. "A Call for Moral Courage in America." Ford Foundation. September 6, 2017.

———. "Open and Free: On Arts, Democracy, and Inequality." Ford Foundation. January 26, 2015.

———. "The Coming of Hope: A Vision for Philanthropy in the New Year." Ford Foundation. January 9, 2019.

Wallace, David. "Fred Moten's Radical Critique of the Present." *New Yorker*. April 30, 2018.

Walters, Joanna. "Massive Lawsuit Says Sackler Family Broke Laws to Profit from Opioids." *Guardian*. March 22, 2019.

———. "Sackler Family Members Face Mass Litigation and Criminal Investigations Over Opioids Crisis." *Guardian*. November 19, 2018.

———. "'This Is Blood Money': Tate Shuns Sacklers – and Others Urged to Follow." *Guardian*. March 24, 2019.

Waterson, Jim. "How Is the BBC Funded and Could the Licence Fee Be Abolished?" *Guardian*. December 16, 2019.

Warsza, Joanna, et. al., eds. *I Can't Work Like This: A Reader on Recent Boycotts and Contemporary Art*. Sternberg Press and Salzburg International Summer Academy of Fine Arts, 2017.

Weber, Jasmine. "A Whitney Museum Vice Chairman Owns a Manufacturer Supplying Tear Gas at the Border." *Hyperallergic*. November 27, 2018.

———. "Guggenheim Museum 'Does Not Plan to Accept Any Gifts' from the Sackler Family." *Hyperallergic*. March 22, 2019.

———. "Indigenous Womxn's Collective Stages Protest Inside 2019 Whitney Biennial." *Hyperallergic*. May 16, 2019.

———. "Whitney Museum Director Pens Letter after Vice Chair's Relationship to Weapons Manufacturer Is Publicized." *Hyperallergic*. December 3, 2018.

Weber, Jasmine, Hakim Bishara, and Hrag Vartanian. "After a Protest at the 2019 Whitney Biennial Opening, Activists March to Warren Kanders's Townhouse." *Hyperallergic*. May 18, 2019.

Weigel, Moira. "Feminist Cyborg Scholar Donna Haraway: 'The Disorder of Our Era Isn't Necessary.'" *Guardian*. June 20, 2019.

Westermann, Mariët, Roger Schonfeld, and Liam Sweeney. *Art Museum Staff Demographic Survey 2018*. Mellon Foundation. January 28, 2019.

White House. "Statement by President Trump on Jerusalem." December 6, 2017.

Whitney Museum of American Art. "Perspectives on Race and Representation: An Evening with the Racial Imaginary Institute." Filmed April 9, 2019, at the Whitney Museum.

Whyte, Murray. "On the Walls at Harvard Museums, They're Calling Out Art's Racist and Sexist History." *Boston Globe*. August 31, 2019.

Vizenor, Gerald, ed. *Survivance: Narratives of Native Presence*. University of Nebraska Press, 2018.

Youn, Soo. "NYU Langone No Longer Accepting Donations from the Sacklers, the Family that Owns OxyContin Maker Purdue Pharma." *ABC News*. June 12, 2019.

Younge, Gary. "Interview: The Secrets of a Peacemaker." *Guardian*. February 17, 2019.

Zinn, Howard. *A People's History of the United States: 1492–Present*. Harper Perennial Modern Classics, 2005.

Zuckerman, Ethan. "Six or Seven Things Social Media Can Do For Democracy." *EthanZuckerman*. May 30, 2018.

Notes

Introduction

1 Arts and Democracy, an organization that fosters cultural organizing, has useful resources about this work on its website, including the following definition of this work: "Cultural organizing exists at the intersection of arts, culture and activism. It is a fluid and dynamic practice that is understood and expressed in a variety of ways, reflecting the unique cultural, artistic, organizational and community context of its practitioners. Cultural organizing is about integrating arts and culture into organizing strategies. It is also about organizing from a particular tradition, cultural identity, and community of place or worldview to advance social and economic justice." See "Cultural Organizing: Definition and Framework," Arts and Democracy official website, accessed March 18, 2020.

2 Immigrant Movement International, Corona, also known as IMI Corona, was a community run space initiated by artist Tania Bruguera, together with the Queens Museum and Creative Time. As of 2020 the organization continues to operate independently from the museum as Centro Corona.

3 Liz Robbins, "'Economic Tsunami': Fearing Donald Trump, Immigrants in New York Spend Less," *New York Times*, November 23, 2016.

4 Sarah Cascone, "The Guggenheim Teams Up with More Than 100 Museums to Fight Trump's Immigration Ban," *ArtNet News*, September 21, 2017.

5 The Art Space Sanctuary guidelines can be found on its website, artspacesanctuary.org.

6 Robin Pogrebin, "At Queens Museum, Director is as Political as the Art," *New York Times*, October 8, 2017.

7 "Statement by President Trump on Jerusalem," White House, December 6, 2017.

8 "Museum Facts and Data," American Alliance of Museums, accessed April 29, 2019.

9 See the Political Activities and Lobbying page on the US Internal Revenue Service website, particularly the links to "political activities" and "legislative activities" at irs.gov/charities-non-profits/charitable-organizations/political-and-lobbying-activities accessed December 13, 2020.

10 Zachary Small, "A New Definition of 'Museum' Sparks International Debate," *Hyperallergic*, August 19, 2019.

11 Ibid.

1 Revelations

1 Andrew Russeth, "'They Should Be in Jail': Nan Goldin, Anti-Sackler Opioid Activists Take Fight to Guggenheim, Met," *ArtNews*, February 10, 2019.

2 Dan Keating and Samuel Granados, "See How Deadly Street Opioids Like 'Elephant Tranquilizer' Have Become," *Washington Post*, October 25, 2017.

3 "Drug Overdose Deaths," Centers for Disease Control and Prevention, accessed May 22, 2019.

4 Patrick Radden Keefe, "The Family That Built an Empire of Pain," *New Yorker*, October 3, 2017.

5 Ibid.

6 Quoted in Ibid.

7 Ibid.

8 This method of dropping flyers from the upper ramps of the Guggenheim rotunda was borrowed from protests conducted by G.U.L.F.—Global Ultra Luxury Faction, the direct action arm of the artist and activist group Gulf Labor, which has been protesting the Guggenheim's connection to unethical labor practices in the construction of the Guggenheim Abu Dhabi. It is also a time-tested technique used by the US military to drop warnings of impending bombings, from Vietnam to Iraq.

9 Alex Marshall, "British Gallery Turns Down $1.3 Million Sackler Donation," *New York Times*, March 19, 2019.

10 Sophie Gorman, "Louvre Removes Sackler Name amid Controversy over Opioid Crisis," *France24*, July 21, 2019.

11 Soo Youn, "NYU Langone No Longer Accepting Donations from the Sacklers, the Family That Owns OxyContin Maker Purdue Pharma," *ABC News*, June 12, 2019; Ellen Barry, "Tufts Removes

Sackler Name Over Opioids: 'Our Students Find It Objectionable,'" *New York Times*, December 5, 2019.

12 Elizabeth A. Harris, "The Met Will Turn Down Sackler Money Amid Fury Over the Opioid Crisis," *New York Times*, May 15, 2019.

13 Sopan Deb, "Met and Brooklyn Museums Will Not Use Saudi Money for Programs in the Middle East," *New York Times*, October 18, 2018.

14 Vasif Kortun, "Questions on Institutions," *SaltOnline*, January 12, 2018.

15 Edward P. Alexander and Mary Alexander, *Museums in Motion: An Introduction to the History and Functions of Museums* (AltaMira Press, 2007), 29.

16 Naomi Rea, "A French Museum Director Pushes Back Against a Radical Report Calling on Macron to Return Looted African Art," *Artnet*, November 28, 2018.

17 Daniel Boffey, "Rijksmuseum Laments Dutch Failure to Return Stolen Colonial Art," *Guardian*, March 13, 2019.

18 John E. Simmons, *Museums: A History*, (Rowman & Littlefield, 2016), 126.

19 Charles Esche, interviewed by Laura Raicovich, June 5, 2018, the Netherlands.

20 Robert Behre, "Charleston Library Society Turns a Very Expensive New Page (about $5 Million Worth)," *Post and Courier*, May 21, 2019.

21 John E. Simmons, *Museums: A History* (Rowman & Littlefield, 2016), 135.

22 Amy Lonetree, *Decolonizing Museums: Representing Native America in National and Tribal Museums* (University of North Carolina Press, 2012), 12–13.

23 Ibid., 10.

24 Alexander and Alexander, *Museums in Motion*, 6.

25 Ibid., 6.

26 John E, Simmons, *Museums: A History*, (Rowman & Littlefield, 2016), 136.

27 Ibid., 150.

28 Stamberg, Susan. "How Andrew Carnegie Turned His Fortune into a Library Legacy," NPR, August 1, 2013.

29 George Brown Goode, *Museum History and Museums of History* (New York: Knickerbocker Press, 1889), 263.

30 Cotton Dana, quoted in Gail Anderson, *Reinventing the Museum: The Evolving Conversation on the Paradigm Shift* (AltaMira Press, 2012), 21.

31 Ibid., 21.

32 Ibid., 24.

33 Ibid., 29.

34 Ibid., 29.

35 "John Cotton Dana—Newark's First Citizen," Rutgers University Libraries, accessed September 24, 2020; Cynthia Robinson, "From the Editor-in-Chief," *Journal of Museum Education* 44, no.1 (2019): 1–3.

36 Emily Badger, "Every Library and Museum in America, Mapped," *CityLab*, June 7, 2013.

37 Cotton Dana, quoted in Gail Anderson, *Reinventing the Museum: The Evolving Conversation on the Paradigm Shift* (AltaMira Press, 2012), 28–9.

38 Since I began this conversation with the Brooklyn Public Library, we have planned a series of public programs together called the Art and Society Census, which I discuss in greater detail in the coming pages.

39 Visit the Brooklyn Public Library's webpage on the 28th Amendment for a wealth of details on these public discussions.

40 Laura Raicovich, "Why Libraries Have a Public Spirit That Most Museums Lack," *Hyperallergic*, November 7, 2019.

41 Aruna D'Souza, *Whitewalling: Art, Race & Protest in 3 Acts* (Badlands Unlimited, 2018), 70.

42 Ibid., 79.

43 Ibid.

44 Bridget R. Cooks. "Black Artists and Activism: Harlem on My Mind (1969)," *American Studies* 48, no. 1, Spring 2007, 25

45 Ibid., 74–5.

46 Ibid., 71.

2 Art and Context

1 While Elgin had "permission" to take the Acropolis statuary from the Ottoman Sultan who governed Athens as early as 1801, the process of removing, packing, and then transporting the sculptures to London was a long and complex one. For a summary account, see Juan Pablo Sánchez, "How the Parthenon Lost Its Marbles," *National Geographic*, March 4, 2017.

2 Hartwig Fischer, quoted in Iliana Fokianaki, "How I Lost My Marbles; or, Calling for Colonial Patricide," *Frieze*, March 6, 2019.

3 Felwine Sarr and Bénédicte Savoy, "The Restitution of African Cultural Heritage: Toward a New Relational Ethics," November 2018.

4 Fokianaki, "How I Lost My Marbles."

5 Alex Marshall, "This Art Was Looted 123 Years Ago. Will It Ever Be Returned?," *New York Times*, January 27, 2020.

6 Aaron Ross and Marine Pennetier, "France Returns 26 Artworks to Benin as Report Urges Restitution," *Reuters*, November 23, 2018.

7 From a virtual conversation with Simone Leigh, Sharifa Rhodes-Pitts, and the author for new students at RISD on September 9, 2020.

8 Anya Jaremko-Greenwold, "Protesters Block, Demand Removal of a Painting of Emmett Till at the Whitney Biennial," *Hyperallergic*, March 22, 2017.

9 Hannah Black, "Hannah Black's Letter to the Whitney Biennial's Curators: Dana Schutz Painting 'Must Go,'" *e-flux*, March 1, 2017.

10 Coco Fusco, "Censorship, Not the Painting, Must Go: On Dana Schutz's Image of Emmett Till," *Hyperallergic*, March 27, 2017.

11 Randy Kennedy, "White Artist's Painting of Emmett Till at Whitney Biennial Draws Protests," *New York Times*, March 21, 2017.

12 "About," The Racial Imaginary official website, accessed March 17, 2019.

13 Whitney Museum of American Art, "Perspectives on Race and Representation: An Evening with the Racial Imaginary Institute," filmed April 9, 2019 at Whitney Museum.

14 Ibid.

15 Ibid., 1:05:23–1:08:27.

16 Ibid., 1:10:47–1:11:10.

17 Tina M. Campt, *Listening to Images*, (Duke University Press, 2017), 6.

18 Whitney Museum of American Art, "Perspectives on Race and Representation: An Evening with the Racial Imaginary Institute," 1:34:10–1:36:43.

19 Adeola Enigbokan, "Work ethics: On fair labour practices in a socially engaged art world," *Art & the Public Sphere*, 4, no. 1, December 2015, 18.

20 Whitney Museum of American Art, "Perspectives on Race and Representation: An Evening with the Racial Imaginary Institute," 2:03:15–2:03:25.

21 National Gallery of Art, "Statement from the Directors," June 27, 2019.

22 Jason Farago, "The Philip Guston Show Should Be Reinstated," *New York Times*, September 30, 2020.

23 Hrag Vartanian, "National Gallery of Art Director Discusses the Decision to Delay the Philip Guston Exhibition," *Hyperallergic*, October 1, 2020, podcast 00:30–00:40.

24 All Musa Meyer quotes: Sarah Cascone, "Philip Guston's Daughter and Other Critics Speak Out Against Four Museums' Decision to Postpone a Major Retrospective on the Artist," *Artnet*, September 25, 2020.

25 Whitney Museum, "Perspectives on Race and Representation," 1:14:55–1:14:59.

26 Ibid., 1:21:07.

27 Ibid., 1:21:58–1:22:27.

28 Ibid., 2:11:25–2:13:45.

29 Ibid.

30 Racial Imaginary Institute event 1:27:09–1:27:57.

31 Tikkun Olam is a Jewish concept of responsibility for the "repair of the world." For a considered look at the history of this concept, see Jeremy Schwartz, "Tikkun Olam, Unpacked," *Reconstructing Judaism*, December 1, 2016.

32 Patricia C. Phillips et al., *Mierle Laderman Ukeles: Maintenance Art* (Prestel, 2016), 168.

33 Ellen C. Caldwell, "An Interview with Sam Durant," *Riot Material*, January 29, 2017.

34 Sam Durant, "Artist Statement Regarding *Scaffold* at the Walker Art Center," *SamDurant*, May 29, 2017.

35 Sheila Regan, "After Protests from Native American Community, Walker Art Center Will Remove Public Sculpture," *Hyperallergic*, May 29, 2017.

36 Carolina Miranda, "Q&A: Artist Sam Durant was pressured into taking down his 'Scaffold.' Why doesn't he feel censored?," Los Angeles Times, June 17, 2017.

37 Sam Durant, interviewed by Laura Raicovich, June 7, 2019.

38 Durant, "Artist Statement."

39 Durant also penned a long reflection on Scaffold earlier this year which details further nuances in his thinking. It can be found here: samdurant.net.

40 Louise Erdich, "Letter to the Editor," *Star Tribune*, November 15, 2017.

41 Sunaura Taylor, *Beasts of Burden: Animal and Disability Liberation* (New Press, 2017), 60.

42 Ibid., 57.

43 La Tanya S. Autry, "Refusing Tokenization / Racial Fantasy," *Artstuffmatters*, February 14, 2020.

44 William H. Frey, "The US Will Become 'Minority White' in 2045, Census Projects," *Brookings*, March 14, 2018.

3 Show Me the Money

1 Anand Giridharadas, *Winners Take All: The Elite Charade of Changing the World* (Knopf Doubleday Publishing Group, 2018). Giridharadas defines MarketWorld in *Winners Take All* as "an ascendant power elite that is defined by the concurrent drives to do well and do good, to change the world while also profiting from the status quo" (30). Darren Walker and the Ford Foundation are a specific and fascinating focus of Giridharadas's book.

2 Ibid., 230–31.

3 Caitlin Dickerson, "Parents of 545 Children Separated at the Border Cannot Be Found," *New York Times*, October 21, 2020.

4 Hrag Vartanian, Zachary Small, and Jasmine Weber, "Whitney Museum Staffers Demand Answers after Vice Chair's Relationship to Tear Gas Manufacturer Is Revealed," *Hyperallergic*, November 30, 2018.

5 (De)Institutional Research Team, "Whitney Museum Guide," Whitney Museum of American Art, accessed September 24, 2020. A PDF of the brochure is available at d-irt.com.

6 Ibid.

7 Jillian Steinhauer, "The Whitney Biennial: 75 Artists Are In, and One Dissenter Steps Out," *New York Times*, February 25, 2019.

8 Colin Moynihan, "Eight Artists Withdraw From Whitney Biennial Over Board Member's Ties to Tear Gas," *New York Times*, July 19, 2019.

9 The full text of Kanders's resignation letter is available in Robin Pogrebin and Elizabeth A. Harris, "Warren Kanders Quits Whitney Board After Tear Gas Protests," *New York Times*, July 25, 2019.

10 Andrew Edgecliffe-Johnson, "Tear Gas Company Boss on the Benefits of 'Less-Lethal' Weapons," *Financial Times*, January 12, 2020.

11 Parallel to the Whitney pressures, since early 2018, alumni and students demanded that ties be severed between Kanders and his alma mater, Brown University; see Klara Zimmerman, Sophie Duncan, Trevor Culhane, and Camila Bustos, "Op-Ed: Why is Brown Greenwashing Tear Gas and Rubber Bullets?" *The Brown*

Daily Herald, February 7, 2018. These calls intensified as Safariland tear gas was identified at the Black Lives Matter protests of late May 2020, and shortly thereafter, the *New York Times* reported that Safariland divested from its teargas divison. See Robin Pogrebin, "Warren Kanders Says He Is Getting Out of the Tear Gas Business," *New York Times*, June 9, 2020.

12 Hannah Black, Ciarán Finlayson, and Tobi Haslett "The Tear Gas Biennial," *Artforum*, July 17, 2019.

13 For a good primer on how this thinking evolved through US tax codes, see Kelsey Piper, "The Charitable Deduction Is Mostly for the Rich. A New Study Argues That's By Design," *Vox*, September 3, 2019.

14 Nicolas J. Duquette, "Founders' Fortunes and Philanthropy: A History of the U.S. Charitable-Contribution Deduction," *Business History Review* 93 (2019): 553–84.

15 Deborah Krieger, "A Visual History of Federal Art Spending in the United States," *Hyperallergic*, March 17, 2014.

16 "National Endowment for the Arts (NEA)," American Alliance of Museums, accessed October 17, 2020; "Drug Overdose Deaths," Centers for Disease Control and Prevention, accessed May 22, 2019.

17 Anand Giridharadas, "When Your Money Is So Tainted Museums Don't Want It," *New York Times*, May 16, 2019.

18 For a proposal created by New York City activists, artists, and cultural workers that seeks to radically increase the city's culture budget as well as make specific policy and action recommendations to address gentrification, labor, and cultural inequity, see "The People's Cultural Plan for Working Artists and Communities in New York City," People's Cultural Plan official website, May 18, 2017.

19 This, of course, brings up whether "the public" is actually interested in what museums do, which is a much-needed discussion that must also be had in chapter 6 of this book.

20 See Elizabeth Warren's proposal "Ultra-Millionaire Tax" at elizabethwarren.com/plans/ultra-millionaire-tax, accessed December 8, 2020.

21 Elizabeth Warren (@ewarren), "My Two-Cent Wealth Tax," Twitter, October 15, 2019.

22 Jim Waterson, "How Is the BBC Funded and Could the Licence Fee Be Abolished?," *Guardian*, December 16, 2019.

23 "Where the Money Goes," National Lottery, accessed March 18, 2020.

24 Elizabeth Oldfield, "National Lottery Is a Bad Deal for the Poor," *TheosThinkTank*, August 11, 2011.

25 "About the Funds," Minnesota Legacy Fund official website, accessed March 18, 2020.

26 A fascinating thread of contemporary economic theory attempts to debunk the so-called "deficit myth" and challenges the proposition that federal taxation revenues must precede spending, and that federal deficits are bad. See Stephanie Kelton, "The Deficit Myth," *Public Affairs*, June 2020.

27 Rebecca Solnit, "Whose Story (and Country) Is This?," *LitHub*, April 18, 2018.

28 See National Endowment for the Arts, "Latest Data Shows Increase to U.S. Economy from Arts and Cultural Sector," March 19, 2019. Further, while the numbers and impacts are real, one major issue is how this data has been used to instrumentalize culture as a lever for gentrification and led to ugly displacement; another concern is how it has created a quid pro quo approach to public funding for the arts that is directly argued only on the basis of economic impacts, rather than the far more beneficial and broader impacts of culture on society. The discrediting of Richard Florida's work on the "creative class" has gone some way in countering this trend, but there remains a good deal more to do.

29 I focus on these two elements, in particular, because this entire book could be devoted to this topic and still not reach any useful conclusions. The subject is as fraught as it is complex, and I provide the following thoughts here as a way into some of the thornier aspects of this discussion.

30 From a conversation between Helen Molesworth and Laura Raicovich, September 2020.

31 Helen Molesworth, "On the Reinstallation of the Permanent Collection," *Artforum*, January 1, 2020.

32 Christopher Knight, "Critic's Notebook: MOCA Still Mum about Curator's Firing, Despite Crucial Questions and Too Few Answers," *Los Angeles Times*, March 20, 2018.

33 "About," Art and Feminism, accessed March 18, 2020.

4 Unlearning, Undoing, Remaking

1 Ariella Aïsha Azoulay, *Potential History: Unlearning Imperialism* (Verso Books, 2019), 207.

2 Ibid., 195.

3 Ibid., 167.

4 Ibid., 167–8.

5 The show, which took place in 2018, was curated by Manon Slome and me; it was presented by the Queens Museum and No Longer Empty at the museum, in Times Square, and throughout New York City.

6 Technically it was its own exhibition within an exhibition, as part of the museum's long-running Artist's Choice series.

7 Ibid., 170.

8 Amy Lonetree, *Decolonizing Museums*, 9–10.

9 Ibid., 123.

10 Ibid., 133.

11 Saidiya Hartman, *Wayward Lives, Beautiful Experiments: Intimate Histories of Riotous Black Girls, Troublesome Women, and Queer Radicals* (W.W. Norton & Company, 2019), 347–8.

12 In Australia, Indigenous land is referred to as "Country."

13 A particularly exemplary model in the United States is the Vera List Center for Art and Politics, which not only devoted a year of study in 2016 and 2017 to "Indigenous New York," but has also held related private and public convenings, and continues to center Indigenous thought in its work. See "Archive," Vera List Center, accessed March 18, 2020.

14 Museum of Contemporary Art Australia, "Material Histories," filmed March 17, 2020 at MCA, Sydney, 00:14–00:30.

15 Interview between Elizabeth Ann Macgregor and the author, October 2019. Further, regarding statistics about populations of Native Peoples, about 3.3 percent of Australia identifies as Aboriginal or Torres Strait Islander (see Australian Bureau of Statistics, "Estimates of Aboriginal and Torres Strait Islander Australians," September 18, 2018); in the United States people who identify as American Indian or Alaska Native comprise 1.7 percent of the total population (see Minority Health, "Profile: American Indian / Alaska Native," accessed March 18, 2020). I want to note that census taking is always a tricky business for all kinds of socioeconomic reasons, and the "counting" of people in any group is equally complex. There is also the matter of who "counts" that is widely and intensely debated. I use these statistics to provide a general sense of percentage of population, recognizing the substantial flaws in how they were calculated.

16 Interview between Maud Page and the author, October 2019.

17 Sen Nag Oishimaya, "The Most Visited Museums in North America," *WorldAtlas*, accessed January 28, 2020.

18 "On October 9, 2016, Decolonize This Place Staged the First of Three Anti–Columbus Day Actions at the American Museum of Natural History (AMNH)," Decolonize This Place official website, accessed March 18, 2020.

19 Jeremy Hobson, "Teddy Roosevelt's Complicated Legacy 100 Years after His Death," *WBUR*, March 21, 2019.

20 Eugenics Archive, "T. Roosevelt Letter to C. Davenport about 'Degenerates Reproducing,'" accessed March 18, 2020.

21 Art historian Harriet Sennie has argued for an interpretation that these two nameless figures are allegories for the continents of the Americas and Africa, but this is a difficult reading to imagine casual museum visitors recognizing today.

22 The full report, with its methodologies, aims, and recommendations may be accessed here: New York City, *Mayoral Advisory Commission on City Art, Monuments, and Markers: Report to the City of New York*, accessed January 28, 2020.

23 American Museum of Natural History, "Addressing the Theodore Roosevelt Statue," June 21, 2020.

24 To get a sense of the wildly divergent views on this subject, compare Nick Mizroeff, "How Do We Address a Statue of President Roosevelt That Affirms Racist Hierarchies?," *Hyperallergic*, September 24, 2019, to Edward Rothstein, "Natural History Does the Full Pander," *Wall Street Journal*, July 31, 2019.

25 Museum of Natural History, "Addressing the Theodore Roosevelt Statue."

26 In the interest of disclosure, I'll note that I serve on the board of Not an Alternative / The Natural History Museum.

27 The Natural History Museum, "Our Letter Has Gone Viral," The Natural History Museum official website, March 25, 2015.

28 Christopher Leonard, "David Koch Was the Ultimate Climate Change Denier," *New York Times*, August 23, 2019.

29 American Museum of Natural History, Letter to Ms. May Boeve, Mr. Bill McKibben, Ms. Beka Economopoulos, *GoFossilFree*, November 2, 2016.

30 American Museum of Natural History slashes fossil fuel holdings as global divestment commitments hit $5 trillion in assets, 350.org, December 12, 2016.

5 The Neutrality Problem

1 Rebecca Solnit, "To Break the Story, You Must Break the Status Quo," *Lit Hub*, May 26, 2016.

2 Rebecca Solnit, interviewed by Laura Raicovich, October 22, 2018.

3 See La Tanya S. Autry, "Museums Are Not Neutral," *Artstuffmatters*, accessed March 17, 2020.

4 La Tanya S. Autry, interviewed by Laura Raicovich, April 20, 2018.

5 Robert Jensen, "The Myth of the Neutral Professional," in *Questioning Library Neutrality Essays from Progressive Librarian*, Alison Lewis, ed. (Library Juice Press, 2008).

6 Roland Barthes, *The Neutral: Lecture Course at the Collège de France (1977–1978)* (Columbia University Press, 2005), 48–9.

7 Ibid., 50–51, my emphasis.

8 Christina Sharpe, *In the Wake* (Duke University Press, 2016), 9.

9 Ibid., 13.

10 Kuoni also pointed me to the non-profit Swiss Chambers' Arbitration Institution, which provides both commercial mediation and national arbitration services. A history of Swiss neutrality and arbitraion can be found here swissarbitration.org/files/560/History/2018_Arbitration%20and%20Mediation%20in%20Switzerland_History%2020180724_ENG_Final.pdf.

11 From an email exchange with the author, March 19, 2019.

12 For a brief but incisive description of her ideas about this, see Jeanne van Heeswijk, "Trainings for the Not-Yet," *JeanneWorks*, accessed April 9, 2020.

13 Chlöe Bass, *As Radical, As Mother, As Salad, As Shelter: What Should Art Institutions Do Now?*, ed. Paper Monument (Paper Monument, 2018), 7–9.

6 Going Forward

1 Chantal Mouffe, "The Museum Revisited," *Artforum*, accessed March 18, 2020.

2 All LAAGP quotes from my interview with Chao and Debanvu: Laura Raicovich, "A Unique Program Pays You to Visit Museums as a Guest Critic," *Hyperallergic*, June 27, 2019.

3 "Look At Art. Get Paid," Website: lookatartgetpaid.org/risd, Pilot: RISD Museum, accessed December 8, 2020.

4 All OAFAC details are from an email exchange between Carmen Papallia and the author in December 2020.

5 While I worked at Creative Time when this project was commissioned, I was not directly involved in its realization. It was curated by Rashida Bumbray, along with Creative Time's then-artistic director, Nato Thompson.

6 "Simone Leigh: Free People's Medical Clinic," Creative Time, accessed March 18, 2020.

7 Jonas Staal, *Propaganda Art in the Twenty-First Century* (MIT Press, 2019), 188–189.

8 For a short overview of the Rojava revolution, see Kenan Malik, "Syria's Kurds Dreamt of a 'Rojava Revolution'. Assad Will Snuff This Out," *Guardian*, October 27, 2019. For a deeper dive into the tenets of the revolution, and a first hand account of a visitor to the region, see Evangelos Aretaios, "The Rojava Revolution," *Open Democracy*, March 15, 2015.

9 "New World Embassy: Rojava," Jonas Staal official website, accessed October 17, 2020.

7 Liberation Serif

1 "Minneapolis City Council Members Say They Plan to Vote to Disband the City's Police Department," *CBS News*, June 9, 2020.

2 For an account of events in Los Angeles, New York, and Portland, see Dionne Searcey, John Eligon, and Farah Stockman, "After Protests, Politicians Reconsider Police Budgets and Discipline," *New York Times*, June 8, 2020.

3 Denis Slattery, "New York Lawmakers Vote to Repeal 50-a, Making Police Disciplinary Records Public," *New York Daily News*, June 10, 2020.

4 Robin Pogrebin, "Warren Kanders Says He Is Getting Out of the Tear Gas Business," *New York Times*, June 9, 2020.

5 Robin Pogrebin, "Museum Boss Salaries: Reduced but Still an Issue amid Wider Cutbacks," *New York Times*, August 18, 2020.

6 American Alliance of Museums, "2019 Annual Meeting Keynote: Kippen de Alba Chu and Kimberly Drew," filmed May 28, 2019, 37:00–40:20.

7 Alex Greenberger, "'It's Helpful to Know All Scales': Online Spreadsheet Discloses Museum Workers' Salaries," *ArtNews*, May 31, 2019.

8 *The Atlantic* published a useful set of arguments against the unpaid internship in 2012 which remains current today. See Derek

Thompson, "Unpaid Internships: Bad for Students, Bad for Workers, Bad for Society," *Atlantic*, May 10 2012.

9 Kevin Patra, "NFL Instituting Changes to Rooney Rule," NFL official website, May 18, 2020.

10 Ben Davis and Sarah Cascone. "The New Museum's Staff Is Pushing to Unionize—and Top Leadership Is Not at All Happy About It," *Artnet*, January 10, 2019.

11 MCAccountable is accessible at sites.google.com/view/mcademands/august-21-update, accessed December 8, 2020.

12 MCAccountable, "MCAccountable: Our Collective Letter to the Pritzker Director of the Museum of Contemporary Art Chicago," sites.google.com/view/mcademands/august-21-update, accessed July 16, 2020.

13 The cultural organization, Recess, has recently announced it will be headed by co-directors, and I am eager to see how this plays out over time. See Diana Budds, 'Artist Shaun Leonardo Is the New Co-Director of Recess," *New York Magazine*, November 20, 2020.

Index

A

A Better Guggenheim, 159
Abichandani, Jaishri, 2
Acropolis Museum, 43–4
Alexander, Elizabeth, 74
American Alliance of
 Museums, 10, 160
American Association of
 Museums, 5
American Indian Movement,
 38, 64
American Museum of
 Natural History, 27–8,
 125, 129, 131
Art Gallery of New South
 Wales, 119–23
Art Space Sanctuary, 5, 6, 9
Art Stuff Matters, 133
Arts Council England, 98
Arts Council of Northern
 Ireland, 98
Arts Council of Wales, 98
Arunanondchai, Korakrit,
 90
Association of Art Museum
 Directors, 5

Australian Academy of
 Science, 131
Azoulay, Ariella Aïsha,
 110–12, 114–15

B

Biennale of Sydney, 121
Birthing Tikkun Olam
 (Mierle Laderman
 Ukeles), 63
Black Arts Movement, 38,
 40
Black Emergency Cultural
 Coalition, 40
Black Imaginary Institute,
 54
Black Lives Matter, 47, 150,
 158, 160
Black Panther Party, 64,
 150
Black Youth Project 100,
 126
Brooklyn Public Library, 35,
 143

C

Cabinet of Craving (Mel Chin), 112
Canayo García, Lastenia, 108
Carnegie, Andrew, 29, 33, 97
Charleston Library Society, 26–8
Chin, Mel, 8, 89–90, 112
Christov-Barkagiev, Carolyn, 65
Clinton Global Initiative, 76
Clinton, Bill, 75–6
Creative Time, 150, 160
Cultural Organizing, 2

D

D'Souza, Aruna, 38–41, 51
Dana, John Cotton, 30–1
de Blasio, Bill, 3, 128
Decolonize This Place, 86, 126
Decolonizing Museums (Amy Lonetree), 116–17
(De)Institutional Research Team, 88
Dialogue Advisory Group, 137
Drogadictos Anónimos, 6
Duquette, Nicolas J., 94
Durant, Sam, 26, 64–5, 67–72, 107, 148, 167

E

Economopoulos, Beka, 131
Emancipation Proclamation, 65
English, Josephine, 150
Enlightenment, 22, 24, 28
Erdrich, Louise, 72
Esche, Charles, 24–5
Extinction Rebellion, 1

F

Ferreras-Copeland, Julissa, 3
Field Museum, 27, 131
Finkelpearl, Tom, 162
Fluxus, 114
Ford Foundation, 56, 74
Founding Fathers, 28
Free People's Medical Clinic (Simone Leigh), 150
French Revolution, 22

G

Gerstle, Gary, 126
Giridharadas, Anand, 75, 96
Goldin, Nan, 15, 18–19, 41, 91
Goode, George Brown, 29
Guerrilla Girls, 51
Guston, Philip, 55–8, 60–3, 167

H

Hancock, Trenton Doyle, 53

Harlem Cultural Council,
39

Harris, Lyle Ashton, 53, 59,
62–3

Hartman, Saidiya, 117–18

Hellenic Alexandria, 22

I

In the Wake (Christina
Sharpe), 135

Indigenous Advisory Group,
122

International Committee of
the Red Cross, 110

International Council of
Museums, 12

Ishak, Bassam Said, 152

Istanbul Museum of Painting
and Sculpture, 21

J

J. Paul Getty Museum, 29

K

Kanders, Warren, 78–84,
87–92, 94, 97, 103, 125,
158,

Kim, Christine Sun, 90

King, Jr., Martin Luther, 833,
133

Koch family, 97, 130–1

Ku Klux Klan, 56, 83

Kuoni, Carin, 136

Kurian, Ajay, 54

L

Leslie-Lohman Museum of
Art, 155, 165–6

Lew, Christopher, 60

Locks, Mia, 61

Lonetree, Amy, 27, 116–17

M

Macgregor, Elizabeth Ann,
123

Mackennal, Bertram, 119

Mal Content (Pope.L), 114

Malcolm X, 114, 150

Martínez, Samanda, 146

MCAccountable, 159, 164

McArthur, Park, 15

Meier, Barry, 17

Metropolitan Museum of
Art, 15–16, 18–20, 31,
38–41, 161, 166

Minneapolis City Council,
158

Minneapolis Police
Department, 155

Minnesota Historical Society,
66

Molesworth, Helen, 102, 108

Morgan Library, 29

Museum of Contemporary
Art Australia, 121–2
Museum of Contemporary
Art Chicago, 159,
164
Museum of Contemporary
Art, Los Angeles, 64,
107
Museum of Fine Arts,
Boston, 55
Museum of Fine Arts,
Houston, 55
Museum of Modern Art, 5,
15, 100, 113, 169
#MuseumsAreNotNeutral,
133

N
National Endowment for the
Arts, 94
National Gallery of Art,
55–7
National Lottery Heritage
Fund, 98
National Portrait Gallery, 16,
19, 91
New Deal, 76, 95
New Sanctuary movement,
5
New World Summit
(Jonas Staal), 151
No Longer Empty, 8
North American Free Trade
Agreement, 76

O
Obama, Barack, 2
Ocasio-Cortez, Alexandria,
95, 101
Open Access Foundation for
Art & Culture, 147
Open Casket (Dana Schutz),
26, 48, 50, 68, 70–1

P
Panetta, Jane, 89
Papallia, Carmen, 147
Peabody Museum of
Archaeology and
Ethnology, 27
Peale, Charles Willson,
28
Pence, Mike, 7, 9
Pope.L, 114
Portland Museum of Art,
133
Prescription Addiction
Intervention Now,
15
Purdue Pharma, 16–18

Q
Quai Branly–Jacques Chirac
Museum, 23, 46
Queens Museum, 1–9, 32,
89, 162
Queens Public Library,
34

R
Racial Imaginary Institute, 52–3, 58–61
Reddy, Prerana, 2
Rhode Island School of Design, 144
Rhodes-Pitts, Sharifa, 60
Rojava, 151–3
Roosevelt, Franklin D., 76, 95
Roosevelt, Theodore, 126–9

S
Sackler family, 14–19, 21, 29, 41, 91, 94, 97, 103
Safariland Group, 78–80, 87, 90, 158
Saudi Royal Family, 20–1
Scaffold (Sam Durant), 26, 65, 67–9, 71–2, 107, 148
Schutz, Dana, 26, 47–53, 55, 57–61, 68, 70, 82, 87
Scottish Arts Council, 98
Sense of Emergency, 5
Sharpe, Christina, 52–4, 117–18, 135–6
Simmons, John, 28
Slome, Manon, 8
Solomon R. Guggenheim Museum, 5, 16, 18–19, 36, 159
Spillers, Hortense, 54
Staal, Jonas, 151–2, 167
Standing Rock, 67, 87

Student Nonviolent Coordinating Committee, 38
Syrian National Council, 152

T
Temple of Dendur, 18, 40–1
Tiravanija, Rirkrit, 114
Trouillot, Michel-Rolph, 135
Trump, Donald, 2, 4–5, 9, 45, 75, 79, 100, 152
Tutu, Desmond, 9

U
Ukeles, Mierle Laderman, 59
Ulysse, Gina Athena, 15
United Order of Tents, 150
Untitled (apron and Thai pork sausage) (Rirkrit Tiravanija), 114

V
Vera List Center for Art and Politics, 136
Viso, Olga, 67
Vizenor, Gerald, 117–18

W
The Waiting Room (Simone Leigh), 150

Walker Art Center, 26,
66–8, 70, 72, 74, 107,
148–9
Warren, Elizabeth,
97
*Wayward Lives, Beautiful
Experiments* (Saidiya
Hartman), 118
Weeksville Heritage Center,
150
Whitewalling (Aruna
D'Souza), 38
Whitney Biennial, 26,
47, 51–2, 86, 90,
92

Whitney Museum of
American Art, 49, 51,
78–80, 87, 90, 158
Whitney, Gertrude
Vanderbilt, 85
Winner Take All (Anand
Giridharadas), 75, 96
Works Progress Admin-
istration (WPA) 95–6

Z
Ziibiwing Center of
Anishinaabe Culture &
Lifeways, 111